Heidegger Reframed

Contemporary Thinkers Reframed Series

Deleuze Reframed ISBN: 978 1 84511 547 0
Damian Sutton & David Martin-Jones

Derrida Reframed ISBN: 978 1 84511 546 3
K. Malcolm Richards

Lacan Reframed ISBN: 978 1 84511 548 7
Steven Z. Levine

Baudrillard Reframed ISBN: 978 1 84511 678 1
Kim Toffoletti

Heidegger Reframed ISBN: 978 1 84511 679 8
Barbara Bolt

Kristeva Reframed ISBN: 978 1 84511 660 6
Estelle Barrett

Lyotard Reframed ISBN: 978 1 84511 680 4
Graham Jones

Heidegger

Reframed

Interpreting Key Thinkers for the Arts

L Barbara Bolt

I.B. TAURIS
LONDON · NEW YORK

Published in 2011 by I.B.Tauris & Co. Ltd
6 Salem Road, London W2 4BU
175 Fifth Avenue, New York NY 10010
www.ibtauris.com

Distributed in the United States and Canada Exclusively by
Palgrave Macmillan 175 Fifth Avenue, New York NY 10010

ISBN: 978 1 84511 679 8

A full CIP record for this book is available from the British Library
A full CIP record for this book is available from the Library
of Congress
Library of Congress catalog card: available

Typeset in Egyptienne F by
Dexter Haven Associates Ltd, London
Page design by Chris Bromley
Printed and bound in Great Britain by
CPI Antony Rowe, Chippenham

FSC
www.fsc.org
MIX
Paper from
responsible sources
FSC® C013604

Contents

List of illustrations

Acknowledgements

It has been a pleasure to be involved in the 'Contemporary Thinkers Reframed' series produced by I.B.Tauris. I would like to pay tribute to Susan Lawson's initiative and courage in proposing a series of books on contemporary thinkers aimed specifically at the visual artist and visual-arts students. I would also like to acknowledge Philippa Brewster, Liza Thompson and Gretchen Ladish's patience and commitment to the project. Estelle Barrett has, as always, enriched this book through our ongoing dialogues and her generosity in reading the manuscript. I would like to thank Michele Elliot for allowing me to spend time with her art, read her thesis and write about it. I appreciated the efforts of Kylie Timmins at the Queensland Art Gallery, who organised permission for me to reproduce Qin Ga's *The Miniature Long March* (2002–5), and Qin Ga for granting permission to reproduce it. I would also like to thank Patricia Piccinini and Tolarno Galleries in Melbourne for permission to reproduce *The Young Family* (2002). Finally, the writing of this book would not have been possible without the time granted by the University of Melbourne through its study leave programme. There is nothing more precious than time.

Introduction

The question about the meaning of Being is to be *formulated*. We must therefore discuss it with an eye to these structural items.

Inquiry, as a kind of seeking, must be guided beforehand by what is sought. So the meaning of Being must already be available to us in some way...we always conduct our activities in an understanding of Being. Out of this understanding arise both the explicit question of the meaning of being and the tendency that leads us towards its conception. We do not know what 'Being' means. But even if we ask, 'what is Being?' we keep within an understanding of the 'is', though we are unable to fix conceptionally what this 'is' signifies. We do not even know the horizon in terms of which that meaning is to be grasped and fixed. *But this vague average understanding of Being is still a Fact.* (BT 1962: 25)

The question

What does it mean to reframe Heidegger? This question may seem somewhat premature for those of you who have only just been introduced to Heidegger, or who are struggling to read his primary texts and are looking for some guidance on how to come to terms with his difficult, old-fashioned and obscure prose, the seemingly drawn out and perplexing circularity in the way he sets out his argument and his incessant questioning: what is Being? What is nothing? What is technology? What is art? It may seem more appropriate to ask: what does it mean to 'frame' Heidegger?

In his essay 'The question concerning technology' (1954) Martin Heidegger introduces us to the concept '*Gestell*' (enframing). In his

explanation of this concept he takes us back to the original German term *'Gestell'*. He tells us that *Gestell* ('frame') means some kind of apparatus, and gives us the example of a bookrack or bookcase. He also tells us that *Gestell* is the name for a skeleton (QCT: 20). We can make sense of this in terms of our own everyday understandings in the world. In a painting or a window, for example, the windowframe is the structure that allows us to have a view onto the outside world; it sets the limit and provides a boundary for our view. A skeleton, we know well, provides the structure that holds our flesh in place and allows us to carry ourselves in the world. Hence, we can understand *Gestell* as a structure or apparatus that provides possibilities and sets limits on what and how we think and move in the world. Without a way to structure and make sense of the world, it would be an overwhelming and teeming mass of sensations that made no sense. Thus to 'frame' Heidegger is to provide a structure to help make sense of his philosophical thinking and writing.

One possible way to frame Heidegger is in terms of his personal history, in particular his German origins and his role as an academic at Freiburg University in Germany in the inter-war period, where he became caught up in the fervour of National Socialism, or Nazism. Being aware of this history makes it impossible to address his writing and thinking without acknowledging his dubious links with Nazism, his lack of insight into the potentials of National Socialism, and his failure to acknowledge his own complicity with the National Socialist regime in Germany in the 1930s. Certainly there have been many scholars who feel that Heidegger's complicity with Nazism cannot be overcome, and they refuse to engage with his work. Other scholars, however, point out that Heidegger's thinking on the question of 'Dasein', that is human beings 'being-in-the-world', mirrors his own susceptibility to the pressures of being-in-the-(National Socialist)-world. Hence it offers important lessons for all of us. For these scholars, this

is precisely why we need to study rather than avoid Heidegger's writings.

It is Heidegger's ability to frame human existence or being in terms of its relation to the world that has provided his greatest contribution to thought. His recognition that human existence involves being-in-the-world and being-with-others, and acknowledgement that our thoughts and behaviour are shaped by our relationships in the world that provide the fundamental grounds for his philosophy of being. Such an understanding now seems so self-evident that it is hard to imagine how radical such a thought was when Heidegger first published his major treatise *Being and Time* in 1927.

By placing human beings in the midst of other beings and entities in the world Heidegger challenged the prevailing view that human beings were somehow separate from the world in which they lived. We cannot merely step off the world as we would a merry-go-round and look at it as if we were detached from it. According to Heidegger, we can never know the world from this objective point of view, since we are always already in the world, thrown into it and carried along by its momentum. Heidegger calls this our 'thrownness' ('*Geworfenheit*'). Our everyday experience of being-in-the-world enables us to understand what it is to be a (human) being. This understanding of being or existence challenged and continues to challenge the scientific view of the world, a view that tends to reduce everything, including humans, to objects of study.

Heidegger's notions of thrownness and being-in-the-world brought into question the long-held philosophical belief that we can only know the world through our thinking about it – our ideas or representations of things. Since the seventeenth century, when the philosopher/mathematician René Descartes formulated the dictum 'I think therefore I am', it had been accepted that the only certainty we have in life is that we can think. For Descartes and thinkers who followed, the world outside our minds is always

in question; all that we can ever be sure of is that we think. Thus we can never be sure that anything or anyone really exists outside our ability to think them. Heidegger saw this as nonsense, believing Descartes had precipitated a wrong turning. For Heidegger, we are never alone with our thoughts. Our existence is inextricably tied to being-in-the-world. Thus, in our thrownness we are always already subject to the world in which we live. 'Dasein, as everyday being-with-one-another, stands in *subjection* [*Botmassigkeit*] to Others' (BT 1962: 164). What characterises our existence cannot be reduced to mere thought, but rather must encompass our disposition towards and actions in the world, that is the relationships we establish and the way we act in the world – with both human beings and other 'beings' in the world. It is only through these relationships with things, rather than an objective view of the world, that we come to understand what it is to be a human being. This has special significance for our thinking about art.

Heidegger argues that what differentiates us as human beings from other beings – both natural entities and man-made artefacts – is that we question our being and wonder about the meaning of being a being. We would recognise this condition from our everyday life. Life is full of doubts and questions about who and what we are. For Heidegger this questioning of being is the central preoccupation of his life's work.

Every enquiry made by Heidegger, whether it be the analysis of everyday life, the representationalist nature of modern thinking, the questioning of modern technology or the investigation into works of art, is underpinned by this one central question: what is the meaning of being? What is the Being of a being? Daniel Palmer has observed that

from beginning to end, Heidegger's thinking revolved around this one basic question of the meaning of being...When Heidegger investigates art he does not do so to determine its characteristics

as a specific and isolated region of human experience, but as a possible clue to decipher the meaning of being. (Palmer 1998: 397)

Even those essays that are specifically concerned with art, for example 'The origin of the work of art' (1935–6), seem to be an excuse to take up and explore the theme of the being. Heidegger is not concerned with the artwork *per se* but rather how, through the work of art, the Being of beings is revealed.

Heidegger believes that the task of philosophy and art is to produce movement in thought. We may recognise this preoccupation with 'movement' in our own artistic practice and in the model of avant-garde art. Such movement, Heidegger tells us, cannot be gained through contemplative or theoretical knowledge, but rather must take the form of concrete understandings that arise from our dealings in and handlings of the world. While the everyday may be the starting point for his investigations, Heidegger never takes anything at face value. He believes that in our everyday life, as in our everyday artistic practice, we get stuck in our habitual ways of knowing and acting in the world. He argues that the real 'movement' in understanding must take place in the capacity of enquiry to put basic concepts in crisis, not by defending them. In order to address the question of being we must first be able to formulate the question adequately (BT 1962: 24).

Heidegger's preoccupation with 'Being' and the 'Being of beings' may seem abstract and removed from the Being of an artist. What use is this questioning of 'Being' to us as we go about our business making, exhibiting and attempting to make a living with our art? In the opening quote, drawn from *Being and Time*, we may draw an image of the fervent young Heidegger haranguing a lecture theatre full of students, circling around the question of being without coming any closer to explaining or coming to grips with what Being *is*. But that would be to misrepresent Heidegger. He tells us from the beginning that Being is already available to us in some way and that we always conduct our activities in an

understanding of Being. The masses of eager students who came to listen to his inspiring and passionate lectures did so precisely because his theory was grounded in and exemplified by everyday practical experiences of being-in-the-world, and dealing with the things and the people that surround us.

They also came because his questioning into Being – the Being of beings, the Being of technology, the Being of art – offered a guide into thinking about who and what we are. Taking as its key theme the way beings act in the world and the relationships they establish with other beings, Heidegger's thinking has had a profound influence on the development of the social sciences and the humanities as well as philosophy. His thinking on Being has made a major contribution to some of the major European philosophers of the twentieth century, including Hannah Arendt, Hans-Georg Gadamer, Jürgen Habermas, Jean-Paul Sartre, Simone de Beauvoir, Maurice Merleau-Ponty, Michel Foucault and Jacques Derrida. But what of art and thinking about art: how does his thinking contribute to the arts?

His grounding of the questioning of Being (for example, the Being of art) in process and practical knowledge – the knowledge that comes out of being-in-the-world and dealing with things – makes practical sense to a practising artist. More than this, however, it is his tireless commitment to questioning, in itself, that makes Heidegger so relevant for thinking about what art *is* now, that provides the key to his relevance for us today, since such questioning also lies at the heart of contemporary art and art theory. In the movement from the self-confidence of Modernism, where Modernist artists could claim that 'This is art!', to the uncertainty of postmodernism, where postmodernist artists pose the question, 'Is this art?', there can no longer be certainty. There are only more questions. This questioning follows on from and is imbued with (through the influence of such writers as Sartre, Habermas, Derrida and Foucault) the spirit of Heidegger's untiring commitment to the questioning of *what is*.

It is Heidegger's incisive questioning of what Being *is* and what is the Being of art *now* that provides the key to understanding the relevance of his writings to contemporary art. As we progress through this book we will come to understand that the central question that Heidegger raises about art is one that is most pertinent to our time: is art still an essential and necessary medium in which 'truth' happens for human beings? Is it relevant for our historical existence? (OWA: 205).

Following Heidegger, the question I pose to the reader is whether art is still an essential and necessary way in which we can understand the world in which we live, or has art lost that power? This book in no way aims to provide the answer, for that would go against the spirit of Heidegger's philosophy. Rather, his questioning spirit aims to jolt us out of our preconceptions about art, life and the world. If art is no longer essential and decisive for our historical existence, what is its purpose and why do we do it? The questions that Heidegger asks, and that are taken up in this book, offer a provocation to us to think about our own work and working practices as well as more broadly thinking about the place of art in our contemporary world. From this, we can begin to understand that it is not only the 'content' of Heidegger's writing that is incisive, but rather his spirit, approach and method that proves so valuable for us as students of art.

How to read Heidegger

So how might we proceed? Let us return to our original question. What does it mean to reframe Heidegger? The 're' of 'reframed' suggests 'to frame again', that is to provide another frame, another way of looking at and thinking about his philosophy. Until now, the interpreters of Heidegger's works on art have tended to be philosophers writing on art. For philosophers the key questions are philosophical, and hence where art is the subject of discussion, it tends to be used to tease out or illustrate a philosophical point.[1] This volume introduces Heidegger on art

from an artist's perspective. It has been written for artists and art students, and aims to introduce those key concepts that open out onto questions of practical and theoretical concern for them. While this reframing ranges across the breadth of Heidegger's writings, including his most famous work, *Being and Time*, it tends to focus on his writings on representation, human/tool relations, technology, the work of art and aesthetics.

Heidegger's phenomenological method provides clues on how to read him so that you can get the best out of the texts. He usually starts with a question: what is technology? What is art? What is being? He proceeds by a methodical examination and description of the phenomenon (technology, art, being), beginning with our ordinary everyday experience of the phenomenon – the event, experience or object. At each point of the way, he returns to his fundamental question in order to 'test' the preconceptions that we bring to our encounters with the world against how the phenomenon reveals itself. Through this careful attention to phenomena as they appear, he strips away our everyday preconceptions so that we may see things as they show themselves. We will see this in the following chapters as we examine the everyday, art, representation, technology, the relationship between theory and practice, the 'place' of the artist, aesthetics, and lastly the emerging field of art-as-research.

Heidegger provides a bridge between those art practices that are grounded in materiality and process, and those that are conceptually based. His thinking is as relevant for artists who use their materials as a means to a conceptual end and whose work draws initially from theory as it is for artists whose work is materially based. Heidegger's questioning lies at the intersection of these different modes of working.

This book should be read in conjunction with Heidegger's key texts rather than as an authority on its own. Each chapter focuses on a particular essay or section of his writing, and unpacks his ideas to draw out the relevance for contemporary art and for

artists. The chapters are introduced with a relevant quote from one of Heidegger's texts, and reference a particular artwork, artist or experience of art in order to 'ground' the discussion. The structure of the chapter involves a close reading of Heidegger's texts in relation to actual examples of practice.

Martin Heidegger's seminal work *Being and Time* (1927) introduces the key concepts that underpin understanding of what it is to be a human being. In Chapter 1, Sophie Calle's *Take Care of Yourself* (2007) provides a frame through which such key concepts as 'Dasein', 'Being', 'the Being of beings', 'being-in-the-world', 'care' and 'thrownness' are explained. Heidegger's distinction between the everyday lives of human beings and their concern with their Being as beings, as demonstrated through the analysis of *Take Care of Yourself*, forms the fundamental tension that characterises our being-in-the-world. Through the discussion of Calle's work, we come to understand how we can so easily get caught up in the everyday that we forget what it means to *be* a being. We are thrown into the world and life and get carried along by its momentum. In this 'thrownness' we can never step aside or outside and see the world objectively.

In his essay 'The origin of the work of art' (1935–6), Heidegger makes the provocative statement that 'Art is the origin of the artwork and of the artist' (OWA: 182). Chapter 2 investigates Heidegger's distinction between the work of art and the artwork in order to draw out a definition of 'art' that is relevant for contemporary art. It explains Heidegger's conception of the work of art as the establishment of strife between earth and world, and draws on Homi Bhabha's encounter with Anish Kapoor's sculpture *Ghost* (1997) to explain Heidegger's conception of art as a revealing.

Chapter 3 sets out Heidegger's critique of representation. Through a close reading of Heidegger's essay 'The age of the world picture' (presented as a lecture under the title 'The establishing by metaphysics of the modern world picture' in 1938 and published in 1950), this chapter brings into question our everyday and artistic

understandings of the term 'representation'. Through his explanation of representation as a mode of thought, rather than as a particular type of mimetic imaging, Heidegger demonstrates that a representationalist way of conceiving the world is at the root of the instrumentalist way that modern humans conceive the world around them as a resource for their use.

Heidegger's essay 'The question concerning technology' questions our everyday assumptions about technology, arguing that the essence of technology is not concerned with making and manipulating things but is a mode of revealing that tends to reduce all entities in the world to resources as a means to an end. Heidegger terms this way of thinking an enframing revealing, distinguishing it from the *'poietic'* revealing that characterises art. Taking Anselm Kiefer's art practice as an example, Chapter 4 examines how contemporary art practice has an ambivalent relation to technology and has become caught up in an enframing or technological revealing.

Chapter 5 sets out Heidegger's understanding of 'praxical' knowledge through a close reading of his tool analysis as outlined in *Being and Time*. Heidegger is rare among scholars in that he addresses the relationship between theory and practice in a way that privileges what is known as praxical knowledge. His suggestion that we come to know the world theoretically only after we have come to understand it through handling, offers a radical way of rethinking the relationship between theory and practice in the visual arts. This chapter explores the idea of 'handlability' through William Kentridge's animated films in order to show how the special kind of knowing that comes from handling enables us to offer new insights into the notion of the 'new'.

In Chapter 6 we come to address the role that the artist plays in the creation of art. Through his critique of the Modernist notion of artist as genius, Heidegger sets out an alternative conception of creation whereby the artist is no longer at the centre of artistic production, but rather is co-responsible for the emergence of art.

It is a modelling of creative practice that opens the way for a post-human understanding of creation in the arts. Drawing on his perspicacious account of the making of a silver chalice, elucidated in the essay 'The question concerning technology', this chapter draws out the complex relationship between human and non-human elements in the work of art. This relation is exemplified through an examination of the production of Patricia Piccinini's work *The Young Family* (2002).

In a series of lectures on Nietzsche, published as *Nietzsche: The Will to Power as Art* (1981), Martin Heidegger presents a powerful critique of Western aesthetics. Chapter 7 sets out Heidegger's argument against Modernist aesthetics, and shows how an aesthetic conception of art (where art is seen in terms of aesthetic pleasure) has led to the marginalisation of art as legitimate domain of knowledge. Drawing on Heidegger's account of the early Greek ethical conception of art – where art was seen as providing guidance to how we can live, and hence was inextricably tied to 'truth' and knowledge, this chapter examines the emergence of political aesthetics as a trend that re-connects art to life.

The final chapter of this book addresses the emergence of creative-arts research. The institutionalisation of art in the university has created tensions as well as benefits for artists who choose to enter the academic world. While the incorporation of the creative arts into the academy has enabled them to reassert themselves as a specialised domain of knowledge, it has also placed pressure on the creative arts to conform to dominant modes of research in the university, that is the modes of research offered by the sciences and social sciences. This chapter sets out Heidegger's critique of science-as-research in order to lay out the features of art-as-research. It suggests that Heidegger provides us with some key concepts that can enable the creative arts to develop a distinctive methodology that can distinguish it from the reductionism of the scientific method. While we have come to

understand the importance of questioning as a mode of enquiry, we have also come to understand the dangers of reducing the world and art to objects of investigation.

While Heidegger's prose may at first seem obscure and abstract, it is always related to our being-in-the-world. Bring your own experience of being-in-the-world and being-with-things in the world to your reading of his texts. Relate the ideas and concepts set out in his writings to your experience of living in the world, making, exhibiting, writing about and viewing art. Move back and forwards between Heidegger's description of the phenomenon and your own experience of it. At every point 'test' your own experience in the light of Heidegger's questioning. Does it make sense to you? What questions does it raise for you? Where does it take you? What does it mean for you? Heidegger's writing is not a theoretical treatise about things out there, but is concerned with how we as beings can understand our being-in-the world. For Heidegger, being an artist is being-in-the-world, and is not separate from our Being as a being.

Heidegger Reframed aims to ground Heidegger's writing in the critical questions confronting contemporary visual artists. It takes the most relevant texts of Heidegger's oeuvre and sets out ways of thinking about art in a post-medium, digital, technocratic and post-human age. His intention is not to offer us answers, but rather constantly to pose questions about what it is to be-in-the-world. Through this attention to and questioning of phenomena, Heidegger hopes that we can cast off our habitual way of understanding the world and develop new and different relationships with things in the world. As such he provides an 'artists' guide to the world'.

Chapter 1

Art and the everyday

There is an ancient fable in which Dasein's interpretation of itself as 'care' has been embedded:

Once when 'Care' was crossing a river, she saw some clay; she thoughtfully took up a piece and began to shape it. While she was meditating on what she had made, Jupiter came by. 'Care' asked him to give it spirit and this he gladly granted. But when she wanted her name to be bestowed upon it, he forbade this, and demanded that it be given his name instead. While 'Care' and Jupiter were disputing, Earth arose and desired that her own name be conferred on the creature, since she had furnished it with part of her body. They asked Saturn to be their arbiter, and he made the following decision, which seemed a just one: 'Since you, Jupiter, have given its spirit, you shall receive that spirit at its death; and since you, Earth, have given its body, you shall receive its body. But since 'Care' first shaped this creature, she shall possess it as long as it lives. And because there is now a dispute among you as to its name, let it be called 'homo', for it is made out of humus (earth).

This pre-ontological document becomes especially significant not only in that 'care' is here seen as that to which human Dasein belongs 'for its lifetime', but also because this priority of 'care' emerges in connection with the familiar way of man as compounded of body (earth) and spirit. 'Cura prima finxit': in care this entity has the 'source' of its Being. 'Cura teneat, quamdiu vixerit'; the entity is not released from this source but is held fast, dominated by it through and through as long as this entity 'is in the

world'. 'Being-in-the-world' has the stamp of 'care' which accords it its Being. (BT 1962: 242–3)

Context

I recall the buzz of going to the French pavilion at the 2007 Venice Biennale to see Sophie Calle's work *Take Care of Yourself*. There was much laughter and hilarity among the (mainly) female audience as they moved around the pavilion taking in the exhibition. Here, presented for all to witness, were 107 different women's interpretations of a personal email that Calle's ex-lover 'G' had sent her. The purpose of the email was to break off their relationship. From textual analysis to performance and video, these 'interpretations' ruthlessly deconstructed the form and content of his intimate confession to Calle.

Calle is quite candid that the art project *Take Care of Yourself* grew out of her pain and grief at being dumped by email by G. For Calle, it is quite simply a way of taking care of herself, of coming to terms with the heartlessness and cruelty involved in breaking up. In her preface to the book *Take Care of Yourself* (2007), she provides the context for the work:

I received an email telling me it was over.
I didn't know how to respond.
It was almost as if it hadn't been meant for me.
It ended with the words, 'Take care of yourself.'
And so I did.
I asked 107 women (including two made from wood and one with feathers), chosen for their profession or skills, to interpret this letter.
To analyse it, comment on it, dance it, sing it.
Dissect it. Exhaust it. Understand it for me.
Answer for me.
It was a way to taking the time to break up.
A way of taking care of myself. (Calle 2007: Nina Berberova's Preface)

While *Take Care of Yourself* may be Calle's strategy for taking care of herself, what does it tell us about our relations with other beings-in-the-world? Despite the air of ebullience and light-heartedness that filled the French pavilion, I experienced a strong ambivalence to the work that has haunted me ever since. What are the stakes involved in such a work? What does it mean to take our everyday life and put it on display for the entire world to see? What does it reveal about what it is to be a human being?

Take Care of Yourself raises critical questions about art and life – both about being caught up in the everyday and dealing with the very fact of being a human being *and* about taking these everyday experiences as the basis of art. In its concern with being and the ability of art to 'deal' with what it is to be a human being, *Take Care of Yourself* opens out onto Heidegger's philosophy of Being. The tensions revealed through an analysis of *Take Care of Yourself* enables us to tease out some of the central questions that Heidegger raises in his seminal text *Being and Time* (1927).

The email

G's email read as follows:

Sophie,

I have been meaning to write and reply to your last email for a while. At the same time, I thought it would be better to talk to you and tell you what I have to say out loud. Still at least it will be written.

As you have noticed, I have not been quite right recently. As if I no longer recognised myself in my own existence. A terrible feeling of anxiety, which I cannot really fight, other than keeping on going to try and overtake it, as I have always done. When we met, you laid down one condition: to become the 'fourth'. I stood by the promise: it has been months now since I have seen the 'others', because I obviously could find no way of seeing them without making you one of them.

I thought that would be enough, I thought that loving you and your love would be enough so that this anxiety – which constantly drives me to look further afield and which means that I will never feel quiet

and at rest or probably even just happy or 'generous' – would be calmed when I was with you, with the certainty that the love you have for me was the best for me, the best I have ever had, you know that. I thought that my writing would be a remedy, that my 'disquiet' would dissolve into it so that I could find you. But no. In fact it even became worse. I cannot even tell you the sort of state I feel I am in. So I started calling the 'others' again this week. And I know what that means to me and the cycle it will drag me into.

I have never lied to you and I do not intend to start lying now.

There was another rule that you laid down at the beginning of our affair: the day we stopped being lovers you would no longer be able to envisage seeing me. You know that this constraint can only ever strike me as disastrous, and unjust (when you still see B. and R…) and understandably (obviously…); so I can never become your friend.

But how can you gauge how significant my decision is from the fact that I am prepared to bend to your will, even though there are so many things – not seeing you or talking to you or catching the ways you look at people and things, and your gentleness towards me – that I will miss terribly.

Whatever happens, remember that I will always love you in the same way, my own way, that I have ever since I first met you; that it will carry on within me and, I am sure, will never die.

But it would be the worst kind of masquerade to prolong a situation now when, you know as well as I do, it has become irreparable by the standards of the very love I have for you and you have for me, a love which is now forcing me to be so frank with you, as final proof of what happened between us and will always be unique.

I would like things to have turned out differently.

Take care of yourself.

G.

G's entreaty to Calle to 'take care of herself' should not be seen merely as a parting platitude or riposte. Nor should we see Calle's taking care of herself through the execution of *Take Care of*

Yourself as an instance of art as therapy...although it may have an element of therapy embedded in it. For Heidegger, the notion of 'care' ('*Sorge*') is much more fundamental than that. 'Care' is 'that to which human Dasein belongs "for its lifetime"..."Being-in-the-world" has the stamp of "care", which accords it its Being' (BT 1962: 243). In other words care lies at the core of our being.

Heidegger's view of the human being revolves around care – 'I care therefore I am'.[1] According to Heidegger, it is care and concern for self, for other human beings and for the other entities in the world, that provide meaning and direction for our lives. It makes us wonder and question what it is to be human. What does that mean for us? Imagine for a moment that you did not care if you lived or died, that you did not care about or take care of your family and your friends or the things that are important to you. That something is important to you – your clothes, your tools, your car or your mobile, means that you care. To care is to take responsibility for self, for others and for things in the world.

There may be times when we are depressed, let ourselves go, fail to clean our room or even look after our things. Our world starts to fall apart. Even when we demonstrate a lack of care, Heidegger would argue that it is not because we are without care, but that we show a deficient mode of care. For Heidegger care is Dasein's primordial state of being-in-the-world.

Dasein

Dasein and 'being-in-the-world' are two key concepts in Heidegger's thinking. 'Dasein' is the German word for existence, and in its initial use by earlier philosophers, such as Kant and Husserl, denoted any entity – human or non-human, animate or inanimate. In contrast, Heidegger was very specific in his use of 'Dasein'. He used the term '*Da-sein*' to characterise human existence: '*Da*' meaning 'there' and '*Sein*' meaning 'being': 'there-being'. One might wonder why Heidegger adopts the term 'Dasein', and why translators have left it untranslated when it would seem

logical that the term 'human being' would suffice. However, Heidegger wants us to understand a very specific aspect of our existence, our being-right-there, being grounded in a place in which we live and from which we move in the world. While the Cartesian subject can go on thinking without a body or a place to think from, Heidegger's subject Dasein is always 'there' in the world. Each one of us has a 'there'. The world is not an object separate from the Dasein but something we are born into and live in relation to.

The 'there' of our world, with its complex physical, ideological, cultural and technological space/place provides a set of possibilities and limitations that structure our lives. Despite the homogenising influence of globalisation, there is no one world that Dasein lives in. Each of us lives in a number of intertwining worlds that influence what we value and how we move in the world. Calle's decision, for example, to ask 107 women to participate in her project begins to give us an insight into the rich diversity of worlds in which people move.

Among the women who took part were a family mediator, a proofreader, a judge, a lawyer, a police captain, a talmudic exegete, a moral philosopher, an expert in women's rights at the UN, a clairvoyant, a chief sub-editor, a translator of SMS language, an historian of the eighteenth century, a linguist, a Latinist, a chess player, an accountant, a Bharata Natyam dancer, a puppet at the Jardin d'Acclimatation Paris, a Fado singer, a psittacideae (a type of parrot), a criminologist, a headhunter, a sexologist, a psychoanalyst, a physicist, an etiquette consultant, an ethnomodiologist, a stylist, a diplomat, a clown, a journalist and an Ibekana master. The responses came in every form imaginable: video, dance, braille, song, SMS language, annotated text, parody, drawing and so on.

Each of the women who became involved in Calle's project brought their own world view – their cultural values and attitudes, their experience of life and love, their personal dispositions and

their personal and professional skills – to the task of responding to the email. Each respondent and each response offered us a different way of looking at, thinking about and responding to an extraordinary event in an ordinary life. The judge brought her knowledge of the law, its precedents, facts of law and desire for justice to her analysis, the sub-editor brought her ruthless pen and incisive knowledge of grammar and syntax to shredding the text, the chess player made strategic moves to outwit the opponent, the psychoanalyst delved into the unconscious mechanisms of displacement and repression in order to analyse the text, while an actress performed the text and the Fado singer sang a lament of lost love.

Calle had asked the women to interpret the email according to their professional expertise. The Bharata Natyam dancer's response to the lover's email took the form of a dance, with its ritualised movements, gestures and mimetic potentials. It relied on her physical skill and fluidity as a professional dancer and performer. However, like the rest of the women in the group, her professional world as a dancer is just one of a number of varied and intertwining worlds. She is somebody's daughter, someone's lover, maybe someone's sister or aunt as well as belonging to the world of Bharata Natyam dance. Her cultural heritage, social status, education, life experience and personal experience of love and loss also influenced the appropriate modes of response to such a cataclysmic event in life. What is critical to being-in-the-world, says Heidegger, is not predicated on what we know about the world but rather on knowing how to live and move in it. Existence involves being-in-the-world.

Thrownness

What is at stake for Dasein in being-in-the-world? For Heidegger, the drama of human existence is orientated around the possibilities that being-in-the-world throws up. We are thrown into the midst of life and get carried along by its flows and eddies, its turbulence and

its currents. From the moment of our birth, when we are expelled, screaming and kicking, into the world, gathered up by the doctor or midwife and handed to the mother we didn't choose, in an environment we can't control, at a time over which we have no say, we are thrown involuntarily towards our future. Heidegger calls this Dasein's 'thrownness' (*Geworfenheit*). While we may be able to choose our friends, we can't choose our family or the circumstances of our birth and life. The 'fact' that I was born in Australia to a farming family in a time of prosperity when the government of the time made tertiary education free has profoundly affected what I am today (my current situation) and my future possibilities. Even though Sophie Calle and I are roughly the same age and both identify ourselves as artists, the 'fact' that Sophie Calle was born in Paris to a Parisian art-collecting doctor interested in conceptual art and a literary-journalist mother enabled a different constellation for her future possibilities. Heidegger calls this constellation of factors that takes into account our current life circumstances and our future possibilities 'facticity'.

Each of us is faced with different life circumstances, and each of us will respond in our own unique way. Calle was a young person living in Paris during the revolutionary sixties. The circumstance of her birth and life, her family's wealth, status and progressive values, the radical intellectual climate of Paris and the growth of feminism disposed Calle towards certain ways of being-in-the-world. The fact that she became a radical militant in her teenage years and began working as an artist to counter growing feelings of boredom and aimlessness in her mid-twenties influenced what she would become. The fact that she took up conceptual art to please her father and that she won a scholarship to go to Japan in the early 1980s are integral to Calle's thrownness. The fact that she was dumped by her boyfriend in Delhi and then able to use this experience as the basis for the conceptual work *Exquisite Pain* are all instances of how this particular Dasein responded to her thrownness.

We are thrown into the world, and we have to deal with what is thrown at us. In existing, says Emmanuel Levinas, 'Dasein is always already thrown into the midst of its possibilities and not positioned before them' (Levinas 1996: 24). Here we may return to Sophie Calle's experience of her latest dumping. She is 51 and visiting Berlin. Her mobile beeps. It is an email from her boyfriend. It announces that he is leaving her. He ends the email with the words 'Take care of yourself.'[2] She is thrown into the middle of this life drama. Calle's thrownness, her being 'dumped', delivered her over to forces beyond her control. However, while the circumstances of our thrownness may be beyond our control, it does not mean that our course is totally determined either. So what does Calle do? Probably what many of us would do in the situation. After the disbelief and weeping and wailing, she seeks the care and comfort of a friend. She shows her the email and asks her how she would deal with it.

Calle's 'facticity' affected how she dealt with what the world threw up. She seized possibility, and saw in her personal experience the potential for art. 'The idea came to me very quickly, two days after he sent it,' she said. 'I showed the email to a close friend, asking her how to reply, and she said she'd do this or that. The idea came to me to develop an investigation through various women's professional vocabulary' (Chrisafis 2007). This, says Heidegger, is Dasein fulfilling its own possibilities for Being.

Calle was thrown out of her past. From the possibilities that the world threw up to her, Calle seized possibility in its possibility and through this 'projected' into the future. Heidegger uses the term 'projection' ('*Entwurf*') to describe the way Dasein acts in the world to fulfil its own possibilities as a Being. In using the break-up as the impetus for a major art project, Calle drew on her past experience, dispositions and skills and set up possibilities for what would become. Calle's past (her thrownness), her present (her dealing with the email) and future (how her actions affect what will happen in the future) demonstrate

Heidegger's three-dimensional understanding of time. The past is not past, but is here shaping our now, and what we do now projects into our future. From our vantage point, we can see how that has played out for Calle. What was a personal tragedy has become an international art event that has made Calle even more of an international art celebrity. But her thrownness is not over now, nor will it be in the future. Calle, like you or me, is always in a state of being thrown, and being thrown continues to shape our existence.

However, we are getting beyond ourselves here. In its being-towards-possibilities, Dasein understands itself in its possibilities for being. Being Dasein, Calle wanted to find a way of understanding what had happened, what she should do and how she should move. When she asked her friend what she should do, her friend gave her a number of possibilities: '(S)he said she'd do this or that'. We are probably all very familiar with the structure of this exchange. We ask our friends, our parents or our partner for advice on something that is worrying us. They offer us wonderful words of wisdom or caution us against certain actions, and we duly ignore them and go off and do our own thing anyway. We can't know how to act through other people's advice to us. We have to live it. This is what Heidegger understands as the praxical nature of Being.

Understanding

'The idea came to me,' comments Calle, 'to develop an investigation through various women's professional vocabulary' (Chrisafis 2007). Through asking professional women 'to interpret the letter in their professional capacity', Calle wanted them to *understand* for her. Her use of the term 'understanding' deserves comment. In everyday conversation 'to understand' is to be able to grasp something, usually an idea. However, Calle didn't want them just to think about it and explain it conceptually. She wanted them to 'analyse it, provide a commentary on it, act it, dance it, sing it.

Dissect it. Squeeze it dry. Understand for me. Answer for me.' The interpretation took many forms – a dance, an annotated text, a braille text, a song, a photograph, a 'class act', a parody, a video etc., but in each case understanding and interpretation involved 'doing something' with the email. It involved dealing with or handling the email in some way according to the professional skills that the interpreter brought to the task.

'Doing something' signifies an important shift in our thinking about the term 'understanding'. For Heidegger, 'understanding' is not a cognitive faculty imposed on existence, nor does it have the character of contemplative knowledge of the world. Rather, understanding is the concrete experience of being-in-the-world. 'When we merely stare at something,' says Heidegger, 'our just-having-it-before-us lies before us *as a failure to understand it any more*' (BT 1962: 190). It is only through our practical dealings or involvement with things that the world throws at us that our world becomes meaningful to us. For Heidegger, this practical understanding that comes from being in the world is Dasein's first way of being in the world. Our practical understanding of things in the world comes before any attempt to theorise them or explain them.

We don't become a lawyer or a judge by thinking about it, a sub-editor by contemplating it, a dancer by theorising dancing, a translator by looking at a foreign text, a chess player by sitting looking at the chess pieces on the board. We become a judge, a sub-editor, a dancer, a translator, a singer or a chess player by 'doing it'. Heidegger became a philosopher by practising philosophy. I became a painter by painting pictures. Similarly, my relations with entities in the world are predicated on my handling of them in use. Thus I can't understand the potential of a computer, a tool or my paints by just looking at them and contemplating. I might have some intuitive or learned sense about what they might do and how I might use them. However, it is not until I actually use the computer programs Photoshop

or Flash to create an image, begin to use an axe or a shovel to dig a hole, or squeeze my paints out onto my palette and begin applying them to my canvas that these entities become meaningful to me. It is only through our 'handling' that we gain access to things in the world. Dasein comes to 'understand' the world through its being in the world and dealing with things, rather than through contemplation. For Heidegger, being-in-the-world constitutes the precise form in which an understanding of Being is realised. Being-in-the-world is the understanding of Being itself. This constitutes the fundamental shift from the Cartesian perspective, where I am because I think.

In subsequent chapters, we will see how important Heidegger's notions of understanding and interpretation are for questioning the relationship between theory and practice, but here we also find a 'practical' clue on how to approach Heidegger's texts. We need to 'handle' his ideas practically, rather than merely contemplating the words on the page. For example, when I first tried to read *Being and Time* in isolation from my experience in the world, it made no sense to me at all. However, as I began to 'handle' the ideas in the book in relation to Sophie Calle's work, I came to understand both his concepts and her project (in the Heideggerian sense).

Heidegger's argument that consciousness proceeds from understanding, and this understanding is predicated upon our dealings in the world, offers a radical alternative to the Cartesian explanation of consciousness. Understanding is the 'care' that comes from handling, of being thrown into the world and dealing with things. The relations arising out of care are not the relations of a knowing subject and a known object, but come of being-in-the-world and dealing with things. Our thrownness renders meaningless the distance, perspective, detachment and reflection of Cartesian thinking. Emmanuel Levinas summarises this state of affairs when he says that '(t)o understand being is to exist in such a way that one takes care of one's own existence. To understand is to take care' (Levinas 1996: 18).

The everyday

Sophie Calle's project *Take Care of Yourself* was her way of taking care of herself. In contrast with those of us who would see such a dumping as a humiliating catastrophe, something that we just want to get past, forget and cover over, Calle decided to take it on as a full-scale research project to be investigated in all its nuances. Instead of trashing the email, or falling into dolour, it became the material of art. She comments, 'After 1 month I felt better. There was no suffering. It worked. The project had replaced the man' (Chrisafis 2007). While a depressed person might have become withdrawn and lost in her own world, or shown a deficient mode of concern, Calle's 'facticity' disposed her to turn her intimate personal experience of being dumped into art.

In the artworld, everyday experiences have increasingly become the material of art. However, not every artist takes the trials and tribulations of their private life as something to be literally shared with the rest of the world.[3] Calle's failures in love are known throughout the world through *Exquisite Pain* and *Take Care of Yourself*. *Exquisite Pain* documents an earlier dumping. Through photographs, air tickets, love letters, remembered fragments of conversations and other memorabilia Calle gave us an intimate portrait of lost love. In *Take Care of Yourself* we have the email in its entirety. Her unnamed (but well known) lover G's email has now been commented upon by 107 women and witnessed by millions through its exhibition at the Venice Biennale and in other showings of the work as well as through publication of the coffee-table book of the same name.

We are familiar with the confessional modes of blogging; of Facebook and MySpace. What makes Calle's work art, and what makes art about everyday life different from everyday life?[4] Jonathan Watkins, artistic director for the 1998 Sydney Biennale *Every Day*, comments that in contemporary art practice there is a growing concern with the significance of the everyday. In these practices artists make 'incidentally profound observations on the

nature of our lives as lived everyday' (Watkins 1998: 15). Art about the everyday, says Nikos Papastergiadis in his catalogue essay for *Every Day*, enables us take what is close at hand and through art think about the biggest philosophical abstractions from the position of our intimate experiences (Papastergiadis 1998: 27).

Heidegger agrees that we must begin with our everyday-experience-in-the-world, but he also worries that we get caught up in the 'mere verbiage and chatter of the everyday' and forget the question of Being. We forget what it is to take responsibility for our being-in-the-world. While Heidegger takes everyday life and beings as a starting point for his thinking of Being, he is wary that we have a tendency to fall into everyday gossip about human beings. His criticism of anthropology and sociology (and I would imagine cultural studies) reflects this concern. For Heidegger, the central question concerning Being is not the everyday activities or practices of human beings, but rather what such activities and practices can reveal or disclose about the Being of (human) beings. In order to develop this theme he distinguishes Dasein from everyday Dasein.

In developing his thinking on Dasein, Heidegger pays particular attention to its emanation as everyday Dasein. The distinction between Dasein and everyday Dasein mirrors Heidegger's differentiation between the ontic life of human beings and the ontological, that is a being's concern with its very Being. Here Heidegger's use of 'b' being needs to be contrasted with his use of 'B' Being. He uses 'b' being when concerned with actual entities in the world – you and me, my cat, your dog, your design, the house we live in, the trees in the garden, the shop down the road, the ground, the air and the sea; in fact anything or any event in existence. Sophie Calle and the email she received are beings or entities in the world. Details about her receiving the email, the content of the email with its parting phrase 'Take care of yourself', her reaction to the email and her immediate reaction to call a close friend belong to the ontic life of human beings. However, the

artwork *Take Care of Yourself* can tell us something about what it *is* to be a human being. Heidegger reserves the term Being to address the 'isness' of beings. Being is concerned with the question of what it is to *be* a being rather than the life or existence of an actual human being. Hence we recall that 'Take care of yourself' was not merely a throw-away line used in an email, but that for Heidegger 'care' is 'that to which human Dasein belongs "for its lifetime"…and which accords it its Being' (BT 1962: 243). The difference between an actual human being signing the email 'Take care of yourself' and 'care' as a fundamental character of Dasein's involvements in the world is what Heidegger calls the ontological difference.

In our everyday world we get so caught up in life – in the trials and tribulations of our work, family, friends and activities (artworks to make, articles to read, papers to write, bills to pay, groceries to buy, TV programmes to watch, friends to ring or text, concerts to go to) that we rarely pause to wonder about what this all means for us as human beings, or even what being a human being really is. As I am sitting here at my computer trying to focus on the question of Being, I am worrying about the looming deadline for the book, my imminent return to work after study leave, my failure to keep in contact with my friends, the unsatisfactory phone call I had with my sister-in-law last night and whether I am spending enough time with my partner to keep my relationship balanced. My head is so full of 'the stuff of everyday' that the meaning of Being keeps slipping away.

You will note that the things that are preoccupying me all involve other people – my publisher, my work colleagues, my friends, my family – and my relations with them. Heidegger tells us that *a priori* our being-in-the-world involves being-with-others. Before anything, I experience life in relation to others. I am a social being. Other people's expectations of me and my reactions to them structure my being-in-the-world.

Heidegger argues that our being-in-the-world necessarily leads Dasein to fall (*Verfallen*) into the habit of everydayness. Heidegger doesn't see fallenness as some 'fault' that can or should be overcome. It is part of the 'isness' of being a human Dasein. Everyday Dasein becomes absorbed in the everyday and becomes lost in 'the-*they*'. Heidegger observes that

Dasein has…fallen away (*abgefallen*) from itself as an authentic potentiality for Being its Self, and has fallen into the world. 'Fallenness' into the 'world' means an absorption in Being-with-one-another, in so far as the latter is guided by idle talk, curiosity, and ambiguity. (BT 1962: 220)

In our being-with-one-another and being structured by the 'they -self', Heidegger suggests that we cease to take responsibility for our being-in-the-world and become inauthentic beings. Here Heidegger is not making a negative judgement or suggesting that an inauthentic being has lost Being or is no-longer-being-in-the-world. Rather inauthenticity is a particular mode of being that happens in our everyday life when we get caught up in or absorbed in the they-world. The real question is whether we can really be ourselves, that is authentic Dasein. For the most part, he argues being-with-others involves living the life of the-*they*.

Being-with-others

Being-with-others is part of our thrownness. From the moment we are born, we are thrust into the world with others. Through our interactions with our parents, our teachers and our peers, and through our engagement with the media and other institutions we learn the values and expectations of the particular society in which we live. We learn to behave as they would (want us to) behave. The problem of this being-with-one-another, observes Heidegger, is that 'this Being-with-one-another dissolves one's own Dasein completely into the kind of Being of 'the Others' (BT 1962: 164). The self of everyday Dasein becomes the

they-self, a Dasein subjected to the 'dictatorship of the they'. Heidegger continues,

We take pleasure and enjoy ourselves as *they* take pleasure; we read, see, and judge about literature and art as *they* see and judge; likewise we shrink back from the 'great mass' as *they* shrink back; we find 'shocking' what *they* find shocking. The 'they' which is nothing definite, and which all are, although not as the sum, prescribes the kind of being of everydayness. (BT 1962: 48)

The world of *they* provides a social and cultural context, the matrix of possibilities and limitations that sets standards for how we move in the world. It is still considered 'bad form' to dump someone by text message or email, and Calle's outrage is not just hers. It is also the outrage of the-*they*, as many of the women's responses show. No doubt there is also some discomfort among the-*they* to Sophie Calle's calculated strategy to expose her private life and her ex-lover's email to such public scrutiny. Her own mood may have disposed her towards exposing this cowardly and dastardly act, but that she actually put it on display for the world to see may be seen as an act of pure vengeance and revenge: Sophie Calle behaving badly. Calle denies this motivation. 'No,' she said. 'And a fear that it might be interpreted like that initially made me hesitate' (Chrisafis 2007).

Sophie Calle could be seen to be 'thumbing her nose' at appropriate social propriety. Much of her 'oeuvre' has been concerned with turning everyday life into a subject for investigation: recording and re-creating moments from her life and from other people's lives. Her 'projects' include working as a chambermaid in a Venetian hotel, where she took photographs of guests' rooms and went through their belongings; stalking a man by following him to Venice, photographing him and making notes. In one of these ventures she purloined a lost address book, which she then used to call all the contacts. From this she

developed an alternative profile of the address book's owner, which was published in the newspaper *Libération*.

From her teenage years, Sophie Calle has been involved in a radical political critique. Each one of her projects breaks the 'acceptable' social rules and conventions operating in French society. However, as Heidegger has observed, all behaviour, even rule-breaking behaviour, operates against the backdrop of the-*they*. Further, as we have seen from our understanding of the 'world', there is not one world, and hence not just one *they* world. The artworld operates as a subculture within the broader cultural world, and like other subcultures has its 'way of the they'. The way of the avant garde has traditionally been concerned with breaking rules or putting rules and conventions (and audiences) in crisis. Artists break rules. That's what *they* do. In this context Calle's work does what artists do. Far from being shocked by this, this is what the-*they* (audiences and critics) expect from her.

The ontological difference

So far in this chapter, I have drawn quotes and excerpts from Angelique Chrisafis's newspaper report on Sophie Calle's art and life and her exhibition *Take Care of Yourself* at the 2007 Venice Biennale. Chrisafis's article was published in the *Guardian* newspaper and published on Saturday 16 June 2007 in both paper form and on the Internet. What makes my chapter on the relationship between art and life in the work of Sophie Calle any different from Chrisafis's article on Sophie Calle? We have both researched the work of Sophie Calle and written from this research. Angelique Chrisafis has the advantage over me. She has had the privilege of meeting and interviewing Sophie Calle and can draw on her notes and interview transcript to help weave her story. Here she writes,

A prime example of Calle turning pain into art is another piece for the Biennale. Calle says that when she was told last year

that she would be showing at Venice, another call came through: her mother saying she had a month to live. Calle nursed her at home. But she had heard that people who are dying often wait for the two minutes when their relatives leave the room to slip away.

'It became almost an obsession. I wanted to be there when she died. I didn't want to miss her last word, her last smile. As I knew I had to shut my eyes to sleep, because the agony was very long, there was a risk I might not be there. I put a camera there, thinking if she gave a last jump or start, a last word, at least I'd have it on film.'

This led to another fixation. 'The obsession of always having a tape in the camera, changing the tape every hour, was so great that instead of counting the minutes left to my mother, I counted the minutes left on each tape.'

Calle was in the room when her mother died. She hadn't shot the footage as a piece and didn't feel ready to use it, but her Venice curator persuaded her. 'Pas pu saisir la mort' is a film installation of the last minutes of her mother's life. 'I spoke to my mother about the Biennale…She was so horrified about not being there, I thought the only way I can make her be there is if she's the subject.' (Chrisafis 2007)

Chrisafis is a journalist, and her style of writing is journalistic. Quick grabs and sound bites woven together give her readers a picture of the enigmatic Sophie Calle. Her writing sticks to the facts of Calle's everyday life. It does not attempt to go beyond the everyday and draw out what this might mean for Being. She would soon lose her readership if she did so. Her writing operates in the ontic, in the world of things. It is the type of image-making we have become familiar with in our everyday interactions with the mass media. Whether I am in Hong Kong, Finland, Italy, the United Kingdom, America or Singapore I can pick up magazines that offer me the same stories about the same celebrities as I can when I read the magazines at the checkout of my local Safeway supermarket. Here average everydayness rules on a global level.

Where human beings get totally caught up in everyday activities and thoughts, through reading newspapers, watching television or surfing the Internet, Heidegger argues we become caught in the ontic life of human beings. Here, 'every other is like the next' (BT 1962: 164). With globalisation this dissolution into the kind of the being of 'the other' spreads its network across the world. And where Dasein gains an understanding of itself via entities in the world rather than via Being itself we are fallen Dasein. Emmanuel Levinas explains that in this fall into everydayness: 'Dasein does not understand itself in its true personality but in terms of the object it handles: it is what it does, it understands itself in virtue of the social role it professes … Dasein, fallen, is lost in things' (Levinas 1996: 25).

In everyday life the danger lurks that our understanding will not take the form of shedding a different light on Being, but rather becomes mere chatter and verbiage. Can the same be said of artists whose art engages with the everyday? Does *Take Care of Yourself* become mere chatter and verbiage, or did it really offer us some insight into the Being of beings?

Everyday Dasein gets caught up in the ontic world of things and beings rather than being concerned with the ontological question of Being. In reflecting on Calle's *Take Care of Yourself* through a Heideggerian lens, we become more attuned to the questions of Being than merely finding it entertaining. All the features that constitute Dasein's being-in-the-world in its average everydayness – its *fallenness* (its absorption in the they-world), its *Being-with* (its social context), its facticity, its *thrownness* (its living past) – can be drawn out through an analysis of this work. More than this, however, we have come to see that Dasein's fundamental state is care. For Heidegger, as we will come to understand in the next chapter, art provides a space in which to be able to understand Being rather than to get caught up in the everyday world of being and entities.

Chapter 2

Art, art business and the work of art

The establishing of truth in the work (of art) is the bringing forth of a being such as never was before and will never come to be again. The bringing forth places this being in the open region in such a way that what is to be brought forth first clears the openness of the open region in which it comes forth. Where this bringing forth expressly brings the openness of beings, or truth, that which brought forth is a work (of art). Creation is such a bringing forth. (OWA: 187)

The context

In his catalogue essay 'Anish Kapoor: making emptiness' (1998), Homi Bhabha tells of his first viewing of Anish Kapoor's sculpture *Ghost* (1997):

It was a day of rain and dust as AK (Anish Kapoor) and I drove into the stoneyard. You said, 'I want you to see something,' pointing to a shrouded dark stone, its light blinded by dust (*Ghost*, Kilkenny limestone). As we approach the rough-hewn stone, its irregular mass effortlessly, unconsciously awaits our audience. *Svyambhuv*, the Sanskrit word for the 'self-born' aesthetic (as distinct from *rupa*, the man made form imposed through human artifice) has been a long preoccupation of yours and, from one angle, *Ghost* resembles one of those 'irregularly shaped protuberances'. But then, suddenly, the facade belongs to *rupa*. I am always struck by the formality of the openings you cut into your stone pieces. Doorways, elongated windows, thresholds, finely finished portals, lintels with razor-like edges, that contrast with the raw halo of encrustations and crenellation, the chemical activity of the ages, around them. The torqued, ambivalent movement of the stone is unmistakable: *svyambhuv: rupa*, and then

in a flash; *rupa: svyambhuv* – self-made/man-made and then, in an iterative instant, back again man-made/self-made. Front and back not opposed to each other, but partially turned inwards, partly away, from themselves, catching side-long glimpses. A strange diagonal gaze. The whole stone is caught in an act of torsion; turning away from an earlier state, emerging from another time, half-glancing away from us, only partly there, obliquely revealed, a *mise-en-scène* in transition…In transition, between the material and the non-material…the passage between stone and a poetic existence …As one turns to face the other, it encounters a blind spot, the necessary void: 'it discloses these beings in their full but concealed strangeness as what is radically other – with respect to the nothing.' (Bhabha 1998: 20–2)

In his encounter with *Ghost*, Homi Bhabha came to the realisation that the work of art is *never just* an object, the artwork, but is always a process; a transitional moment when our assumptions about the world are brought into crisis and we are able to see the world in a new and unique way. Bhabha's account of this encounter brings us very close to Heidegger's understanding of the work of art. In this oscillation we experience the struggle between earth (between the self-born, the percept) and world (the man-made, the perceptual and the conceptual). The crisis that Bhabha experienced in coming face-to-face with *Ghost* was the 'doubt that dwells in the work and forces it to postpone its presence, to delay its disclosure, not to be what it says it is in the first instance' (Bhabha 1998: 39). Heidegger would term this crisis 'strife'. 'In setting up a world and setting forth of earth', claims Heidegger, 'the work (of art) is an instigating of this strife' (OWA: 175). It was through Bhabha's concrete experience of *Ghost* that he came to the understanding that the work of art creates strife, puts us – our perceptions, our preconceptions and our conceptions – in crisis. Strife, Heidegger tells us, 'does not happen so that the work should at the same time settle and put an end to strife by an insipid agreement, but so that the strife may remain a strife'. He continues that through '(s)etting up a

world and setting forth the earth, the work accomplishes this strife' (OWA: 175).

Heidegger tells us that 'the work-being of the work consists in the instigation of strife between world and earth' (OWA: 175). Heidegger's reference to the terms 'earth' and 'world' in relation to art is one of the most puzzling aspects of his thinking on art. What is earth and what is world? While I will return to this in later sections of this chapter, Heidegger's insistence that the work of art is the instigation of strife between earth and world needs immediate explanation. How might we think this? How might this help us understand what art is?

Our everyday understanding of earth as 'mute' matter which is formed by human action can provide us with a starting point for thinking about these concepts. Matter is, after all, says Heidegger, 'the substrate and field for the artist's formative actions' (OWA: 152). However, Heidegger cautions us against this way of thinking, or what he calls the form–matter structure (OWA: 152–3). Bhabha's distinction between *svyambhuv* (self-made) and *rupa* (man-made form imposed through human artifice) may prove to be a more useful way to tease out the distinction that Heidegger makes between our everyday understanding of earth and his unique use of the term. The relation between *svyambhuv* and *rupa* suggests that earth is not mute, but an active force in the work of art. Heidegger comments,

In the creation of a work, the strife, as rift, must be set back into the earth, and the earth itself must be set forth and put to use as self-secluding. Such use, however, does not use up or misuse the earth as matter, but rather sets it free to be nothing but itself. This use of earth is a working with it that, to be sure, looks like the employment of matter in handicraft. Hence the illusion that artistic creation is also an activity of handicraft. It never is. (OWA: 189)

Heidegger's observation that, whilst artistic creation gives the illusion that it is the work of human handiwork it *never* is, raises more questions than it answers. If the term

'earth' is not interchangeable with 'raw matter' and if the creation of a work is not a question of handicraft, then what is art?

Art and the 'artworld'

In his 1964 essay 'The Artworld', Arthur Danto argued that Warhol's *Brillo Box* came to function as art because at a particular time the artworld enabled it to be understood as art.[1] When Danto saw the boxes of Brillo pads in an exhibition of Warhol's works in the Stables Gallery on East Seventy-fourth Street, he was interested in how they could be considered art and not merely as artefacts of commercial culture. He proposed that in order for something to be understood as art, and not just an artefact of commercial culture, the object or artefact needed to be understood in the context of art history and a legitimising theory of art. It seemed to him 'that without both of these, one could not see the *Brillo Box* as a work of art…in order to do so one had to participate in a conceptual atmosphere, a "discourse of reasons", which one shares with others that make up the artworld' (Danto 2004: 5). We can only understand what art is through its embeddedness in an artworld. Thus in the context of Pop Art – both the practice and the theoretical discourse around it – Warhol's *Brillo Boxes* became art (see Danto 2004: 6–7). It had nothing to do with handicraft.

George Dickie built on Danto's notion of the artworld in his Institutional Theory of Art (ITA). Literally interpreted, the ITA says that art is what the artworld says it is.[2] Writing in the 1980s, Dickie made the argument that it was not a question of what an artwork looks like, what it is made of, what formal or what aesthetic qualities it possesses. What is important is whether 'it' operates within the institutional discourses of art. An artwork is only an artwork if the institutional discourses of art say that it is art. Thus for Dickie, 'A work of art is an artefact of a kind created to be presented to an artworld public' (Dickie 2004: 53).

We will recall from the previous chapter that Heidegger's 'world' is the structure that shapes our relations to the people

and things around us. As a subset of the world, the artworld consists of the values, attitudes, practices and beliefs that structure what art is and who belongs to the artworld. As artists, we make art. We go to the art shops to buy art materials and art equipment to make art. Many of us (but not Sophie Calle) go to art school, where we take courses in art practice, art theory and art history, and exhibit in end-of-year art exhibitions. We hope, post-art school, that we will find an art gallery and an art dealer who will take us on, so that we can exhibit and sell art. During such exhibitions we fervently (and quietly) hope that some art critic will chance upon the exhibition and write a critical but positive review of the work. Art criticism and patronage will ensure that we become part of the artworld. But we maintain our diligence. In order to keep up with the current trends we go to exhibitions, buy art catalogues, read art reviews written by art critics and are frequently to be found in art bookshops surreptitiously leafing through the latest art magazines and journals. We fly all over the world to this biennale or that triennial and to keep up acquaintance with other artists. In all this activity, we belong to the artworld. It would seem to make logical sense that the artworld structures our understanding of art. Heidegger would agree that art is historically contingent. The fact that *Brillo Box* appeared as art in the USA in the 1960s and not in Maoist China (or in Europe in the 1860s) makes sense when one assesses the historical conditions under which we understand our possibilities as beings. Yet this does not answer the question of what art is. Just as we needed to look beyond the ontic world of beings (which includes the artworld) to understand the Being of human beings, so Heidegger believes that we need to look beyond the artworld definition of art to assess the Being of art. We need to question art in its essence.

The essence of art

In the epilogue to 'The origin of the work of art' Heidegger makes the provocative statement that perhaps lived experience is the

element in which art dies (OWA: 204). This statement requires clarification. How can lived experience be the element in which art dies, when Heidegger also claims that the work of art emerges through lived, embodied experience? He affirms this when he says that lived experience is 'the source that is standard not only for art appreciation and enjoyment but also for artistic creation' (OWA: 204). The apparent contradiction in Heidegger's statement revolves around the distinction that he draws between 'Art' and 'art'. We see Heidegger again using capitals and lower case, as with his differentiation of Being and being. Here, he uses this strategy to draw the distinction between the essence of art ('Art') and art business ('art'). For Heidegger, the essence of art operates in the realm of Being. Art business or 'art' is what happens in the midst of the everyday as we try to negotiate the 'business' of making, exhibiting, viewing, buying and selling artwork in a modern technocratic society (see Robertson and Chong 2008). In this question we are returned to the distinction between Being and beings.

We will recall that this is what Heidegger terms the ontological difference. While ontology is concerned with Being as such, the ontic is concerned with the actual lived experience of human beings in a social context. Hence, while the essence of art (Art) is concerned with art as such, the life of an individual artist, the practice of an artist, and the artwork all operate in the ontic realm of beings. The ontic is the realm of art business and much else as well.[3]

The distinction between Art and art needs at the outset to be put in the context of Heidegger's central metaphysical question. How in the midst of beings, that is lived experience, is Being realised? How in the middle of art business can Art emerge? This remains the most difficult of questions for all of us working as contemporary artists.

The artworld and the theories of art that arise out of a conviction that art is what the artworld says it is (for example,

the ITA) operate in the world of the ontic. They are concerned with art business, not with Art in itself. While Heidegger would agree that it is not a question of what an artwork looks like, what it is made of, what formal or what aesthetic qualities it possesses, and acknowledges the artworld, he would disagree with both Danto and Dickie that the artworld defines what 'Art' is in itself. Such a view of art has not formulated or addressed the central question of the Being of art; what art is in its essence.

I will return to the notion of the essence of art shortly, but it is important to register here that Heidegger does not see 'essence' as some enduring universal quality that may be ascribed to art. There is not one defining feature or attribute that holds for the multifarious forms that art takes. The essence of something is not an attribute or state of that thing. Rather, for Heidegger, the essence is a 'happening', where the truth of art is revealed.

Heidegger worries that in our preoccupation with art business, art in itself may no longer be the essential and necessary way in which truth happens in our historical age (OWA: 205). Where art business rules supreme, the truth of art is forgotten. Heidegger comments,

As soon as the thrust into the awesome is parried and captured by the sphere of familiarity and connoisseurship, the art business has begun. Even a painstaking transmission of works to posterity, all scientific efforts to regain them, no longer reach the work's own being, but only a remembrance of it. (OWA: 193)

Heidegger is clear that the essence of art does not lie in the ITA. He is also sure that it does not lie in connoisseurship, or what we know as aesthetics. And finally, as we have seen, he does not believe that the essence of art resides in the making, manipulating or manufacturing of artworks.

The 'work' that art *does* is categorically not the object – painting, sculpture, drawing, print and so on – that we have come to call an artwork. This evaluation also holds for musical and

poetical works. In Heidegger's thinking, art in its essence is a mode of creating an open region in which truth ('*aletheia*') emerges. 'Art is the setting-into-work of truth…Art lets truth originate' (OWA: 202). This concern returns us to the question what is the truth of art; what is its essence?

In light of the postmodern critique of concepts such as essence and truth, originality and intentionality, Heidegger's questioning about the essence and truth of art may seem not just outmoded but also ideologically problematic. Feminism and post-colonialism in particular have identified how 'truth' has been formulated for the benefit of the dominant order and how 'essence' has been used historically (particularly in relation to sex, race and class) as an essentialising term to maintain the status quo and keep people in their place. Why would we want now to return to these terms, given the ideological baggage they carry?

Heidegger clearly wants to distinguish his use of notions of truth and essence from the common understanding that we attach to the terms. He derives his notion of truth from his enquiries into early Greek life, and draws attention to the Greek term '*aletheia*', which the Romans translated as '*veritas*'. We usually understand *veritas* or truth as the correctness of an idea. Something is true because it correctly represents or corresponds with a fact, or is in accord with its subject matter. In the West, the history and theory of visual arts associate *veritas* with truth to nature, that is with mimesis. This relationship between *veritas* and mimesis is evident in a famous story recounted by Pliny, which tells of the rivalry between two Greek painters in the fifth century BC, Zeuxis and Parrhasius, to paint the most true-to-life painting.

However, Heidegger makes it very clear that his use of the term 'truth' does not fit with corresponding theories of truth. While he may draw from van Gogh's 'mimetic' painting of the peasant shoes to argue that truth happens in van Gogh's painting, truth is not to be equated with correctness. Heidegger explains that while truth happens in the work of art, 'this does not mean that something is

correctly displayed', that is mimetically portrayed. Rather, he says truth happens when something is brought forth out of itself. For Heidegger,

'Bringing-forth' brings hither out of concealment forth into unconcealment. Bringing-forth comes to pass only insofar as something concealed comes into unconcealment. This coming rests and moves freely within what we call revealing (das Entbergen). The Greeks have the word aletheia for revealing. (QCT: 11–12)

Here we can return to Bhabha's astounding revelation when he came face-to-face with *Ghost*. In that moment, Bhabha observes that, as 'one turns to face the other, it encounters a blind spot, the necessary void: it discloses these beings in their full but concealed strangeness as what is radically other – with respect to the nothing' (Bhabha 1998: 22). In his account of this encounter, Bhabha brings us very close to Heidegger's understanding of truth as the work of art. For Bhabha, as for Heidegger, it is through strife that a truth emerged in and through the artwork. In an artwork, Heidegger says, 'truth is set to work' (OWA: 175). The revelation that happens through the encounter with an artwork, not the art object, *is* the work of art.

This is a very different way of thinking about truth, and also about the essence of art. Van Gogh's shoes did not reveal the truth because they provided a good mimetic likeness of a pair of shoes, but because they provided a revelation about the Being of the peasant's shoe. Where shoes in a shoe shop or in a shoe catalogue are reduced to an exchange value, van Gogh's painting of the shoes provides a space, an open region for the truth of the shoes to emerge. We are pulled up short, pulled out of the humdrum of the everyday and everyday thinking, and are brought to a different place of thought. As Heidegger observes, 'The essence of art, on which both the artwork and the artist depend, is the setting-itself-into-work of truth. It is due to art's poetic existence that, in

the midst of beings, art breaks open an open place, in whose openness everything is other than usual.' (OWA: 197)

We can perhaps understand Heidegger's concept of truth as *aletheia* or a revealing in Paul Klee's famous dictum 'art makes the invisible visible' or in John Berger's observations that Morandi's still-life paintings are not about painting bottles but are concerned with 'the process of the visible first becoming visible, before the object seen has been given a name or acquired a value' (Berger 2000: 19). Here Morandi's quest resonates with Heidegger's struggle to reveal the truth about the essence of art, that is the Being of art.

Just as van Gogh's painting is concerned with the disclosure of what the pair of peasant shoes *is* in truth, so Morandi's painting reveals how the becoming visible of visibility *is*. Berger tells us that the objects that Morandi paints 'can be bought in no flea market. They are not objects. They are places, places where some little thing is about to come into being' (Berger 2000: 19). Like Morandi's still-life paintings, Kapoor's *Ghost* created a space or an open clearing in which Bhabha was able to witness 'the passage between stone and a poetic existence' (Bhabha 1998: 22). In the setting-into-work of truth, we are catapulted out of the ordinariness of our day-to-day existence and into the actuality of the work of art.

We may think that the Modernist art gallery, the so-called 'white cube', provides the perfect example of an open region in which the 'truth' of art is revealed. In his book *Inside the White Cube: The ideology of the gallery space* (1986) Brian O'Doherty tells us the modern gallery was built in accordance with laws as rigorous as those for building a medieval church, with the sole purpose of providing a space for reflective contemplation. He comments,

The outside world must not come in, so windows are usually sealed off. Walls are painted white. The ceiling becomes the source of light. The wooden floor is polished so that you click along clinically, or carpeted so that you pad soundlessly, resting the feet while the

eyes have at the wall. The art is free, as the saying used to go, 'to take on its own life'. (O'Doherty 1986: 15)

However, rather than enabling art to come to presence as Art, the 'white cube' is replete with its own preconceptions, which frame the work as 'art'. These are the preconceptions framed by the artworld. In other words, the modern gallery sets in place art business and offers artworks for our enjoyment and aesthetic experience.

Strife

As we will see in Chapter 7, Heidegger is very critical of the aesthetic framing of art. He believes that aesthetics robs art of its essential and necessary role in understanding Being. Heidegger believes that aesthetics reduces art to mere experience and pleasure, and as such stops us questioning things in themselves. In the place of enjoyment or aesthetic experience, Heidegger offers us strife. We have already seen that strife characterises the relationship between world and earth. In 'setting up a world and setting forth of earth, the work is the instigation of the strife in which the unconcealments of beings as a whole, or truth is won' (OWA: 180). How can we understand this dynamic in which the work of art is the strife between world and earth?

The word 'strife' immediately brings to mind an event where there is a bitter struggle or violent conflict. Seen from this point of view, it may be argued that Marcel Duchamp created strife in 1917 when he signed 'R. Mutt' on a urinal, titled it *Fountain* and exhibited it amidst howls of consternation. However, Heidegger makes it clear that it is not the artist who creates strife, but the work of art, strife between world and earth.

Heidegger steers us away from accepting our commonsense understanding of strife as a destructive force, making the point that if we were to equate strife with discord and dispute, we would only ever experience disorder and destruction (OWA: 174).

Strife is not the competitive and mastering dynamic of the boxing ring, where world has to win out over earth. In strife, Heidegger tells us, 'each opponent carries itself beyond itself' (OWA 174). To go beyond oneself is productive.[4] Further, Heidegger maintains that the work of art is not concerned with resolving strife so that we can 'enjoy' it or feel comfortable. Strife is set in motion so that it can remain strife.

The strife in *Fountain* was not that Duchamp had upset the jury with a flagrant act of defiance, but that in transforming the urinal into a new being, he called into question the assumptions about what art *is* in itself. In the heat of the debate around the work, Duchamp's artist friend Beatrice Wood identified the significance of this act:

Whether Mr Mutt with his own hands made the fountain or not has no importance. He CHOSE it. He took an ordinary article of life, placed it so that its useful significance disappeared under the new title and point of view – created a new thought for that object. (Wood quoted in Godfrey 1998: 30)

In Wood's estimation, the urinal's use value had disappeared, and an opening had been created in which a 'new thought' for that object could emerge. As we have already seen, Sophie Calle also did this in *Take Care of Yourself*. This is what Heidegger calls the 'setting-into-work of truth' (OWA: 202) of the work. The setting-into-work of truth involves setting up a world and setting-forth of earth.

We touched on the notions of earth and world in the beginning of this chapter, but now we return to a fuller explanation. In 'The origin of the work of art', Heidegger uses the concept of world in the same way as in *Being and Time*. The concept of 'world' encapsulates the way our values, attitudes, practices and institutions structure how we operate in the world. It includes our material cultural objects as well as those immaterial structures such as ideology and belief structures. 'Earth' on the other hand

is a more complex notion. In everyday usage, earth and world are sometimes used interchangeably. More commonly earth is seen as that amorphous mass upon which, and out of which humans create their world. In this commonsense understanding, earth is brute mute matter available to be used and moulded by humans.

Particular strands of aesthetics and art theory, particularly those strands influenced by Kant – for example, the work of Schiller – tell us that art is formed matter. A painting or a thrown jug is a formed thing. Warhol's *Brillo Boxes* are also formed things. The form–matter synthesis seems to be common sense in the world of art. However, where art is conceived of as formed matter, Heidegger notes, matter becomes 'the substrate and field for the artist's formative action' (OWA: 152). Such a view places humans at the centre, as the ones who make the world. Here earth as matter provides the ground on which man acts. This is definitely not how Heidegger sees earth or the relation between world and earth.

Earth and world

Heidegger uses the example of the Greek temple to articulate his understanding of the relationship between world and earth. He begins his account in descriptive terms. 'A building, a Greek temple…simply stands there in the middle of the rock-cleft valley…Standing there, the building rests on rocky ground' (OWA: 167).[5] Here it is easy to assume that the rocky ground merely provides the support for the human actions. However, Heidegger goes on to dismantle our assumptions about the relation between earth and world. He continues,

This resting of the work draws out of the rock the obscurity of that rock's bulky yet spontaneous support. Standing there, the building holds its ground against the storm raging above it and so first makes the storm itself manifest in its violence. The lustre and gleam of the stone, though itself apparently glowing only by the grace of the sun, first brings to radiance the light of the day, the breadth of the sky, the darkness of the night. (OWA: 167–8)

From his initial description we could still think that Heidegger uses the term 'earth' in our everyday sense as the matter on which the world is built. The man-made temple is both built of stone from the earth and is embedded in the rock. However, it becomes apparent that what is important is the dynamic between earth and world. It is the lustre and gleam of the stone that enables us to appreciate the radiance of the light of the day, the breadth of the sky and the darkness of the night. Further, it is the firm structure provided by the rock that allows us to become aware of the invisible space of air and the surge of the surf.

Heidegger's reference to the 'making visible of the invisible space of air' recalls another sculpture titled *Ghost* (QWA 1990: 168). Rachel Whiteread's *Ghost* is a cast of a Victorian room, and in it the negative space that we usually take for granted is suddenly and profoundly made visible to us as it is transformed into a hulking form. In our everyday life we move about in rooms, go in and out of doors, sit at tables in rooms paying scant regard to 'the invisible space of air'. In Whiteread's work, what is normally taken for granted, and hence becomes invisible to us in everyday life, is forcefully brought back into focus. *Ghost*, like the temple, makes visible the invisible. The 'truth' of the work lies in bringing the 'space of air' out of the background inconspicuousness and into the foreground. This is the *ghost* in the work.

In recounting his encounter with Anish Kapoor's *Ghost*, Bhabha also reveals the dynamic between earth and world when he makes the distinction between *svyambhuv* ('self-born' aesthetic) and *rupa* (man-made form imposed through human artifice). As we noted, confronted by *Ghost*, Bhabha commented,

I am always struck by the formality of the openings you cut into your stone pieces. Doorways, elongated windows, thresholds, finely finished portals, lintels with razor-like edges, that contrast with the raw halo of encrustations and crenellation, the chemical activity of the ages, around them. (Bhabha 1998: 20)

At first this description seems to subscribe to the form–matter constellation that Heidegger is so critical of. However, the 'matter' of the rough-hewn Kilkenny limestone does not merely become the substrate for man's formative actions. In the movement back and forward between *svyambhuv* and *rupa*, Bhabha observes that the 'whole stone is caught in an act of torsion; turning away from an earlier state, emerging from another time, half-glancing away from us, only partly there, obliquely revealed, a *mise-en-scène* in transition…the passage between stone and a poetic existence' (Bhabha 1998: 21).

This 'torqued ambivalent movement of the stone' created havoc with Bhabha's preconceptions of Kapoor's work. At first Bhabha recognised in *Ghost* similarities with Kapoor's other work; his 'style', if you like: a commitment to the material beauty (*svyambhuv*) of the granite in itself rather than to the artist's will to master materials in a man-made form (*rupa*). However, as this thought begins to take shape, Bhabha's preconceptions about Kapoor's work immediately start to unravel. As he flip-flops back and forth between self-made/man-made (*svyambhuv: rupa*) and man-made/self-made (*rupa: svyambhuv*), Bhabha is no longer the critic or observer looking at an artwork, but has found himself in the middle of the work, caught up by its torqued ambivalent movement. Here we may recall the discussion on thrownness. We get thrown into the world and get carried towards possibility. In getting caught up by the work, Bhabha came to understand that the work of art was not the object, the artwork, but rather the truth that was revealed. He comments that

(T)he truly made work does not consist in the triumph of objecthood; it is only when the work enters that third space – 'a transitional space, an in-between space' – that the man-made and the self-made, the material and the non-material gather together and tangentially touch in the fevered movement – hither and thither, back and forth – of doubt. (Bhabha 1998: 39)

The 'movement' in understanding, not the artwork, *is* the work of art. In this account of his encounter with *Ghost*, Bhabha enables us to understand Heidegger's conception of the work of art as the strife that happens between earth and world. As Heidegger notes, 'Earth juts through the world and world grounds itself on the earth only so far as truth happens as the primal strife between clearing and concealing' (OWA: 180).

From our previous discussion we understand that truth (*aletheia*), is a revealing, an open space or clearing where beings are unconcealed, that is appear as they are. However, Heidegger also says that truth in the work involves 'primal strife between clearing and concealing. For what ever is revealed, there is also concealment.' Hence he says that in truth there is also untruth. 'Truth is un-truth,' says Heidegger, 'insofar as there belongs to it the reservoir of the not-yet-revealed, the un-uncovered, in the sense of concealment' (OWA: 185).

Unconcealment

What in our experience allows us to understand this simultaneous revealing/concealing that characterises the work of art? From the psychology of perception we may have come across the *Gestalt* figure of the vase and two profiles of the human head. When the figure of the vase comes into appearance, the profiles recede into inconspicuousness; when we focus on the profiles we can no longer see the vase. While each is essential for the other to emerge, when one is revealed as figure the other becomes concealed. Like *svyambhuv: rupa–rupa: svyambhuv* we flip-flop between vase and profile, profile and vase. Figure and ground are not opposed to each other but in dynamic relation. 'As one turns to face the other,' says Bhabha, 'it encounters a blind spot, the necessary void: "it discloses these beings in their full but concealed strangeness as what is radically other – with respect to the nothing"' (Bhabha 1998: 22). In Heideggerian terms, nothing is not nothing but rather needs to be understood as no-thing. No-

thing signifies the dynamic and creative force of possibility. This is earth.

Earth, then, is possibility or potential. The use of the term 'earth' makes logical, if not literal, sense. I dig the soil, enrich it with manure and mulch, water it and plant seeds or seedlings. If I plant beetroot, beetroot will grow. If I plant a fruit tree, it will bear pears or apples or mangoes. While it allows different worlds to emerge, earth remains in the background as ground. Earth is self-secluding, it does not show itself. However, it is not mute matter, but rather 'unfolds itself in an inexhaustible variety of simple modes and shapes' (OWA: 173). For each different crop or use, earth's potentiality is called on in different ways. It is earth as potential and possibility that enables different worlds to emerge. It is from this point of view that Heidegger sees the earth as holy.

Again we may go back to our experience in the drawing studio as a way of understanding how 'the unity of the work comes about in the instigation of strife' between earth and world (OWA: 175). The reference to grounding or ground that is earth recalls the figure/ground relationship we struggle with in drawing. While the page or canvas may appear empty, it is not. Rather it is already full of the preconceived notions of what a painting or drawing is, the history of painting or drawing, one's own history and habitual making. It is also full of potential or infinite possibility. The format provides the frame for this negotiation of strife between earth and world. As we make marks and define contours on the paper, a figure emerges out of the ground. In the West we tend to focus on the figure or world, yet without earth or ground, we could not see world. In other words, the ground allows the figure to emerge. In this *Gestalt*, the figure can only be a figure by virtue of the ground against which it emerges. Heidegger affirms this is so:

The world grounds itself on earth, and the earth juts through world. Yet the relation between world and earth does not wither away into the empty world or opposites unconcerned with another. The world,

in resting upon the earth, strives to surmount it. As self-opening it cannot endure anything closed. The earth, however, as sheltering and concealing, tends always to draw the world into itself and keep it there. (OWA: 174)

This conflict or strife between world and earth comes to the fore not just when we are faced with an artwork, but when we are in the middle of the work of art, making the work.

Francis Bacon's painting practice provides us with an example that demonstrates the ongoing strife that can never be settled. Bacon is famously known for throwing paint and making random and accidental marks in order to 'overcome the figurative and probabilistic givens already in the canvas' (Bacon quoted in Deleuze 2003: 49). In writing about Bacon's work, the philosopher Gilles Deleuze remarked that 'these almost blind manual marks attest to the intrusion of another world into the visual world of figuration. The painter's hand intervenes in order to shake its own dependence and break up the sovereign optical organisation: one can no longer see anything' (Deleuze 2003: 49). His comment that there is the intrusion of another world into the visual world of figuration speaks of the dynamic of world and earth, where 'earth juts through the world' and the 'world grounds itself on earth' (OWA: 180). The throwing of the paint sets in motion the strife that ruptures the calm surface of the world and enables earth as possibility to emerge out of the background inconspicuousness and into the foreground. For Heidegger this event of strife creates the clearing, an open space in which the truth of the work is revealed.

Heidegger's insistence on strife remaining strife in the work of art reminds us of the danger of everyday fallenness. Here habit preconceives the world, whether in our everyday life or in our habitual art practice. The problem for Bacon, as for all artists, is that in our everyday art practices, our ways of working and modes of practice produce a familiarity; become habitual. For Bacon, throwing the paint becomes a preconceived and habitual act. That

is what Bacon does. Thus in the 'average everydayness' of his acts, art practice becomes art business.

Heidegger's concern that strife should not be brought to an end by 'an insipid agreement' references his critique of aesthetic notions of taste, where it is assumed that there can be some agreement about good form. The notion of strife may be seen to exemplify avant-garde transgressive practices. The history of avant-garde practice, with its ongoing attempts to break existing rules and usher in the new, could be seen as a commitment to maintaining strife as strife. However, the conscious attempts on the part of the avant-garde artist to create an event that puts the viewer in crisis does not sit flush with Heidegger's notion of strife. Firstly we may recall from 'The origin of the work of art' that art is the origin of the artist and the artwork. Secondly the new can never be preconceived. Because of this the work of art happens in the strife between world and earth, not in an artist's preconceived notion of what will create strife. Similarly, political art may be seen to instigate strife through its attempts to critique political, social or ideological structures. Again Heidegger would caution us against such an easy answer. Political art tends to operate in the ontic realm of beings. Strife is ontological. It is through strife remaining strife that we may apprehend the Being of beings.

Art is historical

Art does not operate in a social vacuum. For Heidegger, art is in its essence an origin because it is 'a distinctive way in which truth comes into being, that is, becomes historical' (OWA: 202). Each different epoch is characterised by the distinctive way in which 'truth' comes into being. For the early Greeks, art was the distinctive way in which truth was revealed. In the modern age it was science, with its belief in truth as correspondence. However, Heidegger worries that in our contemporary era the 'truth' of art that has been revealed is art business. We get so caught up in negotiating the 'business' of making, exhibiting,

viewing, buying and selling artwork that we forget what art *is* in its essence.

The task of 'The origin of the work of art' is to take us back to that central question: what is the essence of art? In putting this question to the fore, Heidegger asks us to step back from the busy work of art business and reassess the stakes involved in Art. In this reorientation to questioning matters in their essence, it becomes clear why Heidegger worries that lived experience might be the element in which Art dies. If Art is to be an essential and necessary part of the Being of beings, then it is in the midst of beings that Art must happen. This I think is the central lesson of Heidegger's essay. In a time when art business dominates, I would argue that *now* is precisely the time to read Heidegger on art.

Chapter 3

Representation

When accordingly, the picture character of the world is made clear as the representedness of that which is, then in order fully to grasp the modern essence of representedness we must track out and expose the original naming power of the worn-out word and concept 'to represent' (*vorstellen*): to set out before oneself and to set forth in relation to oneself. Through this, whatever is come to stand as object and in that way alone receives the seal of Being. That the world becomes picture is one and the same event with the event of man's becoming *subiectum* in the midst of that which is. (AWP: 132)

Context

In the visual arts, art theorists and historians continue to ground their discussions of art on the unquestioned assumption that art *is* a representational practice and its products are representations. This statement seems so obviously true that we rarely pause to question its validity or even define its terms. When we speak, write, draw, take a photograph, construct a digital image or make a video, there seems little dispute that what we are involved in is making representations. As a consequence of the dominance of representation in art, the history of art *is* the history of representation.

The 're' of 'representation' suggests that to represent is to present again. In Western aesthetics the model of representation as a re-presentation or an analogue for something in the world can be traced back to Pliny's account of a competition between two artists, Parrhasius and Zeuxis:

The artist Parrhasius entered into a competition with Zeuxis. Zeuxis produced a picture of grapes so dexterously represented that birds began to fly down to eat from the painted vine. Whereupon Parrhasius designed so lifelike a picture of a curtain that Zeuxis, proud of the verdict of the birds, requested the curtain should now be drawn back and the picture displayed. When he realised his mistake … he yielded up … saying that whereas he had managed to deceive only birds, Parrhasius had deceived an artist. (Pliny quoted in Bryson 1983: 1)

In this account, one artist's ability to deceive another through a hyper-realistic rendering of the curtains was greeted with great awe. The mimetic skill, that is the ability to re-present reality realistically, was a key marker that distinguished 'great' artists and art in the West, from Parrhasius through to the twentieth century. At the turn of the century, a crisis in representation was precipitated by a complex of factors, one of which was the contribution that photography played in usurping the painter's role as the recorder of life. While mimesis was no longer the objective of art, representation maintained its grip.

Representation as a re-presentation of a 'reality out there' reached its high point in Renaissance art with the conjoining of mimesis with the system of perspective to create a visual system so powerfully 'real' that Western imaging – including contemporary digital imaging – continues to be held in its sway. Perspective appears to offer a window onto the world, while mimesis ensures that the view through this window corresponds with perceptual 'reality'.

If we begin to unpack the model of representation as a re-presentation of some pre-existing reality, the model quickly begins to fall apart. While perspective may be seen to re-present reality, we have come to understand that perspective is a system, a mathematical model that gives the appearance of a world out there. We have also come to understand that a 'seemingly' mimetic image is not a guarantee of some pre-existing reality. Gerhard

Richter's photo-painting *Administrative Building* (1984) tells us this, as do our own 'manipulations' of reality through digital imaging. The view that representation is a reflection of reality may have been overturned by the dissimulation of simulacra, and yet, signs and simulacra aside, the spectre of representation continues to loom large as the system that prescribes the way we know our world (regardless of art) (see Baudrillard 1994). How do we explain this?

Our commonsense understanding of representation has grown out of a modelling of the world. We tend to conceive of representation as re-presentation of reality in some imagistic form – film, literature or visual art. According to this mode of thought re-presentation can be understood as a copy of some pre-existing model, whether it be something that we see in the world or an imagining. In the world of models and copies that underpins representation, there is a model that the copy then imitates.

The preoccupation with models and copies can be traced back to Plato's postulation of an ideal world of forms. In this conception, ideal form pre-exists any actuality. The image, or what we have come to know as representation, can only ever be an imperfect copy of ideal form. The visual arts, even more than language or philosophy, are infected with models and copies. As a consequence, discussions and debates around visual representation in the West have tended to be coloured by notions of the 'natural attitude' and the 'essential copy'.[1] According to this, the representation or copy can only ever be a poor imitation of the 'real'. There will always be a gap between reality and representation. The gap is often figured as a lack.

Commonsense artistic judgements are often based on assessing the degree of exactitude between representation and 'reality'. As a result of this framing, the critique of representation has tended to be conflated with the critique of 'realism' or 'figuration'. In this conflation, representation equals realism and representation is opposed to abstraction. However, what is at stake

in representation is not, as commonly supposed, simply the realistic or figurative representation of a reality that 'exists out there'. For Heidegger, representation cannot be conceived so literally. It is not just concerned with realism or figuration, but rather representation posits a particular relation to, or way of thinking about, the world that preconceives the world. Representation, or more correctly representationalism, is not an outcome, but rather a mode of thinking. It is a relationship to the world that involves a will to fixity and mastery. Hence, according to such a conception we should not confuse representation with 'realism'. Further, in its capacity to preconceive its outcome, abstraction may be as representationalist as realism. Modernism is not immune from the critique of representation.

Representationalism

The question of 'representation' is central to any debate around the making and interpretation of 'images'. One of the greatest efforts in philosophy and art in modern times has been devoted to overcoming the limits of representation. Much has been said against representation by philosophers (such as Heidegger, Deleuze and Guattari, and Irigaray), and many attempts have been made by contemporary artists (particularly postmodern, post-colonial and feminist artists) to eliminate representation once and for all. It brings us back to the question what is this 'thing' we call representation, and why does it continue hold such a grip on our imagination?

Representation has a strong purchase on everyday life. We represent and are represented in many different ways: in parliaments, in the courts, in representations of all sorts – textual, verbal, aural, visual and so forth. As a painter, I am represented by a gallery at the same time as I *paint* representations. The extent to which 'representation' permeates our lives is summed up in the philosopher of science Bruno Latour's observation that

The most humble of us lives surrounded by a princely retinue of delegates and representatives. Every night, on television, our representatives in Parliament talk on our behalf. We have delegated to hundreds of non-human lieutenants the task of disciplining, making, and moving other humans or non-humans – lifts, cars, trains, machines. Hundreds of scientific disciplines and instruments constantly bring far away places, objects and time to us, which are thus represented – that is presented *again* – for our inspection. In dozens of books, movies, plays and paintings, human and non-human characters represent us with our violence and our fears, populating our world with crowds of friends and enemies. (Latour 1988: 15–16)

Used in many different contexts in many different ways, it seems extraordinary that one single word could create such a multifarious and colourful cast of characters. Political representatives sit side-by-side with technological and aesthetic representatives and representations. How can this be, and what is it that allows all these different events and things to operate under the one term, 'representation'? And so it seems that some law, some shared or common quality will come to regulate this multiplicity and justify the use of the term and allow this representation to represent. It is precisely this regulation or ordering – that allows one conception of representation to hold sway over all other conceptions – that is so opposed by Heidegger in his critique of representation.

Heidegger explains that what is at issue is not so much representation in itself, as 'representationalism'. As we have seen, he proposes that rather than re-presenting reality, representationalism is a way of thinking, or a mode of thought that prescribes all that is thought.[2] It orders the world and predetermines what can be thought. In order to distinguish between representation and representationalism, Heidegger returns to the etymological root of the word and concept 'to represent', which he translates as '*vorstellen*'. To represent

means to set something – an object, a person, the world – before oneself and in relation to oneself. When I set up a still life to draw, take a photograph, or make a film, for example, I am doing precisely this. I set up the scenario in order to make a drawing, take a photograph or film a scene. I take things out of their everyday context and frame them from my point of view. I no longer see things for what they are in themselves, that is their being, but rather frame them according to particular intentions I have for the work.

Heidegger argues that in their capacity to conceive everything in the world as an object, humans become the relational centre, the ground against which everything is understood. He observes 'That the world becomes picture is one and the same event with the event of man's becoming *subiectum* in the midst of that which is' (AWP: 132). For Heidegger, representation, or representationalism, is a relationship where whatever *is* is figured as an object for man-as-subject (*subiectum*). It is this objectification of what *is* by man-as-subject that constitutes the central focus of the critique of representation. In art, this relation reveals itself in many ways, but is perhaps best exemplified in the way we set up and view artworks in a gallery.

The relationship to what-is

Heidegger's critique of representation derives from the propensity of humans to objectify and master entities in the world. In order to help us understand how we might imagine the world differently, Heidegger draws out the early Greek understanding of 'what-is' and contrasts it with the modern understanding. He suggests that in the pre-Socratic Greek world, man is the one who is looked upon by what-is. In the modern epoch a reversal occurs. Man is the one who does the looking. He becomes the one who looks upon what-is. What-is becomes an object of man's scrutiny. For the early Greeks, what-is was presence. In this conception, thought and Being were not separated. In the Greek world, argues Heidegger,

Man is the one who is…gathered towards presencing, by that which opens itself…Therefore, in order to fulfil his essence, Greek man must gather (*legein*) and save (*sozein*), catch up and preserve, what opens itself in its openness, and he must remain exposed (*aletheuein*) to all its sundering confusion. (AWP: 131)

In this world, man was looked upon by what-is. Reality looms up before man and confronts him in the power of its presence. Thus, notes Dorothea Olkowski, 'Prometheus is tied to the rock, Pentheus dismembered by the Bacchae [and] Acteon changed into a stag and torn to bits by his own pack of hounds' (Olkowski 1988: 97).

The openness and exposure to that-which-lies-before (*hypokeimenon*) was for the Greeks the horizon of unconcealment. In this apprehension of the world each person was open to what was revealed to it through its being-in-the-world. What opens up in this horizon becomes present as what-is, so that the 'I' belongs in the company of what-is. In the company of what-is, man is neither privileged nor detached, but rather merely exists among other things. Thus in the very ancient Greek world, Being 'is presencing and truth is unconcealment' (AWP: 147). In this openness and exposure, the world is not a picture, that is not a representation. Representation did not negotiate what-is. Heidegger suggests that because the Greeks existed among things and did not position the world in relation to themselves, they could not be *subiectum*. They did not conceive of the world as an object, nor did they objectify the world.

Many of us would baulk at what seems to be a passive acceptance of being-in-the-world. We are so busy planning our lives, setting down the foundations for our future success, imagining or dreaming about what we might become, and distinguishing ourselves, that we could never envisage ourselves just existing among things. Further objectivity is a notion that is critical to survival in a Western technocratic society.

In the modern epoch, 'man', with the help of technological innovations, has become the determining centre of reality, and it

is from this secure centre that man sees the world in relation to himself. He sets what is 'present at hand (*das Vorhandene*) before oneself (AWP: 131), and sets it in place as an object for a subject. In this new relationship to reality, says Heidegger, 'man as representing subject…"fantasises"…he moves in *imaginatio*, in that his representing imagines, pictures forth whatever is, as the objective, into the world as picture' (AWP: 147). Man is no longer vulnerable or open to that which lies before and looms up to confront him, but instead he secures himself as centre and takes precedence over all other possible centres of relationship. He is no longer looked upon by what-is, but is the one who represents what-is.

According to Heidegger, the pre-Socratic Greek world was not predicated on a concept of representation, and the Greeks did not think representationally. However, he argues that late Greek thinking, particularly the thought of Plato, was foundational in preparing the way for the representational epoch. It prepared the conditions and provided the possibility for representation to be set in place. He claims that Plato's notion of forms or ideas laid the foundation that enabled a separation of what-is from presence. What-is came to be determined as '*eidos*', mere appearance or look. In this shift from presence to look, the foundations are laid for what-is to be conceived as an image (*Bild*). This recognition provided the doctrinal basis that, according to Heidegger, would one day permit the world to become *Bild*, become a picture.

Heidegger's critique of representation hinges on the fact that it establishes a 'frame' that produces the objectification and mastery of the world by man as *subiectum*. Heidegger argues that where what-is is reduced to a schema, there is a halt in being. In setting the Greek apprehension of the world as presencing, against the modern representation of the world as *subiectum*, Heidegger aims to bring to the surface what constitutes this loss of, or halt to, being. For the early Greeks, notes Derrida, 'the being of what-is never consists in an object (*Gegenstand*) brought before man, fixed, stopped, available for the human subject who would possess

a representation of it' (Derrida 1982: 306). In contrast, observes Heidegger, modern man brings what is present at hand (*das Vorhandene*) before himself 'as something standing over against' (AWP: 131). In this new relationship to what is, human beings come to see themselves at the centre and all other entities become objects for humans. Through the process of objectification, man becomes the centre over and above all other possible centres. Thus man relates what is to himself since he is the one representing it. In the world of representation and man as *subiectum*, representing is no longer self-unconcealing, as with the Greeks, but is rather a laying hold of and grasping. Heidegger claims that in the epoch of representation, assault rules. The regime of representation produces violence. He concludes,

That which is, is no longer that which presences; it is rather that which, in representing, is first set over against, that which stands fixedly over against, which has the character of an object... Representing is making-stand-over-against, an objectifying that goes forward and masters... In this way representing drives everything together into the unity of that which is thus given the character of object. (AWP: 150)

No longer is man among, and looked upon by, what-is; he now is the one who looks. In this relation, everything what-is is transformed and set in order, as standing-reserve (*Bestand*). Through man's ability to represent or model the world, he secures the world for his own use. But with this newly acquired power, Heidegger warns that a terrible loss is incurred. Because man no longer lays himself open to the world, he can no longer experience what-is as Being. We see this representationalist impulse in the 'art project'. The art project sets in place intentions and preconceives the outcome in such a way that we are no longer open to what could emerge in the process.

The age of the world picture
In his essay 'The age of the world picture' (1950) Heidegger designates the modern epoch *as* the era of representation.[3] In the

West, the modern epoch extends from the time of Descartes to contemporary times. In this era, he argues that the world is reduced to a picture, that is to representation. In this relation of setting before and in relation to oneself, the world becomes a picture for a human subject.[4]

When we think of the word 'picture' we tend to think first of all of a copy of something, perhaps a painting, drawing, photograph, written description, or more commonly a mental image. We tend to assume that a picture has the quality of being like something in the world. However, Heidegger makes it clear that when he talks of a 'world picture' he does not mean a picture, in the sense of a copy of the world. This conception is too literal, and falls back into the presumptions of 'natural attitude' and 'essential copy'. In the Heideggerian conception of representation, 'representation' is neither used in its everyday multiplicity of uses nor in the sense of presenting an image, but rather as a regime or system of organising the world, by which the world is reduced to a norm or a model. In this mediation, the world is conceived and grasped primordially as a picture (AWP: 128).

It was Descartes, according to Heidegger, who inaugurated the new paradigm of representation and reduced the world to a picture.[5] This picture is not a mimetic image, but rather a mathematical model or prototype from which a picture can be built.[6] A prototype, model or schema establishes what the world could be like. It implies the formulation of a concept before an actualisation; that 'the thing' is thought before it is brought into being. Urban planning and architectural design can provide us with an example of this 'compulsion to model'. Small cardboard, MDF and matchstick models are made and set up as models, which picture what the world could be like. Then, by grace of man, the world is created in that image.

Descartes's mathematisation of knowledge provided the conditions of possibility for reducing the world to a schema, a set of standards or norms. It is not a representation, in the sense

of a repetition of presence, but literally a *re*-presentation of the world. For Heidegger, it involves a projection of what-is (AWP: 144). The age of the world picture is not concerned with a visual picturing, with *mimesis*, but rather with a modelling or framing of the world. It is the reduction of the world to data.

The transformation of entities into data is one of the defining hallmarks of our contemporary lives. We willingly provide information about ourselves in application forms, in surveys, online and over the telephone. The information we give, whether it is in opinion polls, census collections, taxation returns, enrolment forms or social-security applications, is transformed into data. This data takes the form of tables of figures, which are then used by bureaucracies and governments to make decisions that impact upon our lives. Inscriptions stand in our place. They are abstractions, which are moved around, combined, compared, superimposed and used to represent us and to make decisions about our lives. And so people running, cycling or walking the dog become shapes on a bar graph or numbers in a table.

Accordingly, the fundamental event of the modern age has been the conquest of the world as picture. Man has been able to structure his reality through an ability to set before himself what-is. Through representationalism, Heidegger argues, 'Man brings into play his unlimited power for the calculating, planning, and moulding of all things. Science-as-research is an absolutely necessary form of this establishing of self in the world' (OWA: 135). Representation, with its formal normative character, predestines our understanding of the world and what it is to be a being.

Heidegger argues that it was through Descartes's re-conceptualisation of the relationship between man and the world that representation becomes the domain of 'man' as *subiectum*. In Descartes's conception of the world, the 'objective' structure of representation implies an ordering, and it is man-as-subject (*subiectum*) who orders the world and produces the picture. The world becomes a picture, and is able to be modelled because 'man'

looks upon it and represents it. In setting the world before, and in relation to himself, man places himself at the centre of all relations.

In representation, someone conceptualises, someone models the world. In this schema, what counts as being is already preconceived and hence controllable. For Heidegger, this means that being, as such, is precluded. We will recall from our first chapter that this is not how Heidegger sees our relation to the world. For Heidegger, Dasein's thrownness means that our understanding of the world is not normative, but emerges in being-in-the-world and dealing with other beings. Herein lies the basis of the Heideggerian critique of representation. In contrast with Descartes, he believes that the world is never objective and cannot be known in advance.

Perspective

How can we imagine the paradigm shift that enabled man to place himself at the centre of all relations, become *subiectum*, and place the world before him as his representation? While the mathematisation of knowledge enabled humans to conceive of the world as a picture, it also impacted on our imaging of the world. In *Vision and Painting: The logic of the gaze*, Norman Bryson suggests that linear perspective enabled a shift in pictorial conventions that confirmed man's altered relation to what-is. He demonstrates how the structure of 'linear perspective', a mathematical model of the world, enabled man to secure himself at the centre of the world.

Bryson contrasts pre-Renaissance fresco painting, mosaic art and glass painting with those early Renaissance works that had begun to employ perspective as an organising principle. In the pre-Renaissance world, he notes, the 'viewing subject is addressed liturgically, as a member of the faith, and communally as a generalised choric presence', not as an individuated viewing subject (Bryson 1983: 96). In accordance with the cyclical nature of liturgy, pre-Renaissance frescoes were presented as a continuous

frieze around the walls of the church. A banding that joined succeeding episodes into a narrative whole facilitated this continuity. Through this structuring, viewers were collectively caught up in and propelled around the cycle. In this context, says Bryson, '(t)he body does not see itself', but 'I' belongs in the company of what-is and is looked upon by God (Bryson 1983: 98).

Bryson identifies three changes which disrupted this continuity and paved the way for 'the body' to see itself, and hence for man to become *subiectum*. Firstly, he claims artists began to disrupt and fragment the narrative space that had formerly held the viewer as part of the liturgical chorus. He identifies Giotto's frescoes at Assisi and Padua as exemplifying this change. In these frescoes, Giotto framed each narrative incident separately, so that they no longer functioned as a continuous narrative. By breaking up the banding, each scene became individuated and the continuous narrative was fractured. The consequence was that each scene came to be viewed individually by 'a viewer' who was singled out from the liturgical chorus.

The individuation produced by framing individual scenes was reinforced by changes in the content of the images. Artists began to create images that exceeded the minimum schema for recognition by including complex symbolism, which needed to be decoded and interpreted by a visually literate viewer. Bryson suggests that 'the reading of symbols constructs the viewer firmly … as a receiver of *this*, single and highly particularised schema' (Bryson 1983: 101). The requirement that the viewer interpret pictorial codes brought looking closer to thinking. Here, viewing contrasts with the religio-aesthetic contemplation of the medieval epoch.

Finally, Bryson identifies the role of perspective in paving the way for a viewer to see themselves as an image. Perspective provided a particular ordering of space that enabled the manipulation of an individual viewer. Instead of promoting a continuous flow that propels the viewer around the space, perspective pulls the viewer

up and into the space of the picture. This punctal site of reception becomes formalised and recorded in Alberti's treatise *De Pictura* (see Alberti 1991). According to the logic of perspective, the viewer takes up a position that is identical with the position originally occupied by the painter, so that painter and viewer look through the same viewfinder on the world. For Bryson, the centric ray, the line running from viewpoint to vanishing point, constitutes the return of the gaze upon itself. In this schema, says Bryson,

The vanishing point marks the installation within the painting of a principle of radical alterity, since its gaze returns that of the viewer as its own object: something is looking at my looking: a gaze whose position I can never occupy, and whose vista I can only imagine by reversing my own. (Bryson 1983: 106)

Thus Bryson argues that objectivity and calculability emerge in the viewing process. According to this logic – one of the logics of representation – the viewer is turned into a representation. In this way, Bryson points out that 'Albertian space returns the body to itself in its own image, as a measurable, visible objectified unit' (Bryson 1983: 106). Albertian space pre-empts the Cartesian subject. The Albertian subject is, in some senses, already Cartesian. Rather than merely existing among others, the Albertian subject was in a position of being able to perceive themselves. This external visualisation complemented the Cartesian *cogito ergo sum*. It was not until the beginning of the twentieth century, particularly in Picasso's experiments with multiple viewpoints, that this unified view of self came under serious question.

An analysis of the changing pictorial conventions provides an insight into the possible trajectory that shifted man from being under the gaze of God and placed him at the centre of all relations. What is less clear is the process by which the medieval God was expelled from this centre of relations. In the logic of perspective, the 'artist' and the 'viewer' came to the position symbolically occupied previously by God. The centric ray requires that the

viewer take up the viewpoint opposite the vanishing point. In doing so the codes of perspective place humans in the centre of the picture, the position that only God had previously held. First there was God. Then man and God stood together at the viewpoint. In time God was pushed aside and displaced altogether. In this move, man secured himself as centre and took precedence over all other possible centres of relationship. This enabled him to attribute many of the qualities to himself that had earlier been applied only to God.

The representational regime – exemplified in the structure and logic of perspective – produces a split between presence and what-is. What-is becomes mediated by a representation. The what-is of representation is something that takes place in and for the mind of a subject. In picturing self as a representation, the Cartesian subject can never apprehend what-is as presence. What-is has been mathematised. It has been reduced to a schema.

Representationalism provides the *Weltanschauung* or world view that structures how we think about and represent all that we can know of the world. The world becomes a production of mind. This is ideology. Heidegger's 'Age of the world picture' is critical of the way that this mode of thinking prevents us from experiencing what-is as being.

However, let us for the moment try to recast this relationship between humans and what-is in another way. What if, for example, humans did not set forth the things that they encounter and place them in relation to self? What if humans did not 'deal' with these things as objects? How would human beings differentiate themselves from what-is? Representation may have its limits, but what would we know if it did not structure our being-in-the-world? If we were to eliminate representation once and for all, would we be plunged into the abyss of chaos?

Without the ordering structure of representation, there exists a 'real' danger that humans would come face-to-face with immediacy, simplicity and unsubstantiated thought. And

what would be its politics? Wouldn't this call 'to presence', this immediacy and simplicity, enable the worst repressive regimes, be they political, social or aesthetic? It would seem that representation is too pervasive to be merely suspended or bracketed out. However, while we cannot eliminate representationalism altogether, that does not stop us from questioning its assumptions. Heidegger suggests that if we accept our being-in-the-world and our place among things we will accommodate things rather than set them before us as objects. His explanation of early Greek thinking offers this possibility to us.

What would this relation of accommodation-to-things mean for our understanding of art? Art is not simply a projection of the mind, nor is it made. In the previous chapter we came to understand that the work of art is the unconcealment of that which has never before been revealed. In art we can never predict what will happen in advance. In subsequent chapters, I will demonstrate that it is through our concernful dealings with other entities in the world – that is our accommodation to our technology, materials, knowledges and bodies – that art leaves the domain of representationalism altogether. Considered from a Heideggerian perspective, art is not a representational practice, and the history of art is not the history of representation.

Chapter 4

Art and technology

What is modern technology? It...is a revealing...And yet the revealing that holds sway throughout modern technology does not unfold into a bringing-forth in the sense of *poiesis*. The revealing that holds sway throughout modern technology is a challenging (*Herausfordern*) which puts to nature the unreasonable demand that it supply energy that can be extracted and stored as such...

The revealing that rules throughout modern technology has the character of a setting-upon, in the sense of a challenging-forth. That challenging happens in that the energy concealed in nature is unlocked, what is unlocked is transformed, what is transformed is stored up, what is stored up is, in turn, distributed, and what is distributed is switched about ever anew. Unlocking, transforming, storing, distributing, and switching about are ways of revealing. But the revealing never simply comes to an end. Neither does it run off into the indeterminate. The revealing reveals to itself its own manifoldly interlocking paths, through regulating their course. This regulating itself is, for its part, everywhere secured. Regulating and securing even become the chief characteristics of the challenging revealing.

What kind of unconcealment is it, then, that is peculiar to that which comes to stand forth through this setting-upon that challenges? Everywhere everything is ordered to stand by, to be immediately at hand, indeed to stand there just so that it may be on call for a further ordering. Whatever is ordered about in this way has its own standing. We call it the standing-reserve (*Bestand*). The world expresses here something more, and something more essential, than mere 'stock'. The name 'standing-reserve' assumes the rank of an inclusive rubric. It designates nothing less than the way in which

everything presences that is wrought by the challenging revealing. Whatever stands by us in the sense of standing-reserve no longer stands over against us as object. (QCT: 14–17)

Context

In the mid-1980s the German artist Anselm Kiefer set up his studio in an old factory and proceeded to run his workshop according to factory-like modes of production. He engaged specialised labour and developed technologically intensive production techniques to enable him to produce large-scale works. In his monograph on the relationship between Anselm Kiefer's art and the philosophy of Martin Heidegger,[1] Matthew Biro observes that as Kiefer's art practice evolved, it transformed from a more traditional practice that involved handwork to an industrialised and mechanised production. Biro comments,

In addition to the rapid expansion of his workspaces, other external indications of Kiefer's shift to a more factorylike mode of production in the 1980s included his vast output of works, the more than 400 percent increase in his work force (from four to seventeen assistants) between 1987 and 1990, as well as his tendency to produce increasingly outsized – even colossal – forms of art. (Biro 1998: 194)

While his studio and work practices have the appearance of industrial production, Kiefer sees himself as an artist making art, not an entrepreneur engaging in the politics and practice of industrial production.

Anselm Kiefer is not alone among artists in adopting large-scale industrial methods. Increasingly, contemporary artists operate large-scale operations and employ a specialised workforce to work with them. Alternatively, many artists outsource the production of their artwork (for example Jeff Koons, Damien Hirst, Olafur Eliasson, Mariko Mori, Matthew Barney), rather than physically making it themselves. This mode of production establishes artists as 'creative directors' and 'project managers' overseeing a process of production. In the context of a modern

technocratic society, the 'image' of an artist working alone in a studio to hand craft artworks now seems an archaic and outmoded way of doing things. Art, for some, has become technological production. The blurring of the boundaries between art production and other forms of production, and the subsequent loss of skill that has resulted from technological production, has changed the fundamental relationship between the artist, art and technology.

In his critical essay on technology, 'The question concerning technology' (1954), Heidegger examines how technology has come to shape our lives and our attitudes to things in the world. He begins his analysis of technology by recalling our commonsense or everyday understandings of technology. In our everyday life we go about the world making and using tools and machines as equipment in-order-to do something. The bed that we get out of in the morning is a piece of equipment that aids sleep, while the toothbrush and toothpaste exist in order to clean our teeth. The kettle provides boiling water for us to be able to make the morning cup of tea or coffee. We wear clothes in order to cover our nakedness, keep us warm, as a fashion statement or to stop us getting sunburnt. The bed, the toothbrush, the kettle and the clothes are equipment that we use in our daily lives as a means to an end. The problem, says Heidegger, is that we are so busy going about our business using things as a means to an end that we do not to stop and think about the things that constitute our lives or how we deal with them. We forget what they *are* in themselves, their Being, and instead merely see them as resources for our use. In fact, in a technocratic society everything, even other human beings, become resources. We live under the rule of instrumentalism, where things don't exist for themselves, but exist in-order-to do something.

Heidegger's assessment of technology offers special insights for artists. As artists, we use specialised technology in order to make our specific forms of artwork. A performance artist will use their body, conceptual artists may use ideas and all sorts of bits

and pieces, while a sculptor may use hammers or welders or sewing machines. Anselm Kiefer, for example, uses an inventory of technical and industrial equipment and materials such as casting equipment, metalwork machinery, hoists, fork-lift trucks, cutters, sand, straw, clay, silver, lead, gold and a skilled labourforce in order to make his artwork. As with our everyday relationship with technology, everything, including his skilled labour force, is a resource in-order-to make an artwork.

The human relation to technology

Heidegger observes that in a technocratic society we use the world and all that is in it as a resource and as a 'means to an end' in order to master it. At a time when there is a recognition that the resources of the world are finite and there is a recognition of the need for a sustainable approach to development, Heidegger's quest to reassess our relation to technology and to develop a different relationship to it becomes an urgent imperative. What if technology were not merely a means to an end established by human beings? How would this sit with the will to mastery displayed by humans? What if technology were not about the use of tools, machines and computers by humans as a means to an end? How might we conceive of this? Heidegger's questioning unsettles the presumption of the instrumental definition of technology.

Written between 1949 and 1954, against the background of the social and political reality of post-war Germany, 'The question concerning technology' can be seen as a response to the devastation of the use of technology as a means to an end.[2] His concern is to rethink this relation and promote an open relation between humans and technology. This quest should not be confused with affirming or promoting technology. In questioning technology, Heidegger aims to enable human existence to be open to the essence of technology, so that we are able to 'experience the technological within its own bounds…[and are not] delivered over to it in the worst possible way' (QCT: 4).

Heidegger is concerned that everyday beings tend to get caught up in the technological, that is what technology can do for us (in the ontic realm of things), without giving due attention to the essence of technology. The problem for a modern technophilic society is how to access the essence of technology when we are so caught up in what it can do for us. In Heidegger's estimation, so long as we represent the world as a resource, and technology as an instrument in-order-to achieve our ends, 'we will remain transfixed in the will to master it' (QCT: 32). He requires us to reassess our relation to technology so that we can perhaps develop a different relationship with it. In this reassessment we need to understand the essence of technology.

For Heidegger, technology in its material manifestation as tools, equipment and instruments is not equivalent to the essence of technology. The essence of technology, says Heidegger, lies in the revealing:

Technology is therefore no mere means. Technology is a way of revealing. If we give heed to this, then another whole realm for the essence of technology will open itself up to us...Technology comes to presence (*West*) in the realm where revealing and unconcealment takes place, where *aletheia*, truth happens. (QCT: 12–13)

The concepts of revealing, unconcealment and *aletheia* are already familiar to us from our reading of 'The origin of the work of art'. We recall that the essence of art was not concerned with making, manipulating or manufacturing artworks, but rather is a mode of revealing, of creating an open region in which truth (*aletheia*) emerges. In 'The question concerning technology', Heidegger affirms that this is also true for the essence of technology. Just as the essence of art is not concerned with making artworks, so neither is technology concerned with making and manipulating things. If both art and technology are a revealing or unconcealment, what is it about 'aesthetic revealing' (or what Heidegger calls *poiesis*), that distinguishes it from a 'technological revealing'?

What are the consequences of this distinction for our understanding of contemporary modes of practice that engage in technological production and outsourcing?

Heidegger's questioning of technology takes a form different to the questioning that proceeds in contemporary art, the questioning that asks is this art? Rather, Heidegger's questioning requires us to consider our own relation to the materials, tools and technologies which we use in-order-to make an artwork. He suggests that where technology is used as a means to an end to make an artwork, and where technology offers human beings the power to transform everything into a resource for human use, we suffer a particular form of 'blindness'. We can no longer see entities in the world and the world itself in any other way. In Heideggerian terms, our horizon of unconcealment is limited to what technology can do for us.

For Heidegger, technological revealing enables the hegemony of representationalism to maintain its grip on the way we understand the world. Under the regime of representationalism, as we saw in Chapter 3, objects are reduced to 'standing-reserve' (*Bestand*), and as such are available to some ends, as desired by the needs of a modern technocratic society. The notion of 'standing-reserve' needs to be understood as a schema where objects are ordered and reduced to their readiness for use by human beings. Things in the world exist 'out there', ready to be collected, quantified and calculated so that humans may use them in their quest to master the world. Objects and equipment become absorbed into the totality of standing-reserve and lose their quality as objects. We see this in the stockpiles of raw materials in dockyards and factories. We also see this in the term 'labour reserve', where human labour is reduced to its capacity to fill 'labour demand'. The consequence of the transformation of the world into standing-reserve is that the earth is viewed as a resource, which humans dominate through technology. In this way, notes Biro, 'the richness and variety of a thing is replaced by a

reduced set of properties: the thing's use value as well as its position in a global network of transformation and exchange' (Biro 1998: 201).

Enframement

The ordering that reduces entities – both human and non-human – to standing-reserve belongs to the dominion or sovereignty of *Gestell* (enframing). We will recall from the Introduction that enframing sets a frame around what and how we can see and think about something and represent it. Enframing, like Heidegger's much favoured *poietic* revealing, to be discussed later in this chapter, is one form of a being's mode of coming to presence. However, unlike *poietic* revealing, enframing does not allow the Being of a thing to be brought forth into appearance. Rather, it is a 'challenging setting-upon (*Stellen*), which sets everything in place as supply' for use by human beings (QCT: 21). In Heidegger's thinking, an enframing revealing constitutes the essence of modern technology.

Enframement, like the picture frame, defines what is to be seen as part of the picture. Anything outside the frame has no legitimate meaning. Thus enframing sets the parameters of how we see and understand the world we live in. We are unable to see the world in any other way. As the only way of revealing, an enframing revealing endangers humans' relationship to themselves and to everything else. Everything and everyone becomes a resource to be used as a means to control and increase profits.

The technological mode of revealing, as enframing, views the world as standing-reserve and places man in the position of ordering it. In this challenging revealing, nature is transformed into energy that can be stored and used as a means to an end. In this mode,

A tract of land is challenged into the putting out of coal and ore. The earth now reveals itself as a coal-mining district, the soil as mineral deposit ... Agriculture is now the mechanised food industry. Air is now

set upon to yield nitrogen, the earth to yield ore, ore to yield uranium, for example; uranium is set upon to yield atomic energy, which can be released either for destruction or for peaceful use. (QCT: 14–15)

Heidegger cautions that enframing is a dangerous way of thinking. To enframe or frame the world as a resource sets up a way of thinking that colours everything according to that mode of thought. He calls the operation that sets in place a particular mode of thought 'destining'. Destining (*Geschick*) means to send or start something on its way. For Heidegger, it is a 'sending-that-gathers [*versammelde Schicken*] which first starts man upon a way of revealing' (QCT: 24). Once set in place and set on its way, a particular mode of destining gathers momentum and multiplies. The danger of enframing as a mode of destining is that it multiplies and takes hold of human consciousness.

Heidegger's criticism of enframing as the distinctive mode of revealing mirrors his critique of 'art business'. Just as enframing is characterised by a challenging setting-forth and ordering of the world as standing-reserve, so the business of 'art' is similarly concerned. In fact, art business as a mode of revealing is an enframing. Heidegger makes it clear that, as a mode of revealing, art business takes us away from the essence of art. We recognise this as we get on the treadmill of buying materials, making the work, promoting it, entering competitions, exhibiting and selling.

Enframing as a mode of ordering and revealing is the supreme danger, since it reduces everything, even human beings, to standing-reserve even as it elevates human beings to a position of control. Heidegger notes that

As soon as what is unconcealed no longer concerns man even as object, but does so, rather, exclusively as standing-reserve, and man in the midst of objectlessness is nothing but the orderer of the standing-reserve, then he comes to the very brink of a precipitous fall; that is, he comes to the point where he himself will have to be taken as standing-reserve. Meanwhile man, precisely as the one so threatened, exalts himself to the posture of lord of the earth. (QCT: 27)

Heidegger talks about this precipitous fall in which man is reduced to standing-reserve by referring to that mode of being that reduces beings to mere resources. Whether as resources or as orderers of standing-reserve, the potential for human beings to understand their Being becomes lost. In the managerialism of technocratic society, it seems that either way we get caught. As standing-reserve we no longer have control over our destiny, but become mere resources in the production machine. As orderers of standing-reserve we take other humans as resources.

Human beings so easily succumb to the danger of becoming orderers of standing-reserve since it enhances their power over nature and confirms their position as 'lord of the earth'. It gives humans the capacity to unlock the powers inherent in nature and use them as a means to an end. Thus technological revealing allows humans to extend their vision further into nature and extend their mastery over everything, including other human beings. Thus we talk, for example, of human resources and human-resource management.

In contemporary culture, this habit of reducing man to a mere resource reaches its height in the activity of corporate 'head-hunting' and the commodification of popstars, filmstars and sports stars as 'celebrities'. These celebrities become resources, used as a means to promote and sell products and images. Artists are not exempt from this reduction to standing-reserve. As Josephine Starrs and Leon Cmielewski have observed,

Artists are like popstars, the more famous and controversial the more likely they are to sell their work. And now there are billboards at Heathrow airport of Tracey Emin selling Bombay Sapphire Gin. First artists become products to be promoted and, then when famous enough they can be used to sell other products. (Starrs and Cmielewski 2000: 8)

Artists as celebrities are reduced to standing-reserve. In his analysis of Vanessa Beecroft's promotion of Gucci products,

theorist Gary Willis draws out the unholy alliance between capitalism, art business and an enframing mode of knowing:

Consider the model of Vanessa Beecroft. In 1998 following her success at the Venice Biennale the previous year, Beecroft staged 35 performative events in 24 cities around the globe sponsored by Gucci. Beecroft's touring exhibition culminated in her show at the Guggenheim Museum in New York where twenty fashion models stood for the two and a half hours of the opening wearing 'Tom Ford', Gucci rhinestone bikinis and high heels...At the opening invited guests could purchase the Gucci bikinis, the Gucci shoes or the Beecroft photographs. While the artworld saw the show as a 'sell-out' by the artist and the museum alike, the media loved it, Leonardo Di Caprio thought it was 'cool' and Gucci's conceptual marketing manager, Tom Ford, was hailed as the new Damien Hirst. The show was the talk of New York that season. (Willis 2007: 53)

Being a celebrity artist brings many rewards, not least of which is celebrity status accompanied by great wealth. This enables artists to take the world as standing-reserve in-order-to make more art and more money and hence assume the position of 'lord of the earth'. In his review of Mariko Mori's *Tom Na H-iu* (2008), Mark Pennings makes the following assessment of artists such as Pipilotti Rist, Olafur Eliassson, Matthew Barney and Mariko Mori (Pennings 2008: 66). He comments that these artists are part of a new elite who act as creative directors and project managers. These artists outsource their ideas to teams and companies who make artworks, which are then delivered to global art institutions constantly in search of novelty. The success of this arrangement, notes Pennings,

has generated substantial financial benefits for these practitioners and has enabled them to marshal considerable economic and creative resources. This has in turn generated new confidence and fuelled ever more grandiose and ambitious projects. (Pennings 2008: 66).

Damien Hirst, another artist who assumes the role of creative director, was able to finance the making of the artwork *For the Love of God*, a diamond-encrusted skull that then sold for fifty million pounds. His comment that 'an artwork is only worth what the next guy is going to pay for it' seems to confirm Heidegger's prognosis that where art business rules, the 'truth' of art is forgotten.[3]

Where an enframing revealing dominates our way of thinking about the world, Heidegger claims it drives out every other possibility of revealing. Revealing becomes characterised by a regulating and securing of standing-reserve (QCT: 27). And in this mode of revealing, man is in danger of apprehending nothing apart from what is revealed in ordering. This ordering becomes the standard on which everything is based. Heidegger's explanation of standing-reserve provides a gloomy prognosis of the fate that awaits humanity.

In its seductive power, as a destining, enframing threatens to foreclose every other mode of revealing. While we accumulate more and more things, we become totally distracted from the task of understanding Being – our being and the being of entities with which we have dealings. However, while enframing provides modern man with a seductive way of being, Heidegger contends that it is not a fate that we have to follow. He notes that while we are currently living under the influence of an enframing revealing, we don't have to continue to push blindly ahead with technology, hoping that it will eventually come up with the solutions to the world's problems, or on the other hand reject technology 'as the work of the devil' (QCT: 26). He suggests that if humans can actually recognise the danger of the totalising power of enframing, they will become open to the potential of other modes of revealing. In this recognition, Heidegger argues, we may save ourselves from the worst destiny.

The challenge is for humans to be open to a different possibility of revealing, one that no longer positions every being,

including human beings, as standing-reserve. Heidegger is of the opinion that if we are open to the essence of technology, and if we recognise that technological revealing is also a concealing, then we are in a good position to be 'unexpectedly taken into a freeing claim' (QCT: 26). For Heidegger the saving power comes in the mode of aesthetic revealing. He believes that aesthetic revealing as *poiesis* can preserve humans from the danger of the particular technological revealing that is enframing.

Poiesis

Poiesis, like enframing, is a mode of being's coming to presence. However, Heidegger clearly differentiates between the two modes. While enframing concerns an ordering and mastery over what-is, *poiesis* involves openness before what-is. As we saw in the third chapter, the openness before what-is relates to the ancient Greek understanding of presencing. It is a bringing-forth or unconcealment of being. Heidegger observes that for Plato, 'every occasion for whatever passes over and goes forward into presencing from that which is not presencing is *poiesis*, is bringing-forth' (QCT: 10).

Heidegger tells us that the revealing that occurs in nature, or '*physis*' is *poiesis* in its highest sense (QCT: 10). The bursting forth of a blossom into bloom, the birth of a baby or the ripening of fruit are examples of *physis*. Heidegger contrasts this bringing-forth of something out of itself, with the bringing-forth of art, noting that 'what is bought forth by the artisan or the artist...has the bursting open belonging to bringing-forth not in itself, but in another (*en alloi*), in the craftsman or the artist' (QCT: 10–11).

To that bringing-forth that belongs to the bringing-forth of the artist or artisan, Heidegger designates the term '*techne*', the root of our modern word technology. *Techne*, as a particular form of bringing-forth, appears to oscillate between *poiesis* and enframing. Where *techne* belongs to bringing-forth as revealing, Heidegger notes, it is *poietic* (QCT: 13). However, when understood as the term

for the activities and skills of the craftsman, *techne* comes to be seen in an instrumental way. It is a means to an end. If thought of instrumentally, *techne* assumes the character of a controlling revealing. It is this tendency towards control and mastery that establishes the ambivalence of *techne*. Further, in Heidegger's estimation, it is this tendency that ushers in the modern technological age. He considers that the

revealing that holds sway throughout modern technology does not unfold into a bringing-forth in the sense of *poiesis*. The revealing that rules in modern technology is a challenging (*Herausfordern*), which puts to nature the unreasonable demand that it supply energy that can be extracted and stored as such. (QCT: 14)

The distinction between *techne* as *poiesis* and *techne* as enframing becomes clear in Heidegger's discussion of two different usages of the term 'The Rhine'. In the first example, that of modern technology, 'The Rhine' is a river dammed up to supply power. In the second example, 'The Rhine' is the title of one of the poet Hölderlin's hymns.[4] Heidegger argues that where 'The Rhine' is the river dammed for man's use as hydroelectric power supply, it is a challenging-forth. This challenging-forth takes place in the following way. In the damming of the river, the energy concealed in nature is unlocked or made available for use. The potential that is unlocked is transformed into electricity. This electricity is distributed through power grids to homes and industries. This electricity is itself unlocked and made available for use in the production of goods and so on. These unending processes of unlocking, transforming, storing, distributing and switching about ever anew are ways of revealing (QCT: 16). The character of this revealing is one of regulation. In it 'The Rhine' is seen in its capacity to be regulated and secured for human use.

In contrast, he argues that the revealing in Hölderlin's hymn 'The Rhine' is not a revealing limited by such regulation. On the contrary, the work of art brings 'The Rhine' into appearance.

Techne, as *poiesis*, sets 'The Rhine' free to be what it is. It opens up this possibility or that. It is not determined. Thus it could be argued that the work of art *is* the setting of 'The Rhine' on its way to arrival. The contrast between *techne* as enframing and *techne* as *poiesis* is starkly laid out in this example. While Hölderlin's hymn enables an open relation and starts something on its way, the challenging-forth of enframing offers a determined relation of ordering and regulating.

Heidegger worries that in the technological age, where art, like everything else, becomes a technical production, the truth of art as a *poietic* revealing has been replaced by a technological revealing. Here we can return to the ambiguity in the work of Anselm Kiefer. The blurring of the boundaries between art production and other forms of production seen in Kiefer's practice has raised many questions about the nature of art in contemporary society. This has become especially so where an 'artwork' might look like any product of mass production.[5] If Kiefer is concerned with the transformative potential of the material upon which he works, how does this differ from the instrumental definition of technology? What makes his labours so different from technological production (QCT: 16)? How is the revealing in Kiefer's work any different from enframing revealing?

On initial impressions, Kiefer's artistic practice seems to operate as an enframing revealing. The scale of the operation, the employment of quasi-mass-production methods and the employment of skilled labour parallel the operations of industrial production. Kiefer's practices are technological not just because he relies on specialist labour (skilled artisans who can model, mould, cast, sew etc.) but also because he has amassed the resources to enable him to acquire the means of production to proliferate his practice. In his ability to gather together and manipulate enormous quantities of materials to create more art and make bigger profits on the international art market, Kiefer could be seen to be engaged in the 'unlocking, transforming,

storing, distributing and switching around' (QCT: 16) that is characteristic of technological revealing.

However, despite his embrace of technology and technological methods of production, Biro argues that Kiefer's work does not take the world simply as a resource, as something to be used. Rather, he suggests that it reveals the tension between a technological revealing and a *poietic* revealing:

On the one hand, nature is shown to be manipulable – matter to be molded, shaped, and given meaning by being suffused with human intention. On the other hand Kiefer's works also show natural materials to possess a wholeness and integrity of their own – a dense 'significance' apart from human goals and projects that they can be made to serve. By means of technology, Kiefer puts a magnifying glass up to the interface between humans and nature. Sometimes, he reminds his spectators of individual responsibility, when, for example, he gouges and tears his built-up 'natural' surfaces in such a way as to show us his destructive power. Sometimes, he reminds his spectators of the power of nature, as, for example, in his works in which natural materials are used to obscure photographic representations, or, in other works, where he suggests that natural forces possess powers similar to nuclear fission and fusion. By giving him a place where he can store and age numerous natural materials – sand, straw, hair, clay, olive branches, silver, and gold – as well as the tools to cause them to undergo a multitude of changes, Kiefer's factory environment paradoxically allows him to indicate a space for nature outside the field of human endeavour. And in this way, Kiefer echoes Heidegger's concern for nature in the 'technological age' – Heidegger's sense of its fundamental relationship to art and its need to avoid constant technological disclosure. (Biro 1998: 251–2)

For Kiefer, then, the factory is the site of artistic practice as opposed to industrial capitalism. The materials and tools of production are not conceived as standing-reserve. Kiefer does not see himself as engaged in industrial production, but rather as an alchemist who, like Joseph Beuys, is engaged in a process of transformation. In Kiefer's concern to allow natural materials to

show a 'wholeness and integrity of their own … outside of the field of human endeavour, Kiefer figured himself as "a quasi-religious, quasi-scientific" figure who labours to release the transformative potential in the materials upon which he works' (Biro 1998: 209). Here his work becomes *poietic*.

The ambiguities of Kiefer's artistic practice remind us that art is historical and that we exist within the system of thinking rather than outside it. While Kiefer may see himself as an alchemist involved in a transformation, and believe that he is not engaged in industrial production, his mode of operation suggests complicity with technological revealing rather than a critique of it. His production machine grows larger, as does the price of his work.

Heidegger is of the opinion that modernity is characterised by a technological revealing. In the collapse of technological apparatus with standing-reserve, the relationship of humans to their tools becomes one of mastery. It is a bleak picture of the contemporary world, but not one that Heidegger believes should keep its hold on us. What if the relationship between human beings and their technological apparatus were a responsive one rather than a mastering one? For Heidegger, this different being-in-the-world would signal the end of modernity. No longer would tools be conceived of as ready-at-hand for use by man in-order-to. Where technology is conceived in terms of *techne* as *poiesis*, Heidegger is confident that another mode of revealing presents itself to us.

The development of Heidegger's work on modes of revealing raises a fundamental question for us in our everyday lives and in our thinking about what it means to make art. Where our being-in-the-world is characterised by an enframing revealing can other modes of revealing – for example a *poietic* revealing – enable an escape from the frame of enframing? Heidegger lays a wager that it is possible. However, it would seem that technological revealing has come to suit modern humans. Dasein, fallen, is so caught up in the everyday activities of 'unlocking, transforming, storing, distributing and switching about' that it has forgotten that there

are any other possibilities for Being than this enframing mode of being. Where the ordering of the world enables human beings to accumulate more and more things, where the currency of value is money, what value does a *poietic* revealing offer us? What can convince humans of the enriched revealing of *poiesis*? What would induce humans to value technology as *poietic*, rather than pursue technology as a means to an end for human benefit?

Through art business, artists too have become caught in an enframing mode of revealing. In presenting Heidegger's question concerning technology, and drawing out its implications for rethinking the question of art, the task of this chapter has been to demonstrate that a particular mode of art in the modern age has become imbricated in the ordering challenging-forth of enframing. This mode of revealing has the propensity to drive out every other possibility of revealing, including a *poietic* one. However, this fate is not inevitable. In the next chapters I will demonstrate how Heidegger's elaboration of handlability or equipmentality and his reworking of Aristotle's doctrine of the four causes prepare the way to think again what constitutes the work of art.

Chapter 5

Praxical knowledge

'Practical' behaviour is not 'atheoretical' in the sense of 'sightlessness'. The way it differs from theoretical behaviour does not lie simply in the fact that in theoretical behaviour one observes, while in practical behaviour one acts (*gehandelt wird*), and that action must employ theoretical cognition if it is not to remain blind; for the fact that observation is a kind of concern is just as primordial as the fact that action has *its own* kind of sight. Theoretical looking is just looking, without circumspection. But the fact that this looking is non-circumspective does not mean that it follows no rules: it constructs a canon for itself in the form of *method*.

The ready-to-hand is not grasped theoretically at all nor is it itself the sort of thing that circumspection takes as a circumspective theme. (BT 1962: 98–9)

Context

In the documentary *William Kentridge: Drawing the passing*, the South African artist William Kentridge reflects on the making of his animation films, particularly the short films featuring property magnate and mine owner Soho Eckstein:

When the process is working at its best…it is in the activity, that physical activity of drawing that sequence…that new ideas throw themselves forward and become integrated into the film… occasionally there is a breakthrough that happens in the process, the actual physical process of drawing, repeating and repeating… is what releases a new way of thinking. For example in the film *Mine*, Soho is sitting in bed with his coffee plunger…I knew I had to find some way of connecting him with the part of the world

underground... It was halfway through the activity of drawing the coffee plunger, rubbing it out, filming it, redrawing it that I suddenly understood that the coffee plunger could go through the coffee pot and down further into the mine. It was certainly not something that I knew in advance. I didn't know it when I started the day's work. I didn't know it when I took the coffee plunger to start drawing it... There was some unconscious part of me saying 'take the coffee plunger. There is going to be something that you can learn from it.'[1]

In his reflection on his working process, Kentridge makes the observation that it is in the process of drawing that new ways of thinking are released. Kentridge did not solve his problem theoretically by thinking about it. He solved it in the drawing. He observes that it was 'halfway through the activity of drawing the coffee plunger, rubbing it out, filming it, redrawing it that I suddenly understood that the coffee plunger could go through the coffee pot and down further into the mine'. Practical behaviour produces its own kind of sight.

Kentridge's drawing practice becomes a metaphor for and/or an intensification of our thrownness in being-in-the-world. In Kentridge's art, the 'new' does not just appear out of thin air, nor does it emerge as a preconceived thought. The new emerges in and through the process of drawing, just as our thrownness projects us into the future.

Handling

For Heidegger, as we saw in Chapter 1, the drama of human existence is orientated around the possibilities that being-in-the-world throws up. In his phenomenology, the world is not the objective world of things and places, but rather the world is that into which Dasein is thrown. We recall that Heidegger uses the term 'Dasein' for the fundamental fact of being-right-there that characterises being thrown into the middle of things. Being-in-the-middle-of-things, he claims, we don't come to understand the world by contemplating it theoretically, nor do we know it

objectively. Rather it is in being-in-the-middle-of-things, putting things to use and handling things that we come to understand our world. Thus the world is discovered through Dasein's involvement with or handling of it. This constitutes what Heidegger terms the 'worlding of the world'. Our 'involvement' or relationship with the world underpins the primarily praxical nature of being in the world. It is through dealing with or handling entities in the world that the nature of the world is revealed to beings.

Our everyday being-in-the-world is concerned with handling or dealing with things in the world, whether it is with tools, emotions, ideas or other beings. What then makes art a special case of handling? We understand, for example, that children learn to ride a bicycle by riding it, not by being told how to ride it. The manual on road rules that we are required to read before sitting our driving tests do not help us to drive a car any better, and it is not until we negotiate those road rules in practice that they begin to make practical sense. We may also understand the folly of trying to follow instructional manuals when trying to put together a flat-pack, or learning a new software package. It proves no substitute for the trial-and-error of 'doing it'. Similarly, as we saw with Sophie Calle, no one, not even our parents or our best friend can ever tell us how to 'break up' from a relationship. We only break up by doing it.

How is art – the handling of materials and ideas to produce artworks or performances – any different from our everyday dealings in the world? Heidegger suggests that in our everyday handling of things we tend to act out of habit, and forget to notice what things *are* in themselves. In our habitual activities, everything falls into inconspicuousness and our use of things becomes a means to an end. Objects and entities come to exist in-order-to. Thus we will use a car, public transport or a plane to get from point A to point B, never stopping to marvel at just what it is to be able to travel over great distances and speeds in such a short time. We may use a software package to make an

image or video, giving no thought to the 'magic' of it. When we use our mobile phone, we forget (if we ever even knew) the wonder of the first telephone transmission. We tend just to use things. The tool or piece of equipment gets lost or becomes inconspicuous in its use. For Heidegger, the privileged place of art arises from its capacity to create a clearing, a space where we once again notice what entities are in themselves. He suggests that we are forced to reconsider the relations that occur in the process or tissue of making life. Our handling of and dealings with entities in practice offers a special form of (in)sight. We recall from the previous chapter that this is a *poietic* rather than an enframing revealing.

This chapter sets out Heidegger's 'tool analysis', presented in the section 'The worldhood of the world' in *Being and Time*, in order to demonstrate how practical behaviour shapes our understanding the world. Here we will recall from Chapter 1 that our understanding arises from concrete experience of being-in-the-world, rather than our contemplative knowledge of it. Heidegger's explanation of handlability or equipmentality contrasts with mathematical knowledge that sets out to discover abstract principles that it then applies to the real world. His belief that it is through use or handling, rather than abstract theorising, that we come to understand the world provides the key to rethinking the relation that we have come to know as 'artistic practice'.

In practice, the mode of understanding with the 'eyes and hands' operates in a different register from the representational paradigm of man-as-subject in relation to objects that has shaped our understanding of knowledge since Descartes. Handling is a relation of care and concernful dealings, not a relation where the world is set before us (knowing human subjects) as an object of knowledge. Kentridge reveals the dynamics of this thinking in an interview with Carolyn Christov-Barkargiev. In replying to Christov-Barkargiev's observation that 'You've often said that everything you do is drawing and that you see drawing as a model for knowledge', Kentridge comments,

What does it mean to say that something is a drawing… Drawing for me is about fluidity. There may be a vague sense of what you're going to draw but things occur during the process that may modify, consolidate or shed doubts on what you know. So drawing is a testing of ideas; a slow motion version of thought…The uncertain and imprecise way of constructing a drawing is sometimes a model of how to construct meaning. What ends in clarity does not begin that way. (Kentridge 1999: 8)

In this relationship of handling, the work of art is the particular understanding that is realised through our concernful dealings with the tools and materials of production. Working with his hands and eyes in relation to the charcoal and paper produced a kind of veracity, a 'thinking aloud' that enabled him to solve the visual problem of how to connect Soho sitting in his bed making his morning coffee with the underground world of the mine. This type of thinking through practice has come to be known in the creative arts as 'material thinking'.[2]

The tool analysis

The foundations for material thinking may be found in Heidegger's 'tool analysis'. Here Heidegger examines the particular form of knowledge that arises from our handling of materials and processes. His model of how the world is 'already discovered' through the use of a piece of equipment is orientated around a constellation of praxical terms. For Heidegger, the primary dealings we have with the world are those things that we put to use. He says,

The kind of dealing which is closest to us…is not bare perceptual cognition, but rather that kind of concern which manipulates things and puts them to use…Such entities are not thereby objects for knowing the 'world' theoretically, they are simply what gets used, what gets produced, and so forth. (BT 1962: 95)

What is notable here is that when we use things or we produce things, we don't just 'use them', we are in a relation of concern. Tools are not simply things to be used by us.

According to Don Ihde, Heidegger's tool analysis is the vehicle by which Heidegger sets out how the 'worldhood of the world is make phenomenologically apparent' (Ihde 1979: 116). Through this analysis we gain an apprehension of the shape accorded to the human–tool ensemble. It is through our concernful dealings with things that the world is already discovered. We do not come to 'know' an entity theoretically through contemplative knowledge in the first instance. As we have already seen, we come to know this entity theoretically only after we have come to understand it through handling.

In his distinction between theoretical knowledge and use, Heidegger identifies two different ways that we encounter what tools are in themselves. When we handle or deal with tools, their being is discovered in terms of 'readiness-to-hand' ('*Zuhandenheit*'). This being, as ready-to-hand, contrasts with our just looking, for example when tools are in their packaging in the hardware shop or the art suppliers. Here they are simple presence. Emmanuel Levinas notes that 'it is precisely because handling does not follow upon a representation that handlability is not a simple "presence"' (Levinas 1996: 19). In handling, tools are not set before us as an object. In presence, on the other hand, entities appear as 'just there', as 'present-at-hand' ('*Vorhandenheit*').

As ready-to-hand, a tool's being emanates from its usability and manipulability 'in-order-to' do something. The being of the ready-to-hand derives from its character as 'something' *for* something. In this conception, equipment manifests itself in its readiness-to-hand in-order-to do something. I use a pair of scissors to cut material or a scalpel to cut card. Dowel pins are used to join two surfaces. In other words, production has the structure of the assignment of something-to-something. According to this description, the ready-to-hand belongs to the realm of productivity, not that of contemplation.

In his tool analysis, Heidegger cites the example of using a hammer to establish the distinction between knowing

through handling, or praxical knowledge, and theoretical or contemplative knowledge:

The less we just stare at the thing called hammer, the more actively we use it, the more original our relation to it becomes and the more undisguisedly it is encountered as what it is, as a useful thing. The act of hammering itself discovers the specific 'handiness' of the hammer ... No matter how keenly we just *look at* the 'outward appearance' of things constituted in one way or another, we cannot discover handiness. When we just look at things 'theoretically', we lack an understanding of handiness. But association which makes use of things is not blind, it has its own way of seeing which guides our operations and gives them their specific thingly quality ... The kind of seeing of this accommodation to things is called *circumspection*. (BT 1996: 65)

Four important points can be gleaned from this quote. Firstly, Heidegger distinguishes between observing something and using it. Secondly, Heidegger makes the claim that in using a hammer our relation to it becomes more original. Thirdly, he suggests that theoretical observation does not help us to understand the handiness of a thing. We can only understand the handiness or what a thing does when we deal with it practically. Finally, he argues that our use of things or practical dealings with things is not blind, but rather has its own kind of seeing or sight. Thus Heidegger points out that when we just look at the outward appearance, a thing lies there before us as present-at-hand. For him, a purely theoretical engagement with the hammer will not allow us to comprehend its being as a hammer, that is its usefulness. It is through handling or using the hammer that we can understand the nature of the hammer.

Thus it is through working with the materials and tools of practice that we come to understand what these materials, this tool or that piece of equipment can do. Thus we can read software manuals *ad infinitum*, but not until we work with a particular software program can we come to understand its handlability. We encounter it as a useful thing and discover its particular qualities when we handle it in practice. This inversion of practice and

theory, in what has become termed '*praxis*', becomes central to my rethinking of the relationship of theory and practice in creativity. Praxical knowledge – learning through doing – makes practical sense to an artist.[3]

How praxical knowledge works

Kentridge's art practice exemplifies the operations of praxical knowledge. During his art-school education, Kentridge was trained to see drawing as a preliminary activity to the main activity of painting – as a way of sketching out ideas, solving visual problems and rehearsing compositions for the final work, the painting. However, in the activity of drawing, he realised that drawing was the work or art, rather than a preliminary to the work.

Drawing enabled him to understand the handiness of a piece of charcoal, a piece of soft cloth and a rubber. Through this 'context of intelligibility' his practice moved into new territory. In the process of drawing and rubbing out, Kentridge realised that the eraser left a trace or ghost of an image. Rather than destroying the drawing, Kentridge recognised the possibilities that this 'failed erasure' offered. Through the ghosting of images, it traced the passage of time and process. It evoked time and movement. Instead of throwing the drawings in the bin (as I have seen many drawers do) Kentridge embodied this discovery as part of his process. Each drawing came to have built into it the history of that sequence. For Kentridge, handling or dealing with the charcoal, cloth and rubber had released a new way of thinking. In Heideggerian terms, he gained an original relation to the charcoal, eraser and paper.

Through such dealings, the apprehension that Kentridge gained was neither merely perceptual nor rational. Rather, his handling of the tools of drawing revealed its own kind of knowledge or 'sight'. The kind of sight through which we come to know how to draw, to dance or to write, Heidegger terms 'circumspection' ('*Umsicht*'). Here we can summarise the praxical dimension of the worlding of the world. Dasein does not come to

know the world theoretically through contemplative knowledge. It is only through use that we gain access to the world and establish original relations with things. For Heidegger, it is through circumspection that the 'new' emerges.

Artists who work in the crafts tend to be keenly aware of the stakes involved in praxical knowing. In a retrospective publication *Lines Through Light*, the Australian glass artist Stephen Proctor ruminates on the attitude required to work with glass:

Use skill with conscious awareness. It is only when you work with your hands that you understand. Until then it is theoretical and although possible incomprehensible, because when the work begins and grows, it reveals something not before conceived. It is a discovery, a life and a sensibility of its own that is created through the working...A piece of work is the embodiment of time and thought...When working with cutting wheels you have to work with your whole being, listening as well as looking, feeling as well as measuring. To get your 'eye' accustomed, to train it as it is the inner eye which gives the work its life. (Proctor 2008: 92–3)

His observations and reflections embody the sensibility that operates in Heidegger's notion of circumspection. Proctor continues his reflections by observing how working with glass (as with other materials) requires us to be 'attentive and sensitive to the materials', since 'every touch of the wheel has effect' (Proctor 2008: 93). It is through our concernful dealings with our materials that something never-before-conceived is revealed. This is where our theoretical understandings grow out of practice.

What do these observations, and indeed Heidegger's concept of circumspection mean for our understanding of the 'new'? According to theories of the avant garde, the 'shock of the new' has been figured as transgressive, an attempt to break existing rules and usher in the new. The relentless quest for the new that drives avant-garde art practice has continued in contemporary practice, despite the postmodern critique of the avant garde and of originality.

Yet, as we have seen, Heidegger says that humans do not have any control over unconcealment. Heidegger tells us that unconcealment (of the new) is never a human handiwork, that the 'thinker only responded to what addressed itself to him' (QCT: 18). Thus by definition the new cannot be preconceived, and in the face of the seemingly limitless possibilities practice cannot know or preconceive its outcome. According to Heidegger, then, the new emerges through process as a shudder that presents itself to us.

The danger of representational thinking, as we have seen in Chapter 3, is that when we hold before us an 'idea' of what we think we are making, we may not be open to what the work may address to us. We may be so busy looking 'elsewhere' (that is to our preconceptions) that we miss it altogether. This preconception closes off possibility rather than making us open to what may be unconcealed through the work of art. Thus, no matter how hard we try to think and create the new, our conscious efforts will not succeed.

Here we can return to Heidegger's claim that it is through circumspection that the new emerges. I would suggest that the 'shock of the new' is a particular understanding that is realised through our dealings with the tools and materials of production, rather than a self-conscious attempt at transgression. In the 'work' of art, we do not consciously seek the new but rather are open to what emerges in the interaction with the materials and processes of practice. Thus it is only through use that we gain access to the world and establish original relations with things. Emmanuel Levinas observes that through these material dealings 'we gain access to the world in an original and an originary way' (Levinas 1996: 19). Faced with what is thrown up, we seize possibility in its very possibility. This way of being thrown forward towards one's own possibilities is, as Heidegger argues a crucial moment of understanding.

We will recall that when Heidegger talks of 'understanding', he is not referring to understanding as a cognitive faculty that is

imposed on existence. 'Understanding' is the care that comes from handling, of being thrown into the world and dealing with things. Levinas notes that the originality of Heidegger's conception of existence lies in positing a relation that is not centred on the self-conscious subject. He says, 'in contrast to the traditional idea of "self-consciousness" [*conscience interne*], this self-knowledge, this inner illumination, this understanding... refuses the subject/object structure' (Levinas 1996: 23). This relation of care is not the relation of a knowing subject and an object known. We care because we have an investment in things.

Following on from this logic, 'Art' can be seen to emerge in the involvement with materials, methods, tools and ideas of practice. It is not just the representation of an already formed idea. In this formulation, a praxical engagement with tools, materials and ideas takes precedence over any theoretical-cognitive engagement. In this matrix, engagement with tools or technology produces its own kind of sight. Just as Kentridge discovered the potential of charcoal and eraser by working with them, so it is not until I begin mixing my paints and laying down colour that I understand what paint can do. Similarly, I may think I have a good idea, but until I begin to work with it and 'handle' it I cannot understand where it will take me.

On initial impressions, Heidegger may seem to take an anti-theoretical stance. Understanding comes from practical handling not theoretical contemplation. Such a position would suit those of us who struggle with art theory. Why should we have to engage with theory when it is only through handling that we come to understand the Being of our materials, tools and equipment? However, Heidegger makes two points pertinent to this question. Firstly, he states categorically that practical behaviour is not atheoretical, because he points out that handling is not blind, but produces its own kind of sight (BT 1996: 65). Secondly, he observes that although theoretical and practical behaviour are different in that in the former we observe and in the latter we act,

circumspection requires us to apply theoretical understandings in order that we don't remain blind, and theoretical engagement or observation involves a particular form of care.

In relocating our interest in handling as care, we can once again address the question of art practice. Seen this way, the cutting-wheel and the glass of Proctor's practice and Kentridge's charcoal and eraser are not just 'used', the 'subject matter' is not present-at-hand, and nor is the artwork merely an end. Handling as care produces a crucial moment of understanding, and that understanding is a revealing of possibility in its very possibility. This, not the completed artwork, is the work of art.

Circumspection

Heidegger's the use of the terms 'sight' and 'blindness' in terms of circumspection, cannot be taken literally. Here 'sight' is not about the visual apparatus but is a form of knowingness. 'Blindness', by contrast, is a form of forgetting. Circumspection involves a special form of looking around that is dependent upon a prior context of intelligibility. Our context of intelligibility comes from our being-in-the-world, understanding what things can do, and having a sense of the complex web of relations that exist between things. Heidegger terms this relation to the ready-to-hand, the 'fore-structure'. This makes practical sense. If we were to walk into Proctor's glass foundry, Kentridge's studio or Bill Henson's photographic studio, we would have an apprehension of the sorts of networks and connections required for work as a glass artist, a film-maker or a photographer. In order to work as an analogue photographer, for example, an artist needs to understand what different types of cameras can do, the characteristics of different film stocks, how to load a camera, and adjust the aperture and the shutter-speed of the camera according to available light, the subject matter and the type of film in the camera. All this, and we have yet to take a photograph, let alone process the film and print a photograph.

Our fore-structure enables us to interpret and respond to the possibilities that things throw up. Heidegger delineates three aspects to the fore-structure: 'fore-having', 'fore-sight' and 'fore-conception'. 'Fore-having' is the understanding of an entity and the context in which it exists. For example, if we work in the digital realm, our understanding of the context of the digital environment will help us negotiate new software packages that we encounter. 'Fore-sight' provides the focus or lens through which the entity is to be interpreted. My understanding of the qualities of different kinds of paint and what they do enables me to interpret paintings no matter what their content. Finally, 'fore-conception' is the prior knowledge of something that one needs of the ready-to-hand in order to understand it. For example, without prior knowledge of what a canvas stretcher can do, it will appear incomprehensible, therefore unusable.

Heidegger uses the term 'accommodation to things' to alert us to the give-and-take or the adaptation that is involved in working with a new tool, a process or a material. While we may theoretically know the practical purpose of something, it is only through our actual material engagement with things that we realise what something can actually do. It is this practical knowledge that enables us to adapt our working process to take into account the being of a tool or material. An example will exemplify the accommodations involved in circumspection. An inexperienced potter will struggle to make a form on a potter's wheel. In this person's hands, the un-centred lump of clay will wobble and bump uncontrollably as it spins around. An experienced potter, on the other hand, will be able to balance the complex interplay of forces and energies of the clay – its plasticity and density in relation to the centrifugal and centripetal forces of the spinning wheel. At each moment of throwing a pot, the potter will accommodate the plasticity of the clay, its wetness, dryness or graininess at the same time as responding to the forces of the wheel. The potter accommodates these by modifying or increasing the pressure of

touch, adding or wiping away slurry, and increasing or decreasing the speed at which the wheel turns, until the clay is centred and can be opened out and drawn out and upwards.

At first we may see centring of clay as an act of mastery in which the potter brings the clay under control in-order-to make a pot or a bowl. However, seen from the point of view of circumspection, we come to understand that throwing a pot does not involve a mastery over the clay but rather an accommodation that allows the clay to emerge in its own way. Japanese tea bowls, in particular, demonstrate this accommodation to the material from which they were formed. They are born of the earth and are sympathetic to this history. The potter is indebted to this history, and is expected to accommodate the strong, rough granular structure and tactile surface so that it emerges in the finished pot. The basic principles of the Japanese potter, notes Siegfried Wichmann, enables

Concentration and silent absorption in the object, the *wabi*; *shibui* signifies the discipline, the consistency, the unpretentiousness, the raw quality, the austere essence. The pot must not express intention; it must revert to its fundamental value ... Therefore asymmetry is not dictatorial, and not brash; it is anonymous and yet totally itself. (Wichmann 1985: 347)

It is perhaps not surprising, therefore, to learn of the influence of Eastern philosophy, and Japanese philosophy in particular, on Heidegger's philosophical thinking. Here Heidegger's notion of circumspection enables us to understand that our relations with material are not relations of mastery but involve responsiveness to and care for the tools and materials, so that they may operate and emerge in their own way.

The focus on care and concernful dealings that is wrapped up in Heidegger's notion of circumspection reminds us how we take our tools and equipment for granted when they are in working order. We rarely pause to think of what they are in themselves, but rather become focused on what they can do for us. When we first

learn a new process or skill, or work with a new tool, we are very aware of the accommodations that we make. However, once our use of the ready-to-hand, the tool, becomes second nature or habitual we forget to think about it beyond its use value. The tool or process becomes inconspicuous.

Heidegger's elaboration of the ready-to-hand is not intended to reduce equipment to its usability. Rather his interest is in how the kind of being that equipment is reveals itself in its assignment of something-for-something. He is concerned with what is discovered in use, that is what shows itself. We saw this exemplified in the hammer hammering.

The peculiar quality that presents itself in circumspection is that when we are using a tool we are no longer aware of its qualities as a tool. We are so concerned with the working that we no longer 'know' the tool in a theoretical sense. The tool as merely present-at-hand recedes or withdraws. Perversely, it is only when a tool fails or is unusable that we once again become aware of it. It becomes unready-to-hand. In its unreadiness-to-hand, Heidegger argues, it becomes a mere 'thing' that lies there. It is the 'just-present-at-hand-and-no-more of something ready-to-hand'. In its unreadiness-to-hand as being-just-present-at-hand, Heidegger contends, we are helpless. In this helpless mode, we exhibit a deficient mode of concern (BT 1962: 103).

Two salient features emerge from this discussion. Firstly, we forget what tools and equipment *are*, and secondly, it is only in the tool's withdrawal in use that we are reminded of the being of the ready-to-hand, that is what the tool actually is and what it actually does. Ihde tells us that as Dasein concentrates on its business making something it is so focused on the work that it 'refers through the tool-equipment towards the world in which the work or result appears' (Ihde 1979: 120). In this, he observes, the ready-to-hand can be so easily overlooked. In fact, according to Heidegger, the ready-to-hand is concealed. It becomes grafted into us.

I sit here on my chair typing away. I am so focused on meeting my deadline and completing this book that I forget that without the generosity of the chair holding me up I would be sitting on the floor. Until I mislay my glasses and can't read a thing, I forget that without them I would not be able to read Heidegger's texts. It is easy to overlook the fact that without a study table and a computer I could not actually write this book. In use, the ready-to-hand becomes transparent, and I forget that I am *not* the only entity responsible for this book.

I will return to the question of attribution in the following chapter, but for now I work furiously on writing this book and, when not working on that, I receive and send emails willy-nilly. However, my relation to all these entities alters fundamentally as soon as something breaks down – the chair breaks or there is a power failure or the email goes down. According to Heidegger, the equipment becomes just a thing present-at-hand, and I become helpless in its manifestation as unreadiness-to-hand.

Art and the unready-to-hand

Heidegger reminds us that it is only when a tool or equipment breaks down or something is missing that its being as equipment comes to the fore. Through this unreadiness-to-hand he argues we become aware of the Being of a piece of equipment. In setting this out he identifies three instances in which an entity as unready-to-hand comes to light. Firstly, the unreadiness comes to hand when the tool is damaged or the material unusable. We discover its unusability when we try to put it to use and it won't work. In its uselessness the unready-to-hand becomes conspicuous, for example when the stapler breaks while I am stretching a canvas, or when the tube of paint has dried out because it is so long since I have used it. The second instance shows itself when something is missing, that is not-to-hand. The more urgently we need something the more obtrusive becomes the unready-to-hand. We become helpless in the face of this absence. For example, when

I go to use the stapler and find it empty, and the shops are shut, I become very aware of the unready-to-hand. The third situation is when something 'stands in the way' of our concern. He says,

anything which is unready-to-hand in this way is disturbing to us, and enables us to see the obstinacy of that with which we must concern ourselves in the first instance before we do anything else … that which lies before us and calls our attention is experienced as the presence-at-hand of the ready-to-hand. (BT 1962: 103)

Here I could say that meeting the deadline for writing this book stands in the way of painting, or that I cannot begin painting until I have stretched some canvases. Others might say that housework or administration stands in the way. Whatever it is, it remains obstinate and refuses to budge until we have dealt with it.

In the face of the unready-to-hand we are left helpless. Thus a digital artist is rendered helpless in the event of a power failure. During a power failure, the computer becomes just a thing present-at-hand. However, is this always our experience when faced with unreadiness-to-hand? Initially, I would tend towards the affirmative. When the scanner doesn't work, I pack it up and take it to the technician, who tells me to throw it away as it is cheaper to buy a new one. Similarly, when the printer runs out of cyan, I flail around in frustration knowing that, while I only want to print with black ink, there is no way that the printer will do anything until I install a new cyan cartridge. But this is not always the case.

In everyday life, the unready-to-hand becomes an obstacle to achieving our goals. For some artists, however, the unready-to hand becomes a possibility to be seized. Contemporary 'art' tends to capitalise on the possibilities produced by unreadiness-to-hand. The charred violins of Arman, César's compressed car bodies, Maurice Ravel's compositions and Jean Tinguely's assemblages are evidence that art thrives where things are not working properly. Rather than producing helplessness, in these cases the unreadiness-to-hand produces possibility. For example,

in his *Homage to New York: A self-constructing, self-destructing work of art* (1960) Jean Tinguely used the unready-to-hand to create an assemblage that aimed to 'distil the frenzy of our joyful, industrial confusion' (Tinguely quoted in Lucie-Smith 1987: 77). Not only did the work not do what machines are usually supposed to do, but it also created a 'happening' and destroyed itself in the process.

Where artists work with the unready-to-hand, they help to question the instrumentalist way in which we have come to view the world. We will recall that as we go about our everyday activities we become so caught up in the ontic realm of human beings that we are no longer aware of the Being of things – of tools, of society or of our own being. The Being of things recedes or withdraws. In capitalising on the unready-to-hand, contemporary art brings to the fore once again those habitual practices and ways of thinking that characterise our modern technocratic society. Rather than using things as ready-to-hand in-order-to, the artist's use of the unready-to-hand stands out against the system in which it normally exists. We see things again as if for the first time.

Heidegger's conceptualisation of praxical knowledge offers a radical way of refiguring artistic practice. His call for a different relation to technology and his analysis of the ready-to-hand and the unready-to-hand offers an alternative perspective on technology to the instrumentalist notion of technology that holds sway in a technocratic society. It enables us to rethink our relations to the materials and tools of practice as one of concernful dealings, rather than mastery. We develop skill with our materials rather than mastery over them. Further, he shows us how, through our concernful dealings with our tools, materials and our ideas, something never-before-conceived is revealed. This is where our theoretical understandings of the world grow out of practice. This provides the underpinnings of practice-led research. I will address the question of creative-arts research or practice-led research in the final chapter of this book.

Chapter 6

The artist in a post-human world?

Silver is that out of which the silver chalice is made. As this matter (*hyle*), it is co-responsible for the chalice. The chalice is indebted to, that is, owes thanks to, the silver out of which it consists. But the sacrificial vessel is indebted not only to the silver. As a chalice, that which is indebted to the silver appears in the aspect of a chalice and not in that of a brooch or a ring. Thus the sacrificial vessel is at the same time indebted to the aspect (*eidos*) or idea of chaliceness. Both the silver into which the aspect is admitted as chalice and the aspect in which the silver appears are in their respective ways co-responsible for the sacrificial vessel…But there remains yet a third that is above all responsible for the sacrificial vessel. It is that which in advance confines the chalice within the realm of consecration and bestowal. Through this the chalice is circumscribed as sacrificial vessel. Circumscribing gives bounds to the thing…Finally there is a fourth participant in the responsibility for the finished sacrificial vessel's lying before us ready for use, i.e., the silversmith. (QCT: 7–8)

Context

We have come this far and still we have not addressed Heidegger's thinking about the role and function of the artist. His discussion of the artist in 'The origin of the work of art' needs to be seen in the broader context of the aesthetic or modern conception of art. According to such a conception, the artist is the primary figure in the creation of art. Aesthetic theory tells us that art originates in and through the activity of the artist as genius. The 'genius' artist produces great art; the viewer is the one who experiences and enjoys art.

Like the postmodern critics that followed in his wake, Heidegger disagrees. He does not believe that creation is the performance of the genius artist, arguing that modern subjectivism has misinterpreted creation, 'taking it as the sovereign subject's performance of genius' (OWA: 200). However, in contrast to postmodern claims that art is a cultural construct and that art is created through the discourses on art, Heidegger's position is more enigmatic and difficult to grasp. Firstly, while he is very clear that art is historical, he is also adamant that it is art that is the origin of both the artwork and the artist and not vice versa. Secondly, he insists that to create involves letting something be revealed or brought forth into appearance.

From our discussions on *poiesis* in Chapter 4 we recall that Heidegger identifies two forms of creation. He distinguishes between *physis*, the bursting forth out of itself that happens in nature, and the bringing-forth in another that is found in the arts and crafts. While a blossom may burst forth in bloom, the artist enables the bursting forth in another. How might this bringing-forth in another be interpreted? On first appearance it may seem that the potter, the sculptor, the print-maker and the painter engage in a similar activity. They take raw matter and make it into an artwork – this holds true for all forms of art, whether it be a film, a readymade, a performance, a drawing or a conceptual piece of art. According to this conception, what Heidegger calls the form–matter structure, artists and craftspeople use matter to create form; an artwork comes into being through the artist's formative action. The artist's identity as creator is confirmed in this action. However, according to Heidegger this is not the bringing-forth of createdness.

In 'The origin of the work of art', Heidegger explains that while the form–matter structure appears convincing and is seductive, it does not get to the heart of the matter; it distracts us from thinking about what art is in its essence, and hence confuses the role of the creator with createdness. In order to explain what he means by

'creation' and 'createdness', Heidegger takes us back to the early Greek conception of *'techne'*. We may recall that the Greeks used the word *'techne'* to describe the activity of craft and art, and called both the craftsman and the artist *technites*. However, for them *techne* never signified the action of making, and the essence of art was not related to the skill and craftsmanship of the artist.[1] *Techne* was a mode of knowing that allowed something to emerge into unconcealment.

Artist as passageway

The concept of *techne* has important implications for thinking about the role of the artist. If the act of creation involves letting something emerge as a thing rather than making a thing, what role does the artist play in createdness? Here Heidegger is very clear. In 'great art,' Heidegger tells us, the 'artist remains inconsequential as compared to the work, almost like a passageway that destroys itself in the creative process for the work to emerge' (OWA: 166). What does Heidegger mean by this? What is the experience of being like a passageway that destroys itself in the creative process?

Heidegger's assertion that the artist remains inconsequential in comparison to the work does not immediately make sense to us. In a world where celebrity artists are photographed with filmstars, rockstars, sports stars and other celebrities for magazines and other mass-media events, it would seem that artists remain very central. Ever since Giorgio Vasari wrote his *Lives of the Great Artists* in the mid-sixteenth century, the 'artist' has been considered anything but inconsequential as compared to the work (Vasari 2005). The history of art is built around artists, and 'value' in the art market is established in relation to the artist's name. Auction houses sell Picassos, Kandinskys, Matisses, Pollocks, Emins and Hirsts. The belief in the status and subjectivity of the artist appears so deeply entrenched in our contemporary era that we do not even question it.

While in Modernism the view of the Modernist artist as genius may have reflected a misinterpretation of creation as the sovereign subject's performance of genius, in the contemporary world, artists have achieved a different status. 'Great artists' are those that have been elevated to the status of celebrities. Their subjectivity can add value to other goods and services, not just the artworks signed with their name. Thus we have seen that Tracey Emin sells Bombay Gin, Vanessa Beecroft is the face of Gucci, Olafur Eliasson installations promote Louis Vuitton products. It may be all very artful, but nevertheless it could be argued that this constitutes an enframing revealing. Here the artist becomes the central figure in the realm of art business. As we saw in Chapter 4, the seductive power of enframing as a destining revealing threatens to foreclose every other mode of revealing. Such a revelation causes us to stop and ponder. Are we destined to figure art and the artist within an enframing mode of revealing? Perhaps this blindness to Art in itself is precisely Heidegger's point, for he says that in order to gain access to the work, 'it would be necessary to remove it from all relations to something other than itself, in order to let it stand on its own for itself alone' (OWA: 165).

The mechanics of art business may function to keep the name of the artist to the fore. However, Heidegger is adamant that Art, not the artist, is the origin of the artwork. He also tells us that Art is the origin of the artist. Here Heidegger turns our everyday understandings of the relationship between the artist, creation and art upside down. While Heidegger likens the artist to a passageway, he does not say that the artist destroys her/himself. This much is clear. There has been an exponential growth in the number of artists who spend a lifetime devoted to this thing called art. What, then, is Heidegger's point? In createdness, the artist has a responsibility to create the possibility for Art, to start Art on its way into arrival. Once art is set on its way, the artist becomes inconsequential, as compared to the work.

We know from our own experience that once an artwork is sent out into the world – to an exhibition or an art competition – the artist can never predict what will happen, how the work will be received or 'read'. Roland Barthes's seminal article 'The death of the author' (1977) and Michel Foucault's essay 'What is an author?' (1986), have confirmed that notions of originality, authenticity and intentionality are outmoded concepts in a postmodern world. While Barthes and Foucault specifically address authors and writing, their lessons are important for how we think about the relationship between artists and artwork. Reception theory, with its focus on the viewer as the one who makes meaning of the work, seems to make sense. Viewers bring their own values and attitudes to the viewing of a work, and hence the artist's intentions and actions count for very little once art is circulating in the artworld. This has been one of the essential lessons of visual culture (see Sturken and Cartwright 2001). However, this is not Heidegger's point. As a passageway, the artist may be insignificant in comparison to the work, but the same also goes for the viewer. Viewers are preservers of art. As preservers, they are also required to set aside their preconceptions in order to allow a total openness that enables the 'truth' of the work of art to reveal itself.

In 'The origin of the work of art', Heidegger makes a distinction between creators and preservers. It would be easy to read artists and viewers, but I don't believe that is what Heidegger intends. There is no reason at all why beings should be divided into 'artists' and 'viewers'. Viewers, we have come to understand, are as much creators as artists are preservers. Seen from this point of view, artists, viewers, art galleries, curators, gallery owners, auction houses, collectors, art historians, art books and art critics are all in their own way preservers.

While preservation may seem to involve a cast of characters from Arthur Danto's artworld, we have seen that Heidegger does not define art in terms of the institutional artworld. There is

nothing to say that making art, showing art, selling art or curating works in galleries will preserve art. His reservations become very clear when he talks about aesthetic engagement, commenting that 'when works are offered for sheer artistic enjoyment this does not yet prove that they stand in preservation as works' (OWA: 193). We have already seen that the artworld – with its complex network of artists, galleries exhibiting, promoting and selling work, and art theorists, art historians and critics creating discourse around the work – operates in the realm of art business. As art business its role in preservation is at best dubious. Heidegger believes that what is essential to both creation and preservation is 'a willingness' to openness. In openness, the creator and preserver do not bring preconceptions or intentions to the encounter with art. Preservation is a process of unconcealment that allows art to emerge in its own way.

For Heidegger, the preservers of the work, those who come to experience and apprehend the work of the work as revealing, belong as much to the createdness as the creators. In createdness, the work asserts that *it is*. Heidegger insists that createdness enables us to be transported out of the realms of the ordinary into an open region. While this sounds very liberating, it also raises certain difficulties for us 'mere' mortals. To be transported out of the realm of the ordinary we must suspend our usual way of looking and thinking about the world. This is quite a difficult way for us to think, as we go about our business making a name for ourselves as artists – applying for grants, making work, exhibiting and promoting ourselves to art galleries and to the artworld. When we exhibit, we set out our intentions in artists' statements. In grant applications for project proposals, we set up a project in advance. We set out our aims or intentions, and describe the project. In this way we are thinking representationally, rather than allowing the work to emerge in its own way. Here, Heidegger pulls us back and cautions us that we are in the realm of art business rather than Art.

Creation involves letting something emerge as a thing, rather than making a thing. This requires the artist to be open to the call of Art. But how can we achieve this? Surely our preconceptions about *what art is* mediates every experience of art? However, Heidegger warns that if we come to the work blinded by our intentions and preconceptions or armed with existing models of interpretation we will not ever be able to move beyond the realm of the ontic into the openness of Being. Where everything that *is* is standing-reserve and at man's disposal as a means to an end, it is very hard for human beings to let it Be.

What would this openness of/to Being look like? Heidegger believed that early Greek society provides a model of this openness. For the Greeks, as we saw in Chapter 3, reality loomed up before man and confronted him in the power of its presence. In order to fulfil their essence as beings, the Greeks had to remain open or exposed (*aletheuein*) to reality in 'all its sundering confusion' (AWP: 131). While we should in no way collapse 'Greek man' and 'artist', I surmise that the task is similar. Both are concerned with openness to Being. Thus in order to enable Art to emerge, the artist must remain exposed to all of art's sundering confusion rather than trying to master it.

A post-human future?

Heidegger's modelling of his thinking about Being on early Greek culture may appear irrelevant to our contemporary experience of being-in-the-world. It is tempting to see his thinking as nostalgia for a time long past. Given this preoccupation with a past culture, what value does Heidegger's thinking offer us in what we have come to call a post-human world? How can his philosophy respond to the place of the artist and art in post-humanism?

The concept of the post-human has grown out of the impact that new technologies have had on the way we live and understand our lives (and hence our Being). It is this fundamental change in relations that has necessitated a rethinking of the relations

between humans and non-humans, between art and life. Where techno-science has come to create a seamless prosthetic union between humans and intelligent machines, the autonomy of the so-called Cartesian subject has been undermined. Some contemporary writers and artists, for example the artist Stelarc, celebrate this union. Other writers, such as Francis Fukuyama (2002), claim that the post-human epoch merely inverts the hierarchy of power so that technology becomes the master and humans become slaves to technology. This is the fate of an enframing revealing. Others more crudely envisage that in a post-human world there would be no humans around to feel and sense, let alone worry about their Being.

In her book *How We Became Posthuman: Virtual bodies in cybernetics, literature and infomatics* (1999), N. Katherine Hayles suggests that the post-human does not signal the end of humanity, nor is it anti-human. For her, the post-human involves a shared relation between the human and non-human. This shared relation or engagement involves developing new ways of thinking about what it is to be a being, and provides an opportunity to reassess our relations with other beings. The question for this book is how, or perhaps whether, Heidegger's questioning of the human relation to technology offers us modes of thought that allow us to think through these circumstances.

Unlike philosophers such as Gilles Deleuze, whose philosophy anticipates the post-human, Heidegger's phenomenological approach grounds his work in the humanist tradition. The privileged position of human beings as Dasein, established in Heidegger's philosophy of Being, confirms this. We will recall that Dasein is distinguished from other entities in the world precisely because it is the one being who thinks about its Being. What makes human beings unique, says Heidegger, is that humans alone ask the question what is Being?

However, we will also recall that for Heidegger being encapsulates all entities, that is anything that has an existence at

all. It includes the human and the non-human beings – animals, objects, chemical processes and molecules. Being constitutes the essence of these entities or beings. According to Heidegger it is this shared sense of existence that makes human beings inseparable from all other entities. Hence being-in-the-world is the existence human beings share with all other entities.

If a post-human society does not signal the end of the human, but rather points to a different relation with technology and objects in the world, how might Heidegger's thought be of value? It is precisely because Heidegger prepares the way for a new relation to technology that his work is critical to helping us think through what this relation might look like. Heidegger's decentring of the artist and his rethinking of the human–technology relation offers us a way out of both a subjectivist view of the artist as genius and also the view that the artist has been reduced to standing-reserve. It offers an alternative to those, such as Fukuyama, who worry that in a post-human future technology will overcome us (see Fukuyama 2002).

Co-responsibility and indebtedness

Heidegger's example of the creation of a silver chalice, in 'The question concerning technology', enables us to think differently about our relations with technology and other objects in the world. It is an explanation that also opens the way for us to reconceive createdness. Heidegger begins by telling us that the master silversmith does not make the silver chalice. Instead, he proposes that the silversmith is co-responsible for and indebted to other co-collaborators for the emergence of the silver chalice as a silver chalice. Those co-responsible include the silver from which the chalice is made (the matter), the idea of chaliceness (aspect) and the purpose to which the vessel is going to be put (circumscribing bounds) (QCT: 6). Together with the silversmith, they bring-forth something into appearance. This is createdness.

Heidegger's refiguration of createdness requires us, as artists, to question our own relationship with both the human and non-human entities that we deal with in art. This makes increasing sense in a post-human world where there is an interfusion between human beings and technology. But how does Heidegger get from our everyday understanding that artists make an artwork, to the idea that the artist is just one of the entities co-responsible for the emergence of art?

In our everyday thinking about art, artists use their equipment and materials as a means to an end in-order-to make an artwork. In this everyday thinking, instrumentalism reigns. Heidegger says that 'wherever ends (the artwork) are pursued, and means (tools, material, skills and assistants) are employed, wherever instrumentalism reigns, there reigns causality' (QCT: 6). Here Heidegger points out that the root of our instrumentalist understanding of technology lies in the notion of causality.

Heidegger notes that Aristotle first set out the doctrine of the four causes that explained causality. For Aristotle, the first cause is identified as '*causa materialis*'. This is the matter or material out of which something is made. In Heidegger's example of the making of a silver chalice, the *causa materialis* is silver. Imagine a sacrificial chalice made out of plastic, plaster or playdough, for example. Such an entity would have a very different being than a silver chalice. The second cause, '*causa formalis*', relates to the form that the thing takes or the shape into which the material enters. The forming of a chalice can be contrasted with the forming of a dress, a sculpture, a painting or a ceramic pot. Each emerges in its own way. The third cause, '*causa finalis*', is the end or the purpose for which the thing is made. The purpose for which something is made will determine the form of the thing, and thus its relation to *causa formalis* and *causa materialis* becomes obvious. Thus, a vessel that is made in-order-to drink from will need to be able to contain and hold liquid, be leak-proof and have a smooth lip for drinking from. The sacrificial religious

rite of communion for which the chalice is required determines its form as a chalice and influences the choice of silver as the matter from which it is made. In contrast, for example, Meret Oppenheim's fur-covered cup, saucer and spoon in *Luncheon in Fur* (1936) would not be used in a sacrificial religious rite, at least within the established institutional religions. Nor, for that matter, would *Luncheon in Fur* provide the setting for an afternoon tea party. The action implied in bringing a hairy-lipped cup full of warm fluid to one's lips is not conducive either to celebrating the ritual of communion or to drinking tea.[2] Finally, the fourth cause identified is the '*causa efficiens*'. The *causa efficiens* is that which brings about the finished object. In the example of the silver chalice, it is the silversmith (QCT: 6).

The theory of means and ends, which has dominated modern understanding of technology (including the making of art), has focused on the cause that brings something about, the cause that gets results. It is for this reason that Heidegger suggests that it is the *causa efficiens*, or the artist, that has been credited with making the work of art. In harnessing means to ends, including the acts of conceptualising and outsourcing the work, the artist signs their name as the one who has made or caused a work to come into being. The centrality of the commissioning artist has remained unchallenged.

However, Heidegger's rethinking of createdness and his reinterpretation of causality produces a quite different dynamic, one that shifts the terms from mastery and instrumentalism to care and indebtedness. Here I would like to return to the quote that introduces this chapter and show how Heidegger reverses the chain of causality to argue that the artist is indebted to the other co-collaborators for the emergence of art. He claims,

Silver is that out of which the silver chalice is made. As this matter (*hyle*), it is co-responsible for the chalice. The chalice is indebted to, that is, owes thanks to, the silver out of which it consists. But the sacrificial vessel is indebted not only to the silver. As a chalice, that

which is indebted to the silver appears in the aspect of a chalice and not in that of a brooch or a ring. Thus the sacrificial vessel is at the same time indebted to the aspect (*eidos*) or idea of chaliceness. Both the silver into which the aspect is admitted as chalice and the aspect in which the silver appears are in their respective ways co-responsible for the sacrificial vessel. (QCT: 7–8)

The artist's responsibility does not derive from their role as *causa efficiens*, or because in working they bring about the finished object. Heidegger contends that the silversmith is co-responsible for bringing the silver chalice forth into appearance (QCT: 8). Heidegger teases out a different relation between the silversmith, the silver and the chalice. As matter is co-responsible for the chalice, so the chalice is indebted to the silver (QCT: 7). Further, a silver chalice wouldn't be a chalice without the idea of chaliceness, nor would it be a sacrificial vessel without the circumscribing bounds of the religious ritual of communion. In a similar, way we could say that Duchamp's *Fountain* (1917) was indebted to the circumscribing bounds of the artworld for its being able to be seen as art and not as a urinal. In Heidegger's thinking, these ways of being responsible are also indebted to the efforts of the 'silversmith for the "that" and the "how" of their coming into appearance and into play' (QCT: 8).

Although there is an important ethical imperative inherent in Heidegger's reframing of causality as co-responsibility and indebtedness, it is not an ethical assertion, as we might imagine. His reframing derives from his questioning of the essence of causality. He argues that the essence of causality is not, as modern thought would have it, a simple case of cause and effect. Heidegger traces the etymology of the word '*causa*' back to the Roman and then the Greek.[3] While *causa* was the Roman designation for 'cause', the Greeks used the term '*aition*'. In Greek thinking, '*aition*' carries with it a different sense. He suggests that as the Greeks thought it, causality is 'the letting of what is not yet present arrive into presencing' (QCT: 10). Here, according to Heidegger, '*aition*'

means 'that to which something else was indebted' (QCT: 7). From this basis, he concludes that the doctrine of four causes may be rethought and the trajectory of means and ends reversed. Where we have come to accept the view that humans use materials and methods to achieve an artistic end, Heidegger makes the claim that the four co-responsible factors let something come into appearance. Thus, in this reversal of the causal chain of means and ends we can reconfigure the 'artistic relation': artists, tools, equipment, ideas, materials and processes become co-responsible for the emergence of art.

The importance of the refiguration of createdness becomes immediately apparent in thinking through the processes engaged in by contemporary artists. While some artists may still work alone in their studio, we have seen that in contemporary art artists adopt modes of practice that involve different configurations and relationships with other artists, artisans, tradespeople and the like. Some of these collaborations are motivated by the scale or technical complexity of the work. Artists like Anselm Kiefer retain a hands-on approach to their practice, working directly with their 'assistants'. Other artists adopt a hands-off conceptual approach to the work, whereby the artist-as-facilitator conceives of the idea and directs proceedings, while others carry out instructions to bring the artwork into appearance. This has a long history. In 1922, for example, László Moholy-Nagy set a precedent when he rang up a sign-painter and gave him instructions over the phone on what he wanted painted. The resulting painting was *Telephone Picture* (1922).

We need to pause here and assess where we have come in our discussion of the artistic collaboration. Firstly we might note that in all the cases cited the artwork is attributed to the artist-as-conceiver rather than to the whole constellation. While some artists may acknowledge and name their assistants, this is by no means always the case. There remains an instrumentality in the use of assistants in-order-to. These forms of relationships differ

from collaborations, such as Gilbert and George and the Chapman brothers, whose work is identified as a collaboration (see Green 2001). Secondly, the term 'collaboration' rather than 'co-responsibility' is used in describing these practices. And finally, when we talk about collaboration, we tend to refer to the other human collaborators.

Heidegger is making a much more radical shift when he talks about co-responsibility and indebtedness. In his thinking, human and non-human elements – materials, ideas and purpose – are co-responsible, not for making an artwork, but rather for the emergence of Art. While Heidegger's example of the silversmith and the silver chalice was used to make a philosophical point about the relation between technology and human beings, the

1. Patricia Piccinini, *The Young Family* (2002).

trajectory of his thought has importance for refiguring our thinking about art in a post-human world.

A contemporary example will demonstrate this point, and return us to the question of the role of the artist in a post-human world. Australian artist Patricia Piccinini exhibited an artwork titled *The Young Family* (2002) in her exhibition *We are Family* at the 2003 Venice Biennale (Figure 1).[4] Thematically this artwork is a prophetic work concerned with the relationship between technology and human beings. It addresses biotechnological manipulation, and is concerned with what this means for human beings in a post-human world.

In *The Young Family*, such 'raw materials' as silicone, polyurethane, leather and human hair have been transformed into a maternal bovine-human-like creature suckling a clutch of bovine-human babies. With her semi-translucent skin, wispy body hair, venous skin, stretch-marks and other very human flaws, we wait for breath to issue from the mother of this clutch. We have seen this graphic verisimilitude before, for example in the sculptures of Ron Mueck's, such as his bloated and exhausted *Pregnant Woman* (2002), and in John De Andrea's *Allegory: After Courbet* (1988). However, in Piccinini's *The Young Family*, the uncanniness rests in the fact that it is, and it is not, human; it is simultaneously bovine, sow-like and human.

Patricia Piccinini, like her contemporary Damien Hirst, conceives of the work and employs specialist technical artists to execute it. For *The Young Family*, she contracted the sculptors Sam Jinks and James Thompson to fabricate and craft the objects in her installation. Jinks, like Mueck, trained in special effects for film, and has come to use these skills in his own sculptures as well as working with Piccinini on projects. The verisimilitude that he brings to such works as *The Young Family* also characterises his own work, such as *The Hanging Man* (2005). How can we understand the relationship between the 'artist' and the 'collaborators' in this constellation?

Piccinini describes her role as facilitator/artist, a role in which she draws together the people, the materials, the processes and skills that enable her to realise her concepts. She comments that 'I conceive the work and then bring together the pieces ... If I didn't have great people working on the projects, it wouldn't work. I don't want the ideas to be limited by what I can physically do. The ideas come first' (Piccinini quoted in Williams 2004: 87).

A Heideggerian mapping of the network of indebtedness and co-responsibility that allows the artwork *The Young Family* (2002) to emerge reveals the complex sets of relations that are involved in this work's coming to appearance. The idea (*eidos*) to which the artist Piccinini is indebted derives from science and ethics, and in particular to biotechnology. Hence *We are Family* is indebted in aspect (*eidos*) to mutation and mutability. The translation of these ideas about mutability and the post-human into material form is in turn is indebted to the matter (*hyle*) of silicone, polyurethane, human hair and leather. The matter is simultaneously indebted to the sculpting and casting of Sam Jinks who, with his skill with materials, is co-responsible for the transfiguration that enables these mutant forms to emerge from the potentialities of the materials. Jinks, in turn, is indebted to these materials for their generosity, and also to James Thompson, whose skills with leather complement his own. Thompson is indebted to the leather for its generosity. However, all of this effort would be to nought without the circumscribing bounds of the artworld, and in particular the opening provided by Piccinini's invitation to exhibit in the Venice Biennale. This event provided an opening in which to allow the work to come forward into appearance as *The Young Family*.

Finally we need to return to consider Piccinini's participation and responsibility for the work. Using Heideggerian terms, she simply 'starts something on its way into arrival' (QCT: 9). In her careful handling of ideas, human and non-human collaborators and contexts, Piccinini conceives the work, facilitates the networks of relations that allow the emergence of

the work, and finally brings together the pieces into appearance. In all this work, she is indebted to the other participators in the process. Heidegger would call this 'artistic and poetical bringing into appearance and concrete imagery ... a bringing-forth, *poiesis*' (QCT: 10).

Concernful dealings

Heidegger's reformulation of the artistic relation, as I have exemplified through reference to Piccinini's practice, can be interpreted as granting agency to both the human and non-human elements in the complex ensemble that constitutes artistic practice. Heidegger does not seem to be aware of the radicality of his suggestion. This omission may be partially historical. When Heidegger was writing 'The question concerning technology', between 1949 and 1954, the possibility of attributing agency to objects was, at least in the West, largely unthought. It was impossible for him to think outside this frame. The radical changes in techno-science that have reshaped the human-technology relation in our contemporary epoch have enabled us to think outside the paradigm that set humans as the standard for all causality.[5] This is, after all, the historical distinctiveness that distinguishes different ages from each other.

In the relation of care, responsibility and indebtedness that characterises production, the artist or craftsperson is no longer the sole creator or master of the work of art. Rather, the artist is co-responsible for bringing 'art' forward into appearance. Argued from this perspective, artistic practice necessarily involves a particular responsiveness to, or conjunction with, other contributing elements that make up the particular art-ensemble. It signals a different way of thinking about the precise state of the interminglings between humans and technology.

In our contemporary epoch, ecological necessity has re-awakened a concern to establish a different relation to the

technological. Heidegger's critique of technological thinking, and his ability to rethink the human relation to technology, offers us a way to configure differently the relations involved in art. We can begin to talk of 'skill with' rather than 'mastery over' technologies, materials and processes. According to such an interpretation of creative practice, Heidegger's re-visioning of the human–tool relation as one of care, indebtedness and co-responsibility could be seen to anticipate the relations in a post-human artistic practice.

Commentators have tended to focus much more on Heidegger's pessimistic prognosis of technological revealing, and have tended to overlook the radicality of his refiguration of the human–tool relation. However, I would suggest that his thinking challenges our current understanding of the artistic relation and enables a shift from an instrumentalist use of materials towards a notion of handlability and concernful dealings. It offers a different way of thinking about our relations with our tools, a way of thinking that ushers in a post-human 'understanding' of creative practice.

In this chapter, I have set out Heidegger's critique of the Modernist notion of the artist-as-genius and his reworking of causality as co-responsibility and indebtedness, in order to refigure the complex relation between human and non-human elements in the work of art. While Heidegger may not have anticipated the post-human, his call to rethink the relations between human beings and technology proves to be one of the most productive contributions to how we might figure a post-human understanding of the networks that enable the emergence of art.

Chapter 7

From aesthetics to ethics

Almost from the time when specialised thinking about art and artists began, this thought was called aesthetic. Aesthetics takes the work of art as an object, the object of *aisthesis*, of sensuous apprehension in the wide sense. Today we call this apprehension lived experience. The way in which man experiences art is supposed to give information about its essence. Lived experience is the source and standard not only for art appreciation and enjoyment but also for artistic creation. Everything is an experience. Yet perhaps lived experience is the element in which art dies. The dying occurs so slowly that it takes a few centuries. (OWA: 204)

The context

In 2002, Mongolian-born Qin Ga was one of a group of local Chinese and international artists involved in the Long March Project in China. In their 'walking visual display' tour, the artists set out to retrace the 9500 km route of the Mao Zedong's Long March of 1934–5 (see O'Reilly 2006). In following the route traversed by the Red Army, the project aimed to introduce contemporary Chinese and international art to the Chinese public, many of whom may never have been exposed to contemporary art. At points along the route, events, exhibitions and forums were held to create connections and engender dialogue between the artists and local communities.[1]

During the project, Qin remained in Beijing and had his tattooist, Gao Fend, record the progress of the trip as an annotated

map of mainland China tattooed across his back. While modelled on the Long March, the walking visual display tour didn't quite live up to its model. It was abandoned when the group reached Luding Bridge in Sichuan province, site of a significant battle between the Red Army and the Kuomintang forces in 1935. Qin's body-map remained incomplete. As a consequence, three years later, in 2005, Qin set out to complete the march. He set off from Luding Bridge, with tattooist Gao Fend and three camera operators, to follow the gruelling route to Yan'an. This marked the beginning of his *The Miniature Long March* (2002–5) (Figure 2). At each point of the journey, Gao Fend added to the tattoo on Qin's body. His mapped body, a mobile canvas, provided the prompt for people – villages, fellow-travellers and artists – to share and record their memories and feelings about the Long March and articulate the impact of its legacy upon their lives. Using the ethnographic methods of recording – photographs, daily diary entries, video and ephemeral items from the trip, *The Miniature Long March* creates art as an embodied social history.

In a catalogue essay written for the 5th Asia-Pacific Triennial of Contemporary Art, Ross Gibson describes the Long March Project as transformative at both the social and at the personal level. What begins at a personal and emotional level for each participant is transformed into a 'social dramaturgy', in which communities have been motivated to work together for change.

Gibson's essay links the two terms 'aesthetics' and 'politics' to discuss a new form of political art. Unlike much political art of the late twentieth century, however, this new form delivers no polemical message. Rather, Gibson suggests that it takes a form that begins with the senses and affect before it engages the intellect. He uses the term 'aesthetic politics' to describe this new form of political art:

Aesthetics and politics are not often so closely conjoined. In the dictionary definition, aesthetics are concerned with everything that's

2. Qin Ga, *The Miniature Long March* (2002–5).

'perceptible by the senses'. Which is to say, an aesthetic experience occurs first in the nervous system. An aesthetic experience starts with sensations in the body, providing matters to be contemplated by the intellect, with the effect that your aesthetically induced *ideas* are deeply felt because you have been moved to think, moved by the sensory impact of the artistic encounter. Sensation has led to cognition. Conviction has been prompted by emotion. In this movement, there's transformation, which is the first step in political effectiveness. Moved by the aesthetics, you feel an urge to engage intensively with whatever experiences the world might offer. Let's call this politics.

This is why art continues to be so important in everyday life. It can give you more than a thesis, more than a polemic message. It can put you through directly felt changes. Indeed, if a project claims to be political art but it causes no palpable difference within your sensibility, well it lacks the aesthetic dimension and it probably doesn't deserve to be called art. (Gibson 2006: 18)

For Gibson, aesthetic experience involves a sensory experience. It 'starts with sensations in the body … aesthetically induced *ideas* are deeply felt' because we are moved to think. Thus Gibson argues that art continues to be important to everyday life today because the aesthetic experience is an affective and affecting experience that moves us to action. He suggests that *The Miniature Long March* did precisely that. Qin Ga's tattooed back provided the aesthetic experience or impetus for the villagers to draw on their personal experiences and share their memories, stories, photographs and memorabilia of the Long March and its aftermath. Through this shared dialogue, he claims, a collective rather than an individual transformation occurred.

Heidegger's anti-aestheticism

Heidegger presents his case against aesthetics in 'The origin of the work of art' and in *Nietzsche*, vol. I: *The Will to Power as Art* (1981). The resurgence of interest in aesthetics at the beginning of the twenty-first century, such as in political aesthetics, carries a

different inflection than the Modernist aesthetics that Heidegger was so critical of in 'The origin of the work of art' and in *Nietzsche*. The 'new' aesthetics locates the aesthetic experience in the relations and transactions between participants (both human and non-human) engaged in the work, rather than in the enjoyment of a material object or artwork. Nicholas Bourriaud's (2002) theorisation of relational aesthetics and Michael Serres's (1995) network-inspired processual aesthetics have laid the foundations for the refiguration of aesthetics, and such global events as Documenta XI (2002) have established the political, ethical and collective possibilities that have led to the conjoining of politics and aesthetics in a political aesthetics. Here, aesthetic experience is not the sensuous apprehension of an art object by an individualised art viewer or connoisseur. Aesthetic experience is concerned with relations and connections. Aesthetic value is established through the effectiveness of these connections.

This is not a turn of events that Heidegger could have envisaged in the 1930s when he set out his critique of aesthetics and asked whether art was still 'an essential and necessary way in which that truth happens which is decisive for our historical existence' (OWA: 205). He was writing in the aftermath of Hegel's lectures on aesthetics in Berlin in 1928–9, in which Hegel proclaimed the end of great art. For both Hegel and Heidegger, thanks to the aesthetic framing of art, art was no longer the essential way in which the 'truth' of being was revealed to us. They believed that where art was no longer the bearer of truth, there was no longer a necessary place for art. Where art is no longer a need, argued Heidegger, it comes to 'exist as works only for the enjoyment of a few sectors of the population…It is proof that art has lost its power to be the absolute, has lost its absolute power' (NI: 85).

Here we may pause to stop and think. Did Qin Ga's *The Miniature Long March* reveal a truth to those who were 'touched' by the experience of the artist passing through their village? Do other works 'framed' by relational aesthetics transcend mere

enjoyment? Does the revitalisation of aesthetics as political aesthetics once again provide art with a necessary and essential way in which truth can happen, or do Hegel's and Heidegger's pronouncement of the death of art still ring true for us today?

Heidegger's critique of aesthetics stems from his assessment that modern art had become disconnected from life. He contrasted modern art with an earlier (pre-Socratic) ethical conception of art, where art was seen as providing a guidance to how we can live, and argued that this had been displaced by a conception of art that is related to sensuous apprehension, that is experience. Heidegger argued that it is precisely because art as experience is no longer connected to, or provides a guide to, how we live life that an aesthetic conception of art has brought about the death of art. Where experience provides the standard not only for art appreciation and enjoyment but also for artistic creation, he believed it is the element in which art dies.

While Heidegger agreed with Hegel's claim that great art is a thing of the past, he was not as pessimistic as Hegel. He saw a possibility for the return of great art. For Heidegger, 'great art' does not mean 'high' as opposed to 'low' art; it is not art that has been written about by art historians and theorists or lauded by critics. His definition of 'great art' derives from his definition of the essence of art, and is that art which makes a difference to the everyday lives of people, provides an ethical basis for understanding our being-in-the-world. Great art is great because it has world-historical significance and because it accomplishes an important task: 'it makes manifest... what beings as a whole are' (NI: 84). Thus, for Heidegger, great art plays a decisive role in that it opens up 'the truth of beings as a whole, i.e., the conditioned, the absolute' (NI: 84), so that in its 'truth-disclosing' character it provides guidance for how to live in a particular historical context. Thus what makes art great is not a question of the quality of the artwork, but that it is an absolute need (NI: 84). As absolute need, art is tied to an ethics of life.

An ethical conception of art

Heidegger's appeal to a return to an ethical conception of art can be contextualised in terms of his championing of the early-Greek apprehension of art and life. Despite the rich flowering of artistic activities during the early-Greek period, Heidegger tells us that the pre-Socratic Greeks had no need of a theory of art. In living life, as we will recall from Chapter 3, they did not preconceive their world representationally (which is what a theory of art does) but remained open to what-is. Their attitude was grounded in an openness and exposure to that-which-lies-before (*hypokeimenon*). This allowed the truth of beings to be revealed to them. For the pre-Socratic Greeks, truth was not correctness, as in modern science, but involved a bringing-forth of what-is. In this, art and craft 'along with all other modes of "truth"-disclosure were *techne*, not as making but as a mode of knowing. It was this "truth"-disclosing capacity that enabled art to provide a guide for the Greeks on how to live life' (see Young 2001). Greek society offered an ethical rather than an aesthetic conception of art.

While in the Greek epoch art was inextricably linked with an ethical conception of life, Heidegger believed that in the modern epoch art no longer plays that role either for the artist or for the culture as a whole. This is what he means by the death of great art. In *Nietzsche* vol. I, Heidegger argues that the displacement of an ethical conception by an aesthetic conception of art led to the death of great art. This death begins with Plato and culminates in the ascendancy of aesthetics as the specialised discipline concerned with knowledge about art and artists in the eighteenth century.

Heidegger suggests that it is during the time of Plato and Aristotle that theorising about art begins. While the term 'aesthetics' was not coined until the eighteenth century, Socratic Greek thinking sets the parameters for all future theorising and enquiry into art. Heidegger identifies the conceptualisation of art as the transformation of matter into form (*hyle–morphe*) and Plato's conceptualisation of ideal form as *eidos* (idea) as two

inter-related and critical developments in thinking about art that worked to undermine an ethical conception of art.

The basic distinction that the Greeks made between unformed matter (*hyle*) and form (*morphe*) still informs much of our thinking about art making. It is through the artist's formative actions that unformed matter is transformed and takes a form. This is the form–matter structure that we discussed in the previous chapter. Heidegger acknowledges that such a way of thinking about art is very persuasive. Where art is concerned with the transformation of matter into form, *techne* comes to be understood as a mode of production (making or manufacturing) rather than a mode of knowing or disclosing. As a mode of production, humans get caught up in art as production and a mode of mastery. Where the word 'art' once meant 'the human capacity to bring forth...and more originally as a knowing' (NI: 82), it came to mean the production or making of beautiful objects. A puzzling question emerges from this discussion. How does this conceptual form of matter–form (*hyle–morphe*, *materia–forma*) relate to beauty and the beautiful? How is it that aesthetics came to be concerned with questions about value and beauty?

Beauty and truth

Beauty is a term that is so much part of our modern vernacular that we rarely ponder over its origins or meaning. While at times we may talk about 'inner beauty', by and large when we talk about beauty and the beautiful we are referring to the outward appearance of something or someone. Something or someone is beautiful if they are attractive, lovely, pretty or exquisite to look at. However, Heidegger explains that the seemingly logical connection between beauty and outward appearance is not a given. The connection arises through Plato's elaboration of *eidos*.

We recall from the discussion in Chapter 3 that *eidos* is Plato's term for the immutable transcendent form that can only be

apprehended or 'seen' by the intellect, that is by human reason. In Plato's philosophy, the ideal world of forms, the *eidos*, pre-exists any actual being. It is the template on which we model our reality. Everything in the world can only ever be an inferior model or copy of *eidos*. According to Heidegger's explanation, this 'ideal' becomes the model for our notions of beauty. The ideal is the beautiful. Thus Heidegger notes that by 'the way of the idea, the work of art comes to appear in the designation of the beautiful as *ekphanestaton*' (NI: 80). According to Heidegger, however, the notion of beauty as appearance came to supplant the early Greek understanding that beauty was truth. While the surface appearance remained, the 'resemblance' to ideal form or *eidos* was lost. Art as imitation can only ever be an imperfect copy of ideal form. This explains why Plato banished painters from the Republic.

Where we have come to understand beauty in terms of style, fashion and taste, Heidegger takes us back to the essence of the beautiful to demonstrate how wayward our conception of beauty has become. He tells us that the beautiful is 'nothing other than what in its self-showing brings forth that state' (NI: 78). Here, we need to move between the *Nietzsche* text and the epilogue of 'The origin of the work of art' in order to appreciate fully his argument. For the early Greeks, beauty does not merely exist in terms of the pleasure of the appearance of a thing, but when the truth of the Being of something is revealed. Beauty, says Heidegger, is 'this being of truth in the work and as work' (OWA: 206).

Qin Ga's *The Miniature Long March* may not be seen as beautiful in the commonsense way we understand beauty. However, from a Heideggerian perspective we could argue that it revealed the beautiful. It allowed something of the truth of Mao Zedong's march to emerge as villagers and fellow-travellers shared and recorded their memories and feelings about the march and articulated the impact of its legacy upon their lives. In a similar way, we saw in Chapter 2 that Homi Bhabha's encounter with

Anish Kapoor's *Ghost* revealed a 'truth' about perception in itself. The early Greeks would have understood this truth as beauty. What seems to us to be self-evident once struck the Greeks as strange and caused them to think and wonder. For the early Greeks, wonder is the beautiful.

While for the pre-Socratics the beautiful was related to the true, in modern times that association has been cleaved. The beautiful has become concerned with our appreciation and enjoyment of the appearance of a thing. The consequence, claims Heidegger, is that 'meditation on the beautiful in art now slips markedly, even exclusively, into the relationship of man's state of feeling, *aisthesis*' (NI: 83). The slippage from beauty as truth to the beautiful as an ideal may have started with Plato, but reached its completion in the eighteenth century with the modern age. With the ascendancy of reason and science, and the positioning of man as subject (*subiectum*) in relation to objects, humans used their faculty of reason to make judgements about questions of taste and beauty. Reason gave humans the capacity to envisage the ideal, and consequently model and shape the world of objects. Where the reason of human beings provides the measure of all things, art becomes mere experience. It can no longer provide the 'essential and necessary way in which truth happens which is decisive for our historical age' (OWA: 205). Art becomes aesthetic.

A short history of aesthetics

Aesthetics is a branch of philosophy that emerged in the eighteenth century during the Enlightenment. In the disciplinary divisions that grew out of this 'knowledge explosion', philosophy split into three different strands: logic, ethics and aesthetics. Logic became a branch of philosophy concerned with questions of the true, ethics became knowledge of human character and the good, while aesthetics was concerned with sense, sensation and feelings towards the beautiful. Where art no longer maintained an ethical function it became relegated to the marginal status of sensuous

enjoyment rather than offering something central to our lives. In this division, art no longer had any claims to truth.

While our contemporary understanding of aesthetics tends to be identified with Immanuel Kant's *Critique of Judgement* (1790), the term was first coined by Alexander Baumgarten, in his *Reflections on Poetry* (1735). Baumgarten was a follower of Descartes, but felt that Descartes's bias towards conceptual knowledge led to the exclusion of the aesthetic experience. Baumgarten argued that conceptual knowledge and logic could not take into account the type of 'clear but confused' cognition that takes place in our engagement with the literary and plastic arts. Baumgarten drew on the Greek word for sensation and perception, *aesthesis*, to set down systematically a theory of aesthetics.

In the Enlightenment's explosion of discursive knowledge, the arts of painting, sculpture and architecture became 'fine art'. As fine arts, they were drawn under the umbrella of aesthetics and became concerned with the production of the beautiful, as Heidegger makes this clear in tracing the history of aesthetics:

Aesthetics is that kind of meditation on art in which man's affinity to the beautiful represented in art sets the standard for all definitions and explanations, man's state of feeling remaining the point of departure and goal of the meditation. The relation of feeling toward art and its bringing-forth can be one of production or reception or enjoyment.

Now, since in the aesthetic consideration of art the artwork is defined as the beautiful which has been brought forth in art, the work is represented as the bearer and provoker of the beautiful in relation to our state of feeling. The artwork is posited as the 'object' for a 'subject'; definitive for aesthetic consideration is the subject–object relation, indeed as a relation of feeling. The work becomes an object in terms of that surface which is available to 'lived experience'. (NI: 78)

Heidegger is emphatic that where our lived experience sets the standard for art appreciation, enjoyment and artistic creation, art dies. Our own experience of the artworld may give credence to

Heidegger's position. We only have to go to gallery openings, visit galleries the day after an opening, or go to a classical concert to confirm Heidegger's concern that art exists for the enjoyment of a few, a cultural elite. And when art becomes concerned with spectacle or aesthetic enjoyment it no longer offers a model of how to live. Heidegger suggests that in the modern world, where science has gained dominion over truth, art has been reduced to a leisurely pastime, a sphere of cultural activity that might be seen to enhance the quality of life but certainly is not seen as fundamental or essential to it. For Heidegger, this has led to the slow death of art as something that is important to the way we live our lives. Thus we can conclude that aesthetics is the element in which art dies precisely because it reduces art to a cultural activity along with other cultural activities, such as sport, going to the pub, the movies, the beach or gourmet dining.

Heidegger's reservation about art as experience may be deduced from his criticism of Nietzsche's concept the 'will to power'. Nietzsche, Heidegger claims, sees 'art is the *stimulans* of life, something that excites and enhances life' (NI: 29). Heidegger calls this a 'physiology of art', arguing that 'to deliver art over to physiology seems tantamount to reducing art to the functional level of gastric juices'. He worries that where the apprehension of art is based on feeling or mood, art is at an end. Nothing can be brought to light or revealed in a throng of sensations. Here interpretation vanishes.

Ross Gibson's assessment of the value of 'aesthetic experience' provides a counter-perspective. Gibson is careful to highlight that just because an aesthetic experience starts with sensations in the body, it doesn't involve a collapse into sensation. He believes that the aesthetically induced *ideas* that result from such an aesthetic experience are deeply felt precisely because we have been moved to think, rather than just moved. Thus he argues that art continues to be important in everyday life, and acts as a motivation to action. Perhaps its role is not the 'guide to life' that

Heidegger envisaged, but nevertheless art ceases to exist for the enjoyment of a cultural elite and begins once again to have world-historical significance. However, while for Heidegger the truth in art involves the task of thinking and interpretation, Gibson's observations about the 'aesthetic experience' brings us to the question of the 'aesthetic state'.

In his treatise on aesthetic judgement, Kant identifies the distinguishing character of the aesthetic state as that of judgement. According to Kant, the aesthetic state required in order to make an aesthetic judgement is that of 'disinterestedness'. This is certainly something that we don't experience when we go to a football match or when we go to a rock concert. Disinterestedness does not mean lack of interest, but rather a setting aside of our practical everyday concerns in life in order that we can experience the work in itself. This may sound like Heidegger's notion of 'openness' to the being of the work, but disinterestedness is of a different order. The aesthetic attitude involves the contemplation of art free from our everyday practical concerns, fears and hopes. Thus it involves 'bracketing out' the connections an object or an artwork may have with life.

We recall that for Heidegger, Dasein is never a disinterested observer of the world, but thrown into the world to deal with and take care of things. Heidegger's concern with care as the fundamental state of Dasein may help explain why Heidegger has such disdain for the aesthetic attitude. Once the connection with the substance of life is bracketed out, all that is left is an artwork's formal aspects, it qualities and charms. It becomes harmless and ineffectual, or in Schopenhauer's words 'a sedative for life' (Kockelmans 1985: 60).

The reduction of art to its formal abstract qualities reached its height in Greenberg's formalism. As Modernism's foremost exponent, Clement Greenberg advocated a purity that called on each artform to pare back to its approach to the 'pure' and unique qualities of the medium. Greenberg argued that the task of self-

criticism became to eliminate anything borrowed from life or from any other artform. He advocated that

each art would be rendered 'pure', and in its 'purity' find the guarantee of its standards of quality as well as its independence. 'Purity' meant self-definition, and the enterprise of self-criticism in the arts became one of self-definition with a vengeance. (Greenberg 1992: 755)

Greenberg championed those artists – Morris Louis, Kenneth Noland and Jackson Pollock – whose abstract work focused on the qualities that were specific to painting: the flatness of the surface, the shape of the support and the properties of the pigment. In this conception, art had no other *raison d'être* than its formal abstract qualities. It had no claims to anything else. In high Modernism, art becomes about itself, and totally divorced from life.

The postmodern critique of Modernism, influenced by Heidegger among others, turns on this disconnection of art from life. Postmodern critics argue that value and beauty were not universal or transcendent qualities but were relative and culturally situated. Value judgements and the judgement of beauty were exposed as culturally and ideologically constituted (Eagleton 1990; Derrida 1982, 1987; De Man 1996). According to such critiques, aesthetics served to reinforce particular social and class structures and ideological positions rather than reveal any universal quality. In the swing from the universal to the socially constructed, aesthetic judgement became a term of derision; the question of 'value' became tied to the ideological.

An ethico-aesthetics?

Out of the anti-aestheticism of postmodernism has emerged a renewed interest in aesthetics. This new aesthetics, as we have indicated, is not concerned with mere sensuous experience, but returns to the etymological roots of the term *aisthetike* as the study of human behaviour in terms of sense, sensation and

feeling. What distinguishes contemporary aesthetics from earlier iterations of aesthetics is that it is now concerned with globalised life and politics. This can be seen in many contemporary art events and biennales, such as the 1998 Sydney Biennal, *Every Day*, Documenta XI and the 5th triumph Asia-Pacific Triennial of Contemporary Art, 2007.

Documenta XI exemplifies this shift from the apolitical aesthetics of Modernism to the potential for a global politically and ethically engaged aesthetics. Okwui Enwezor, artistic director of Documenta XI, set out that its aim was to engender direct political action in response to current global conditions. This 'new agenda' once again emphasises art as knowledge. Enwezor saw the Documenta XI as a forum in which artists and cultural theorists map out knowledge networks and develop tactics and strategies relevant to global conditions. Here we begin to see a collapse between 'art' and other forms of research, particularly those of the social sciences. This is a direction that Heidegger would caution against. He believes that in their efforts to theorise the acts of human beings, anthropologists, sociologists, political scientists, historians, philosophers and now artists get caught up in the ontic world of things and beings rather than offering insight into the Being of beings.

While Heidegger's assessment is pessimistic, he also holds out the belief that if art was reinvested with an ethical status it could provide the 'saving power' capable of confronting the destitution of the modern age. The aim of 'The origin of the work of art' was to re-establish the link between art and truth in the hope that his efforts might contribute to a rethinking of the role and value of art in Western society. Through this questioning of art, he hoped, against Hegel, that 'great art' might once again be seen to offer an insight into the historical distinctiveness of an age and become a critical way in which the Being of beings was revealed.

Could it be that political aesthetics provides the way forward, and can rescue contemporary art and thinking about art? While

there is a strong ethical dimension to the new political aesthetics, Heidegger would not necessarily see it as the saviour of modernity and art. It has become too much like anthropology for that. However, political aesthetics certainly offers a counter to the grip that art business holds on art. In re-asserting art's essence as answering an absolute need, rather than operating as a peripheral activity founded in pleasurable experiences for art connoisseurs, a political aesthetics does perhaps move us some way in this direction.

There is one further very important ethical dimension that we may draw from this discussion. In our technocratic era, where, as Heidegger has argued, humans have, like all other beings, been reduced to a resource, a political aesthetics once again offers an opportunity for beings to address their very Being. If a political aesthetics can negotiate the tension between traditional conceptions of aesthetics and an ethical dimension of art, it may offer an important counter to the technological enframing that has come to define contemporary life. This could prepare again for the coming of great art.

Chapter 8

Art-as-research

Knowing, as research, calls whatever is to account with regard to the way in which and the extent to which it lets itself be put at the disposal of representation. Research has disposal over anything that is when it can either calculate it in its future course in advance or verify a calculation about its past. Nature is being calculated in advance, and history, in being historiographically verified as past, becomes, as it were, 'set in place' ('*gestellt*'). Nature and history become the objects of representing that explains. Such representing counts on nature and takes account of history. Only that which becomes object in this way is considered to be in being. We first arrive at science as research when the Being of whatever is, is sought in such objectiveness.

This objectifying of whatever is, is accomplished in a setting-before, a representing that aims at bringing each particular being before it in such a way that man who calculates can be sure, and that means certain, of that being. We first arrive at science as research when and only when truth has been transferred into the certainty of representation. (AWP: 126–7)

Context[1]

In January 1999 David Hockney went to see the Ingres exhibition at the National Gallery in London:

I was captivated by his very beautiful portrait drawings – uncannily 'accurate' about the features, yet drawn at what seemed to me to be an unnaturally small scale... Over the years I have drawn many portraits and I know how much time it takes to draw the way Ingres did. I was awestruck. 'How had he done them?' I asked myself. (Hockney 2001: 21)

The experience of seeing Ingres's drawings became for Hockney the basis of a major research project that led to the publication of a book, *Secret Knowledge: Rediscovering the lost techniques of the old masters* (2001). Hockney's research question was a very simple one: how had Ingres achieved such uncannily accurate portraits at such a small scale in such a limited time? From his own experience as a drawer it did not seem possible that Ingres could have achieved such accuracy through direct observation and freehand drawing. In setting up his enquiry, Hockney followed a hunch that Ingres had used a camera obscura to make these drawings. In order to test this proposition, he set up an experiment in which he constructed a camera obscura and set about making technologically aided drawings with this device. Through an analysis of the qualities exhibited by his 'aided' drawings and the drawings of the 'old masters', and a detailed comparison with the qualities exhibited by unaided freehand drawings, or what he terms 'eyeballing', Hockney argued the thesis that from the early Renaissance, Western artists had not just been aware of but had relied on optics to create living projections. While previous scholarship had acknowledged the use of the camera obscura by artists of the time, Hockney set out to demonstrate its significance as an artist's tool and show how it had produced a paradigm shift in drawing practice in the early fifteenth century.

In Hockney's treatise, we recognise some of the key features of research – a research question, a hypothesis or proposition, a survey of previous research in the field, a methodology, a system for analysing results, and a discussion of results. The difference between Hockney's research and more established experimental research methods is his idiosyncratic experimental methodology, a methodology that had grown out of his studio practice rather than the 'tried and true' experimental methodologies that characterise such fields as science and social sciences, or alternatively the historiographic methods of art history.

A research culture

As we have seen in the previous chapters, science has become the discipline charged with responsibility for truth and knowledge. In the explosion of knowledge that accompanied the Enlightenment, logic became the specialised field of knowledge concerned with questions of truth, ethics was charged with knowledge of human character and the good, while art-as-aesthetics was relegated to the realm of 'mere' experience. It has only been in the late-twentieth and early-twenty-first centuries that art has once again emerged as a legitimate domain of knowledge production. This emergence has a complex history, but one of the key factors has been the institutionalisation of art in the academy.[2] Here, driven by the exigencies of the research culture, art-as-research has emerged as a specific field of research that aims to distinguish itself from other research fields.

The development of art-as-research, alternatively known as practice-led research and creative-arts research has changed what happens at art schools, art academies and art departments within universities. Artists not only make art, but also take on the role of artist-researcher and conduct research into art. The introduction of postgraduate studies in the creative arts has cemented the place of 'research' within our vocabulary.

This book is written at a time when art-as-research is in the process of drawing up its boundaries, defining its concepts and methodologies, and establishing its place as a field of research in a broader field of enquiry. Like the social sciences and humanities before it, the development of art-as-research has proceeded in the shadow of the research 'model' *par excellence*, that is science-as-research. In order to establish its credentials in research, the creative arts have been required to justify approaches and methods, and establish the validity of research findings.

What, then, is our object sphere and what assumptions underlie the discipline of creative-arts research? How, for example, might 'practice-as-research' develop as a mode of research that

deals with the ready-to-hand (*Zuhandenheit*), that is practical knowledge, rather than merely theoretical knowledge, or the present-at-hand (*Vorhandenheit*). What is our understanding of 'truth', what are the 'truth claims' that art-as-research can make? How does this compare with the truth of science-as-research? Heidegger's thinking about art and research offers both challenges and possibilities for our thinking about creative-arts research. His profound critique of science-as-research, which I draw out here, warns of the dangers that might befall the creative arts if it were, like science, to adopt an enframing revealing.

This chapter sets out the stakes involved in the development of art-as-research. It aims to bring together many of the concepts that have been developed through the book in order to address the questions that art-as-research raises. The chapter begins by providing a close exegetic reading of the critique of science-as-research set out in Heidegger's essay 'The age of the world picture' (1950). Then the chapter demonstrates how this critique of science could equally be applied to creative-arts research. Finally it sets out terms that enable the arts to find a way out of the *impasse* that faces science-as-research. It compares the 'truth' claims of science (the theory of correspondence) with Heidegger's notion of *poietic* truth by returning to Heidegger's distinction between *techne* as an enframing and *techne* as *poiesis*. In focusing on the importance of a *poietic* revealing instead of focusing on 'artworks' as objects of study, this chapter demonstrates a different and productive way of thinking of 'truth' in creative-arts research. In keeping with the earlier chapters of this book, the aim is not only to introduce key concepts but also to keep to the fore Heidegger's questioning mode of thought.

Science-as-research

In 'The age of the world picture', Heidegger begins his examination of modern science by stating that the term no longer means the same as it did in the Middle Ages or in early-Greek times. In such

times, science was designated *episteme*, the study of or the theory of knowledge.[3] While for the Greeks *empeiria* (*experimentia*) involved the observation of things in themselves, experiments in modern science begin with the laying down of a law, the setting out of controlling conditions and the establishment of a ground-plan. Where Greek science was concerned with knowing, as such, the essence of modern science is research (AWP: 118).

Heidegger identifies three key characteristics that differentiate science-as-research from this earlier conception of science as knowing – procedure, method and self-perpetuating ongoing activity. Taken together, these three qualities have enabled science to gain hegemony as the model of knowledge production in a technocratic era.

'Procedure' sketches in advance a ground-plan that provides the shape and gives form to science-as-research. Procedure includes the standardised research procedure that the researcher will follow in order to produce research, an established 'peer review' system for evaluating the 'truth' claims of the research and a system of disseminating the findings of the research. In the use of such phrases as 'sketches in advance' and 'ground-plan', Heidegger sets out how science-as-research carries with it a set of assumptions and procedures that structure and bind the research process.

The ground-plan 'sketches in advance the manner in which knowing procedure must bind itself and adhere to the sphere opened up' (AWP: 118). The standardisation of procedures ensures that corroboration of results can be made between studies. Through the standardisation of procedure, other researchers are able to replicate the study in order to validate results from research. It is this correspondence between the results of studies that allows science to make its 'truth' claims. This is one aspect of what Heidegger sees as the 'binding adherence' that constitutes the rigour of research and establishes the validity of its 'truth' claims.

The second characteristic of science-as-research is method. Each discipline or domain of knowledge in the sciences and social sciences – physics, anthropology, psychology, geography, biology, mathematics – adheres to a particular object-sphere about which it holds assumptions (which include conditions) that set up how we can know what-is. The discipline also provides the 'methodology' by which the research can and does proceed. It sets out what research the discipline can conduct, and how its researchers conduct the research. In the physical sciences, for example, where experimental methodology is employed, the experiment is conducted in the light of a fundamental law that has been *a priori* established. This law provides the ground on which the experiment will proceed. The role of the experiment is either to confirm or refute the law. However, Heidegger argues that the prescriptiveness of the scientific methodology is part of the problem. It is an enframing way of knowing. This 'method' creates circularity: the experimental method accounts for the unknown by means of a known and verifies the known by the unknown. Thus, in contrast with Greek understandings of science as observation of things in themselves, Heidegger argues that science-as-research is never a careful observing of things, but rather a testing of the unknown in terms of the already known; a confirmation or refutation in terms of a law already established and set-in-place as representation.

The third feature specific to research is that it operates as 'ongoing activity'. It is through this that it establishes its credentials and creates a self-perpetuating industry. We see this ongoing activity in the research institutes, research output, books, refereed journals, online journals and conferences, and in the ongoing research focus of universities and academies. Peer review is part of this cycle. It enables research to establish the 'truth' of its claims through its history of activity and rigour.

The aim of all this activity is concerned with the perpetuation of the discipline. As a consequence, Heidegger argues that ongoing research establishes a self-perpetuating

activity that is no longer concerned with observing things in themselves but becomes instrumentalist in its 'in-order-to' quality. It is concerned with producing snapshots or pictures of the world as data. Heidegger suggests that in all this ongoing activity, humans use their 'unlimited power for calculating, planning and moulding' as an essential way of establishing self in the world (AWP: 135).

Truth claims

Science's claim to truth lies in its procedures, methods and ongoing activity. Through systematic procedures and replicability, science can lay claim to objective truth. Here truth is seen as correspondence. The creative arts, in contrast, are often criticised for the subjective and emergent quality of their research. Hockney's methodology is a case in point. The initial question that drove Hockney's research arose out of a disjunction between his understanding of the possibilities of drawing and the disbelief he experienced when viewing Ingres's (1829) drawing of Madam Godinot. His hunch and subsequent visual hypothesis about Ingres's drawings derived from his experience in using projection devices and photographic technology in his own drawing practice. It was on his experience as a drawer that he predicated the particular methodology he developed to test his observations in the laboratory of drawing. Finally, Hockney focused on particularity, rather than a generalisation, to examine his proposition.

Creative-arts research often seems nebulous, unquantifiable and untestable: its procedures and methods emerge in and through the work, rather than being prescribed in advance by the discipline. In the academic world, at least, the creative arts are seen to lack credibility because the methods cannot be replicated exactly, and correspondence in findings between studies is not a goal that is valued. Hence creative-arts research does not meet the standards of 'objective' truth that enables it to make truth claims acceptable to science.

The equation of objectiveness or objectivity with truth (through measurement and calculation) has become the hallmark of the tradition of science-as-research. It is also the goal of other disciplines attempting to set themselves up as players in the research field. Thus it is around the questions of 'truth' and truth claims that we may begin to set out the stakes involved in research and begin to differentiate science-as-research from the domain of study that has assumed the name 'art-as-research'.

In previous chapters we have discussed Heidegger's understanding of art as 'truth' as revealing or unconcealment. However, in a technocratic world we have come to understand that the truth is concerned with correspondence and correctness – a conformity between matter (what we observe) and what we know (knowledge). Propositional truth, Heidegger tells us, has always been in correctness. Truth as certainty is just a variation of a theme. The contemporary view of truth that holds sway in the modern age derives from Plato, and entails defining truth in terms of specific criteria that are used to establish truth or falseness. Truth is defined in terms of propositional truth. This is the form of truth that underpins science-as-research.

Research procedure

Sketched crudely, the plan according to which science-as-research operates follows a similar pattern. As we have seen, the research process involves the researcher identifying a research question to define the research. The researcher conducts a literature survey to 'map' the research done in the area and establish the precedents in the field. From the analysis of research in the field, the researcher identifies a gap in the field and proposes a hypothesis or proposition. His or her disciplinary knowledge enables the researcher to set out an appropriate approach and a methodology in order to test the hypothesis. Through the established methodology, the researcher sets up experiments, interviews and surveys to collect data for analysis. Finally, analysis of the 'facts'

gathered will either verify or falsify the hypothesis or proposition. Once the results have been written up, the research is sent out into the world of peers to be tested against the disciplinary regime.

In the world of science-as-research, truth claims always exist within the parameters of specific rules and conditions that have been defined in advance. This provides a frame or a framework for what and how a question can be put. According to this methodology a proposition is either true or false; there can be no degrees of truth or untruth. Heidegger observes that this regime of truth establishes humans at the centre.

Heidegger's questioning of science's claims to an 'original' truth, and how it establishes this 'truth', go to the heart of the critique of science-as-research. For Heidegger, what is at stake in this investigation is how modern science (as reflective of the thinking of the modern age) frames how we know and understand what-is. He argues that modern science's procedures and methods have led to an objectifying and enframing of the world as a resource for man as subject. Heidegger takes issue with our contemporary understanding of truth and our habit of seeing modern science as more correct and more progressive than earlier forms of science.

Heidegger's argument with science-as-research

Heidegger's argument proceeds on the premise that research is the mathematisation of knowledge, a mode of thought that preconceives its outcome. Following Descartes's understanding that science proceeds from a universal order that anticipates the particular, Heidegger suggests that the conditions that define an experiment are anticipated by a law that has already been set in place.[4] We have seen this in science's procedures and methods. Science-as-research proceeds through the delimitation of spheres of objects and laws that prescribe in advance what is to be known. Thus, he says, 'to set up an experiment means to represent or conceive (*vorstellen*) the conditions under which a specific series

of motions can…be controlled in advance by calculation' (AWP: 121). In this conception of scientific methodology, a framework is set in place, and it is this framework that enframes.

The assertion that modern science-as-research is enframing provides Heidegger with a context in which to develop his critique of representationalism as an objectifying mode of thought. The methods of science enable us to witness, first hand, the reduction of what-is to objects. These objects are in turn reduced to standing-reserve. As standing-reserve, objects exist in their readiness for use by man, representing subject. Things in the world exist 'out there', ready to be collected, quantified and calculated, turned into representations, so that man may use them in his quest to master the world. Where there is an object for study there is a subject who studies. The world and everything in it becomes an object for man as *subiectum*. In this, man becomes the measure against which all things are measured.[5]

Heidegger explains that while it was the Sophist Protagoras who said that 'Man is the measure of all those things' (AWP: 143), the early-Greek experience did not equate to the Cartesian *cogito*. In using the term 'measure', Protagoras did not anticipate the measurement and calculation that characterises modern science. Heidegger suggests that the Greek relationship to what-is needs to be understood in terms of the horizon of unconcealment. In unconcealment, there will always be that which remains concealed beneath the horizon. Thus, when Protagoras talks of 'measure', he is not meaning a calculation that can be quantified. He recognises that we can never know everything. While the modern view is that there are no limits to what science can know, the Greeks understood that in unconcealment there will also always be concealedness of what-is (AWP: 146). In truth (unconcealment) there is untruth (concealment).

This early-Greek view of being-in-the-world contrasts with the modern human wish to know and control everything. We will recall from Chapter 3 that in the modern world the human as

subject (*subiectum*) is the one who looks upon the world rather than being-in-the-world.[6] Through the methods of science, humans as researchers have come to believe that they can gain mastery over everything. The consequences of this are to be found in our understanding of and application of science-as-research and art-as-research: 'There begins that way of being human which mans the realm of human capability as a domain given over to measuring and executing, for the purpose of gaining mastery over that which is as a whole' (AWP: 132). Heidegger's analysis reveals to us the way in which modern humans view and interact with the world.

Even prior to the advent of art-as-research, the visual arts were not immune from this objectification, this obsession with measuring and executing with a view to gaining mastery. The structure of subject/object relations, for example, appears to be fundamental to many artistic practices. In mimetic drawing, for example, we (as the active subject) set an object before us and render it as a representation. In photography or film, we frame and make representations of the world out there. In research, this objectifying of what-is, becomes codified in the research procedure, the methodology and in ongoing research activity.

Heidegger believes that science-as-research (and by association art-as-research) is achieved when the Being of whatever is objectified. By objectification, Heidegger means 'a setting-before, a representing, that aims at bringing each particular being before it in such a way that man who calculates can be sure, and that means certain of that being' (AWP: 127). We first arrive at science-as-research (or art-as-research) when and only when truth has been transformed into the certainty of representation.

The fundamental objection that Heidegger has to research revolves around this treating of entities as objects of theoretical investigation (that is the present-at-hand) out of context. Research produces an attitude of 'deficient concern', whereby we come to treat things as objects of scientific enquiry and

entities as statistics with characteristics that can be measured and quantified. Further, the ready-to-hand becomes an object for human use. In this way research promotes an instrumentalist way of seeing the world.

When we conduct research we engage in establishing objects of enquiry and finding ways of presenting and explaining these objects in a thesis. Thus the knowing-subject/object-known constellation, which creates the world as an object for man, is most pervasively found in the form of science-as-research. In the laboratory, in social-science surveys and other modes of research, beings are transformed into marks on paper – tables, graphs, illustrations – thus dispensing with complex lived reality. As a re-presentation, Being as what-is is set aside. Being becomes technical. The 'picture' we are left with is one of alienation from Being.

Thus for Heidegger, objectification and mastery go hand-in-hand with representation and representationalism. Through its ability to reduce everything to an object, science-as-research enframes us; it sets a limit on what and how we think and how we interact with the world. Representationalism reduces the fecundity of the world. Thus his critique is not a critique of mimesis, but rather a critique of a mode of thought that arises through the reduction of the world to an object.

Art-as-research

Those of us engaged in creative-arts research will recognise that the general structure of science-as-research has been adopted by the creative arts. We see its evidence in research-methodology courses in our postgraduate studies. What is our object sphere and what assumptions underlie the drawing up of the discipline of creative-arts research? What is our understanding of 'truth', what are the 'truth claims' that art-as-research can make? What are the consequences of art-as-research as an ongoing activity? The answers to these questions confirm that the legitimacy of

art-as-research is tied to the quantitative methods of science and the qualitative methods of the humanities.

Heidegger's argument that knowing as research 'calls whatever is to account…it lets itself be put at the disposal of representation' (AWP: 126) reminds us that art-as-research, like science-as-research, has a propensity to frame what can be known and seen. In this reduction of research, art-as-research has the potential to become subject to an enframing revealing. From our earlier chapter on technology we will remember that the problem with an enframing revealing is that it threatens to drive out every other way of knowing. How, in the light of the dominance of science as the model of research, can creative-arts research operate without falling into an enframing knowing?

While science has gained exclusive rights over truth, Heidegger argues that art, not science, is an original happening of truth. We have already seen that where truth is figured as correspondence and correctness, assumptions about truth exists beforehand rather than being revealed as a process through which there is concealment and unconcealment. In science, Heidegger observes, 'truth is the cultivation of a domain of knowledge already open' (OWA: 187). The question for the creative arts remains: how can we understand creative-arts research as an original happening of truth?

Unlike science, which has set in advance an object-sphere specific to its discipline and defined its specific methods and modes of analysis, the approaches taken in art-as-research, such as in studio enquiry, often contradict what is generally expected of research. Art proceeds on the assumption that we can never know the outcome in advance and that knowledge is emergent rather prescribed. In this world the 'truth claims' of the creative arts take on a different hue. Heidegger's elaboration of praxical knowledge provides us with a way of conceptualising this.

Practice-as-research is a mode of research that deals with practical research or the ready-to-hand (*Zuhandenheit*) rather

than what is present-at-hand *(Vorhandenheit)*, that is theoretical knowledge. In the chapter on praxical knowledge we came to understand that, for Heidegger, the world is discovered through our involvement with or handling of the ready-to-hand. In practice, the emergent nature of revealing requires that the artist-as-researcher be attentive to what emerges in and through handling, rather than preconceive what will happen. This involves attention to things in themselves. Thus it is through dealing with or handling entities in the world that the nature of the world is revealed in an original and originary way. This is the horizon of unconcealment.

For Heidegger the primary ground for understanding truth derives in the first place from *physis* and *poeisis*. In art as *poiesis*, original and originary truth happens. Truth is not propositional, but rather truth is existence as it unfolds. We recognise this unfolding, which brings something out of concealment forth into unconcealment, as *aletheia*. It is not the presentation of 'established facts' that creates truth, but rather truth emerges through practice. Truth is something that happens as a process rather than something that can be assessed as true or false. It is this notion of truth as process that becomes central both to Art in itself and art-as-research.

Contemporary philosophers of science, for example Donna Haraway and Bruno Latour, have recognised that truth can never be objective. Like Heidegger, they have argued that all knowledge is revealed within the context of existence. Haraway calls this 'situated knowledge' (see Haraway 1990). She dismisses the claims of 'objective truth' in science-as-research as the 'god trick', and demands that modern science accept that truth is local and situated.

Recognition of 'situated knowledge' as a foundation for truth in research brings us much closer to a Heideggerian position. Here the truth of beings is disclosed to Dasein through direct practical experience. This does not mean that Dasein determines truth.

Rather truth is revealed to Dasein. Thus we saw that the 'truth' or Being of a hammer was revealed to Dasein through use, rather than as observation of the theoretically present-at-hand.

Thus we can draw out three concepts that are central to how we may understand art-as-research or practice-as-research and distinguish it from science-as-research. Firstly, truth is a revealing or unconcealment rather than the establishment of truth as correspondence. Secondly, truth emerges in and through practical engagement with things in the world (the ready-to-hand) rather than through theoretical contemplation (the present-at-hand), and finally, the place where truth emerges is a clearing. Truth is an ongoing process, not a measurable outcome.

'Always between us'

In her practice-led master's research project, 'Always between us: bodies, boundaries and liminal space' (2007), visual artist

3. Michele Elliot, *The Dressers (Slip, Skirt and Hoop)* (2005–6).

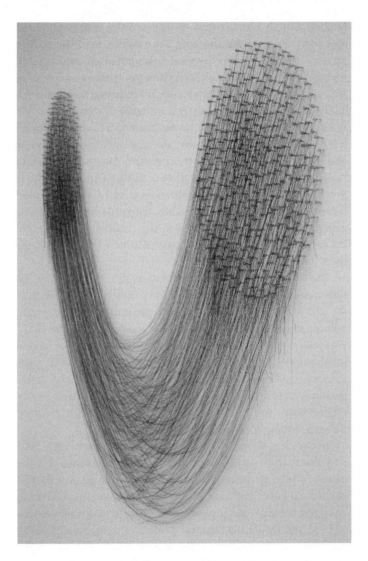

4. Michele Elliot, *Hemispheres:*
Drawn to you (2006).

Michele Elliot's observations on her practice demonstrate the operation of these three concepts. She observes that 'The work of art is a linking process between boundaries of thinking and making' (Elliot 2007: 59). Elliot defines the work as a process as well as a manifestation of a process, commenting that while the 'body of art' provides the physical evidence of that process, the work of art 'comes to occupy a liminal position, a space in between' (Elliot 2007: 2, 59). In this process, the relationship between ideas and materials becomes a central concern. 'Making is a way of finding out, a working through and thinking in materials. It provides the passage, the transition from one state to another' (Elliot 2007: 2). In this relationship, materials are not passive resources to be used by humans in the shaping of an artwork, but rather there is a reciprocal inter-relation in which 'we shape them as much as they shape us'.

The body of work in 'Always between us' reminds us of the reflexivity of the work of art. Creation is not only the domain of the artist, but rather evolves in the powerfully charged social relation of conversation between tools, materials and the artist. We recall that in createdness, the artist is co-responsible for and indebted to the other collaborators in the process for the emergence of art. Elliot constantly acknowledges the active meaning-making qualities of her materials and her tools in this conversation. Her understanding of these qualities emerged through 'handling' these materials.

In choosing to work with plywood in *The Dressers* (*Slip, Skirt and Hoop*) (2005–6) (Figure 3), for example, she discusses the qualities that different materials bring to the project: 'Metal seemed too heavy and loud, plastic too brittle. Wood appeared to be a good solution, and plywood even better in that it allowed me to bend and mould the material to my own ends. As a material, plywood is pliable and reasonably strong' (Elliot 2007: 45). In *The Dressers*, Elliot talks of 'bending and moulding the wood to her ends'. However, she found that as the 'research' progressed, she

became more attentive to 'things in themselves', rather than what they could do for her. Thus in the later work, *Hemispheres: Drawn to you* (2006) (Figure 4), Elliot recognised the work's indebtedness to the being of the cotton thread and the wooden dowels.

While the 'subject' of her research was concerned with the liminal space created by shifting boundaries between thinking and making, Elliot observed that the process of the research shifted and expanded the boundaries of what she had originally set up, constantly testing her aims and intentions' (Elliot 2007: 57). She identified that the research did not follow a linear or direct progression, but was an unfolding that opened up future possibilities.

In her exegesis Elliot compares her own journey with a coincidental journey that her mother had taken. In this story, her mother returned to the city where she was born and had lived as a young woman:

What had always existed within the boundaries of my imagination began to move out into the world of lived experience as I walked the city and watched my mother become that young woman. I was astonished to hear her begin to reconstruct worlds into a fluency of language that she thought she had forgotten. It was one of the many surprises and revelations that could only have come to light through making the journey. (Elliot 2007: 57)

This was the horizon of unconcealment for both Elliot and her mother. Here we return again to Heidegger's notion of thrownness. In taking on the research process, like her mother returning to her birthplace, Elliot was thrown out of her past. From the possibilities that the world (her research project) threw up to her, Elliot seized possibility in its possibility, and through this 'projected' into the future. Elliot drew on her past experiences, dispositions and skills to set up possibilities for what would become. Elliot's past, and her mother's, is not past but is here

shaping our now, and what we do now, and projects into our future. However, we remember that our thrownness is not over now, nor will it be in the future. As Elliot notes, 'As I consider the outcomes of both the research paper and the studio work and conclude this project, I do so with the knowledge that much of this research will carry me forward beyond this degree through ongoing work in the studio' (Elliot 2007: 57).

The exegesis or dissertation

Writing up the research paper allowed Elliot to understand and articulate what had emerged from the process. 'The logic comes after the event,' claims Katy McLeod in her writing on the PhD exegesis (McLeod 2007). The writing that emerges in creative-arts research as distinctive and complementary aspects of art-as-research is one way in which these truth claims can be made. Heidegger stresses this 'value' when he introduces the importance of language, commenting that 'language, by naming beings for the first time, first brings beings to world and to appearance' (OWA: 198).

In creative-arts thesis, it is through the exegesis or dissertation that language brings to appearance. Here it is important to remember the Greek sense of the word 'thesis', as 'a setting up in the unconcealed'. From Chapter 2, we understand that this involves creating a clearing in which the being of what-is can be brought forth into appearance. Heidegger reminds us that the bringing-forth of *poiesis* contrasts with science, which only occurs in a clearing that has already happened. Scientific objectivism involves a standing-over-against that sets things in place, while *poiesis* allows things to appear as present in themselves. Thus, by bringing the Greek understanding to our thinking about creative-arts research, we may come to propose that creative-arts research thesis is a presencing, rather than a standing over against. If we bring this understanding to bear, then our thesis will not be an objectification that fixes the work in place as something rigid,

motionless or secure. Elliot's reflections on her research process demonstrate that in art-as-research, the artwork does not have the character of an object for a human subject. Through our practical engagement with it, art becomes a living process through which a 'situated' truth is unconcealed.

Heidegger's initial question concerning the difference between research and the study of knowledge provides a cautionary tale for creative-arts research. The study of knowledge derives from a careful observation of things in themselves, while research establishes procedures and methods which are put into operation in an ongoing manner to produce objects of knowledge and verifiable facts. Heidegger is adamant that art offers us this saving power because it is not as reductive as science-as-research. However, at a time when art practice has increasingly taken on the quality of research, we are faced with an ultimate danger. If we take the view that art is research, it could be argued that the artist, as much as a scientist or bureaucrat, looks upon the world as standing-reserve. Through their ability to model the world, they secure the world for their own use. The challenge for the artist is to resist the temptation to preconceive the work of art, an approach which does not allow a space in which the Being of the work can reveal itself. Alternatively art becomes reduced to a resource for the artist's ends.

Heidegger worries that with research the scholar disappears, only to be succeeded by the researcher who is engaged in research projects (AWP: 125). Similarly with art-as-research, it could be argued that the artist disappears and is succeeded by the artist-researcher who is engaged in projects. We no longer make art but rather carry out projects. This tendency is not just found in the academy but is also evident in the artworld and in the funding of the arts. Artists apply for project grants, and funding agencies fund projects rather than artists or art. In all this ongoing activity Heidegger believes that we get caught up in a particular way of knowing that is an enframing. We forget what Art is in itself. In our

projects – research projects or artworld projects – we are in danger of getting caught up in art business.

Art-as-research can be seen to threaten the Being of art. Firstly, the danger is that it, like science, becomes representationalist. In its guise as representationalist, art-as-research comes to illustrate theory rather than open a question. Secondly, it is because the creative arts have their own 'ways and modes' of revealing that art-as-research may be seen to compromise the very integrity of art. As we go about the business of art-as-research, we need to remember Heidegger's assessment that artworks 'remain their own ways and modes in which truth directs itself into the work. They are an ever special poetising within the clearing of beings which has already happened unnoticed in language' (OWA: 199).

Conclusion

I cannot imagine what Heidegger would have thought about my strategy of framing the discussion of *Being and Time* around Sophie Calle's *Take Care of Yourself*, or my application of the example of making a silver chalice as a model and a way of thinking through the notion of post-humanism. We cannot envisage Heidegger's reactions to Anselm Kiefer's large industrial-scale sculptural practice or what he would have thought about Damien Hirst outsourcing the production of *For the Love of God*. Qin Ga's *The Miniature Long March* would no doubt have provided a challenge to Heidegger's thinking about the relation between art and life. However, the one thing that I am convinced of is that Heidegger's thinking on art and his questioning of science-as-research holds very important lessons for our thinking about contemporary art.

Through his questioning, Heidegger provides us with a way forward in our enquiries into the Being of art *now*. Through these chapters I have attempted to demonstrate the generativeness of his proposition that any real 'movement' in understanding must take place through our capacity of enquiry putting basic concepts in crisis rather than defending them. *Heidegger Reframed* takes on this challenge. However, in order to set up this enquiry and address the question, we must first be able to formulate the question adequately. That is the most difficult of things.

Notes

Introduction

1 Two valuable framings of Heidegger's writings on art are Kockelmans (1985) and Young (2001).

Chapter 1

1 Michael Watts (2001: 46) coins the term 'I care therefore I am' to describe Heidegger's thinking on the centrality of care to his notion of human Dasein.

2 See Angelique Chrisafis's report on Sophie Calle's art and life and her exhibition *Take Care of Yourself* at the 2007 Venice Biennale: Chrisafis (2007).

3 Such internet activities as blogging and the phenomenon of MySpace and Facebook take everyday personal experience as their subject and their mode.

4 While Calle's work is concerned with the everyday, it differs from Tracey Emin's *My Bed* (1998), in that while *My Bed* offers a raw view onto Emin's everyday life, albeit in a gallery context, Calle's *Take Care of Yourself* offers a meta-commentary on the everyday that takes it to the level of anthropology.

Chapter 2

1 Arthur Danto's essay 'The Artworld' was first published in *The Journal of Philosophy*, no.61, 1964: 571–84. I have drawn on a reprint: see Danto (2004).

2 George Dickie's essay, 'The new Institutional Theory of Art' was first published as part of the *Proceedings of the 8the triumph Wittgenstein Symposium*, no.10 (1983): 57–64. I have drawn on a reprint: see Dickie (2004).

3 Anthony Haden-Guest's *True Colours: The real life of the art world* (1996) exemplifies the type of writing that dwells in the ontic realm of beings.

4 We are reminded that the ability to go beyond oneself is also the state of Dasein in its thrownness. In its state of thrownness, Dasein seizes possibility in its very possibility.

5 In Kockelman's 1985 analysis of Heidegger's use of the term 'earth', he makes the claim that Heidegger would not have taken a landscape as an example to explain his notion of 'earth', since his discussion was limited to 'great art'. I disagree with his assumption that a landscape cannot be 'great art', that is world historically significant, but would suggest that Heidegger avoided the possibility of a 'literal' link being made between landscape and earth.

Chapter 3

1 See Norman Bryson (1983), Chapters 1 and 2 for an extensive discussion of the 'natural attitude' and the 'essential copy'.

2 Drawing on Heidegger's critique of representationalism, Foucault calls this prescription of thought discourse.

3 'The age of the world picture' was originally published in Holzwege (1950). In this thesis I am referring to the text published in translation in *The Question Concerning Technology and Other Essays* (1977). That the version I read is in English and not German is significant in terms of Derrida's discussions of representation and translation. I do not read or speak German and thus what I am dealing with is a representation of *Vorstellung*.

4 Heidegger argues that the event in which the world becomes a picture occurs simultaneously with 'the event of man's becoming *subiectum* in the midst of that which is' (AWP: 132).

5 Michel Foucault (1970) also attributes the representationalism to Descartes, although he identifies a different periodisation.

6 The root of mathematics is '*mathesis*', meaning fore-knowledge.

Chapter 4

1 See Matthew Biro's book *Anselm Kiefer and the Philosophy of Martin Heidegger* (1998) for an analysis of the counterpoints between the work of Kiefer and the theorising of Heidegger.

2 Although Heidegger's examples are somewhat dated, his fundamental question becomes of greater relevance the more humans intermingle

with machines. Developments in the field of robotics and genetics amplify this trend.

3 *For the Love of God* was sold to an anonymous investor in August 2007. For a tabloid report on the sale see Hoyle (2007).

4 See *The Ister*, a film by David Barison and Daniel Ross which uses a trip up the Danube River to its source in the Black Forest as the background against which to navigate Heidegger's 1942 lecture course and Hölderlin's hymn, 'The Ister'.

5 The work of Jeff Koons is exemplary in the context of this discussion.

Chapter 5

1 *William Kentridge: Drawing the passing* (1999) is a documentary made by film-maker Reinhard Wulf and art historian Maria Anna Tappeiner. It is produced by Westdeutscher Rundfunk and published by David Krut Publishing.

2 Material thinking offers us a way of considering the relations that take place within the very process or tissue of making. In this conception the materials are not just passive objects to be used instrumentally by the artist, but rather the materials and processes of production have their own intelligence that come into play in interaction with the artist's creative intelligence. See Carter (2004).

3 Experiential learning as a pedagogy is underpinned by praxical knowledge.

Chapter 6

1 The distinction between craftsmanship and *techne* is often used to create a hierarchy of 'artist' over 'craftsman'. The development of Heidegger's argument does nothing to dispel this. He is keen to differentiate the artist's actions from craft, even if the artist is also a craftsman. 'What looks like craft in the creation of a work is of a different sort' (OWA: 185).

2 In his discussion of Meret Oppenheim's *Luncheon in Fur*, Robert Hughes observes that the cup is 'the most intense and abrupt image of lesbian sex in the history of art' (Hughes 1980: 243).

3 Etymology is the study of the history of words: their origins and how they have come to mean what they currently mean. Apart from providing a fascinating insight, it is a strategy used by Heidegger to enable us to question our preconceived notions about things.

5 This thinking has been taken up by philosophers of science such as Bruno Latour and Donna Haraway.

Chapter 7

1 Lu Jie, the curator of The Long March Project saw this project as an opportunity to make connections, create events and initiate collaborations involving the artists and communities along the route.

Chapter 8

1 The contextualisation for this chapter is drawn from the essay 'The magic is in handling' in Barrett and Bolt (2007).

2 Conceptualism reconceived our understanding of what constitutes art. It replaced the declaration 'This is art' with the question 'Is it art?' The anti-aestheticism of postmodernism and its critique of the foundational concepts of modernism – authenticity, originality, truth and intentionality – further undermined the certainty of Modernism and put art on notice.

3 '*Episteme*' the root of 'epistemology', that is the study of or the theory of knowledge.

4 Judovitz (1988: 75) proposes that in Descartes the unknown must always be already figured or represented in the order of the known.

5 As Heidegger notes, 'the superiority of a *subiectum* (as a grounding lying at the foundation) that is pre-eminent because it is in an essential respect unconditional arises out of the claim of man to a *fundamentum absolutum inconcussum veritatis* (self-supported unshakable foundation of truth, in the sense of certainty)' (AWP: 148).

6 The world can only become a picture when humans set what is in front of them as an objectification or representation and hence, according to Heidegger there was no world picture in the Greek age.

Selected bibliography

Abbreviations of Heidegger works

BT – *Being and Time* (1927).

OWA – 'The origin of the work of art' (1935–6).

AWP – 'The age of the world picture' (1950).

QCT – 'The question concerning technology' (1954).

NI – *Nietzsche*, vol. I: *The Will to Power as Art* (1981).

The 5th Asia-Pacific Triennial of Contemporary Art, Brisbane: Queensland Art Gallery Publishing, 2006.

Alberti, Leon Battista (1991) *On Painting*, trans. C. Grayson, London: Penguin.

Barrett, Estelle and Barbara Bolt (2007) 'The magic is in handling', in *Practice as Research: Approaches to creative arts enquiry*, London: I.B.Tauris, pp. 27–34.

Barthes, Roland (1977) 'The Death of the author', in *Image, Music, Text*, ed. and trans. Stephen Heath, London: Fontana Press.

Baudrillard, Jean (1994) *Simulacra and Simulation*, trans. Sheila Faria Glaser, Ann Arbor, MI: University of Michigan Press.

Baumgarten, Alexander (1954) *Reflections on Poetry* (1735), trans. Karl Aschenbrenner and William B. Holther, Berkeley: University of California Press.

Berger, John (2000) 'How is it There? An open letter to Marisa', *Art Monthly*, no.133 (September), pp. 15–20.

Bhabha, Homi. K. (1998) 'Anish Kapoor: making emptiness', in *Anish Kapoor*, Berkeley, CA: University of California Press.

Biro, Matthew (1998) *Anselm Kiefer and the Philosophy of Martin Heidegger*, Cambridge: Cambridge University Press.

Bolt, Barbara (2004) *Art Beyond Representation: The performative power of the image*, London and New York: I.B.Tauris.

Bourriaud, Nicholas (2002) *Relational Aesthetics*, trans. Matthew Copeland, Paris: Les Presses du reel (originally published in French in 1998).

Bryson, Norman (1983) *Vision and Painting: The logic of the gaze*, London: Macmillan.

Calle, Sophie (2004) *Exquisite Pain*, London: Thames & Hudson.

Calle, Sophie (2007) *Take Care of Yourself*, Arles: Actes Sud.

Carter, Paul (2004) *Material Thinking: The theory and practice of creative research*, Melbourne: Melbourne University Press.

Chrisafis, Angelique (2007) report and interview with Sophie Calle, *Guardian*, 16 June (retrieved 28 November 2007), http://arts.guardian.co.uk/art/news/story/0,,2104506,00.html.

Danto, Arthur Coleman (2004) 'The Artworld', in Peter Lamarque and Stein Haugom (eds) *Aesthetics and the Philosophy of Art*: *The analytical tradition*, Olsen, Malden, Oxford and Carlton: Blackwell Publishing, pp. 27–34.

De Man, Paul (1996) *Aesthetic ideology*, Andrzej Warminski (ed.), Minneapolis: University of Minnesota Press.

Deleuze, Gilles (2003) *Francis Bacon and the Logic of Sensation*, trans. D.W. Smith, London: Continuum.

Derrida, Jacques (1982) 'Sending: on representation', trans. P. Caws and M.A. Caws, *Social Research*, vol. 49 no.2, pp. 294–326.

—— (1987) *The truth in Painting*, trans. Geoff Bennington and Ian McLeod, Chicago: University of Chicago Press.

Dickie, George (2004) 'The new institutional theory of art', in Peter Lamarque and Stein Haugom (eds) *Aesthetics and the Philosophy of Art: The analytical tradition*, Olsen Malden, Oxford and Carlton: Blackwell Publishing, pp. 47–54.

Documenta XI (2002) Ostifilfern-Ruit: Hatje-Cantz.

Eagleton, Terry (1990) *Ideology of the Aesthetic*, Oxford: Blackwell.

Elliot, Michele (2007) 'Always between us: bodies, boundaries and liminal space', unpublished Masters thesis, Monash University.

Foucault, Michel (1970) *The Order of Things: An Archaeology of the Human Sciences*, London: Routledge.

—— (1986) 'What is an author?', in P. Rabinow (ed.) *The Foucault Reader*, London: Penguin, pp. 101–20.

Fukuyama, Francis (2002) *Our Posthuman Future: Consequences of the biotechnology revolution*, New York: Farrar, Straus and Giroux.

Gibson, Ross (2006) 'Aesthetic Politics', *Catalogue of 5th triumph Asia-Pacific Triennial of Contemporary Art*, Brisbane: Queensland Art Gallery Publishing, pp. 16–23.

Godfrey, Tony (1998) *Conceptual Art*, London: Phaidon.

Green, Charles (2001) *The Third Hand: Collaboration in art from conceptualism to postmodernism*, Minneapolis: University of Minnesota Press.

Greenberg, Clement (1992) 'Modernist Painting', in C. Harrison and P. Wood (eds) *Art in Theory 1900–1990*, Oxford: Blackwell, pp.754–60

Haden-Guest, Anthony (1996) *True Colours: The real life of the art world*, New York: Atlantic Monthly Press.

Haraway, Donna (1991) *Simions, Cyborgs and Women: the reinvention of nature*, London: Free Association Books.

Hayles, N. Katherine (1999) *How We Became Posthuman: Virtual bodies in cybernetics, literature and infomatics*, Chicago: University of Chicago Press.

Hegel, Georg Wilhelm Friedrich (1852–51) *Works*, vol. X, parts 1, 2 and 3, Berlin: Dunder und Humblot.

Heidegger, Martin (1961) *An Introduction to Metaphysics* ([1953] *Einfuhrung in die Metaphysik*) trans. Ralph Manheim, Garden City, NY: Doubleday/Anchor Books.

—— (1962) *Being and Time* ([1927] *Sein and Zeit*) trans. John Macquarrie and Edward Robinson, New York: Harper and Row.

—— (1966) *Discourse on Thinking* ([1959] *Gelassenheit*) trans. John M. Anderson and E. Hans Freund, New York: Harper and Row.

—— (1967) *What is a Thing*? ([1962] *Die Frage nach dem Ding?*) trans. W.B. Barton Jr and Vera Deutsch, Chicago: Henry Regnery Company.

—— (1968) *What is Called Thinking?* ([1954] *Was heisst Denken?*) trans. Fred D. Wieck and J. Glenn Gray, New York: Harper and Row.

—— (1970) *Hegel's Concept of Experience*, trans. J. Glenn Gray and Fred D. Wieck, New York: Harper and Row.

—— (1971a) *On the Way to Language*, trans. Peter D. Hertz and Joan Stambaugh, New York: Harper and Row.

—— (1971b) *Poetry, Language, Thought*, trans. Albert Hofstadter, New York: Harper and Row.

—— (1975) *Early Greek Thinking*, trans. David Farrell Krell and Frank A. Capuzzi, New York: Harper and Row.

—— (1977) 'Age of the world picture' in *The Question Concerning Technology and Other Essays*, trans. William Lovitt, New York: Harper and Row, pp. 115–54.

—— (1977) 'The question concerning technology' in *The Question Concerning Technology and Other Essays*, trans. William Lovitt, New York: Harper and Row, pp. 3–35.

—— (1979) *Heraclitus Seminar, 1966–1967*, with Eugen Fink, trans. Charles H. Seibert, Tuscaloosa, AL: University of Alabama Press.

—— (1981) *Nietzsche*, vol. I: *The Will to Power as Art*, London: Routledge and Kegan Paul.

—— (1985) *History of the Concept of Time: Prologomena* ([1925] *Prologomena zur Geschichte des Zeitbegriffs*) trans. Theodore Kisiel, Bloomington, IN: Indiana University Press.

—— (1988) *Hegel's Phenomenology of Spirit*, trans. Parvis Emad and Kenneth Maly, Bloomington, IN: Indiana University Press.

—— (1990) *Kant and the Problem of Metaphysics* ([1929] *Kant und das Problem der Metaphysik*) trans. Richard Taft, Bloomington, IN: Indiana University Press.

—— (1991) *The Principle of Reason* ([1957] *Der Satz vom Grund*) trans. Reginald Lilly, Bloomington, IN: Indiana University Press.

—— (1992) *Parmenides* ([1942–3] *Parmenides*) trans. Andre Schuwer and Richard Rojcewicz, Bloomington, IN: Indiana University Press.

—— (1996) *Being and Time*, trans. J. Stambaugh, Albany, NY: State University of New York Press.

—— (2002) 'The origin of the work of art' in *Basic writings*, trans. David Farrell Krell, London: Routledge, pp. 139–212.

Hockney, David (2001) *Secret Knowledge: Rediscovering the lost techniques of the old masters*, London: Thames and Hudson.

Hoyle, Ben (2007) 'A head of its time: $122m and no bones about it', *Weekend Australian*, 1–2 September: p. 15.

Hughes, Robert (1980) *The shock of the new art and the century of change*, London: British Broadcasting Corporation.

Ihde, Don (1979) *Technics and Praxis*, Dordrecht: Reidel.

Judovitz, Dalia (1988) 'Representation and its limits in Descartes', in H.J. Silverman and D. Welton (eds) *Postmodernism and Continental Philosophy*, Albany, NY: State University Press of New York: pp. 68–84.

Kant, Immanuel (1952, 1961) *Critique of Judgement* (1790), trans. James Creed Meredith, Oxford: Clarendon Press.

Kentridge, William (1999) *William Kentridge*, London: Phaidon.

Kockelmans, Joseph (1985) *Heidegger on Art and Art Works*, Dordrecht: Marinus Nijhoff Publishers.

Latour, Bruno (1988) 'Visualization and social reproduction', in G. Fyfe and J.Law (eds) *Picturing Power: Visual depiction and social relations*, London: Routledge: pp. 15–38.

Levinas, Emmanuel (1996) 'Martin Heidegger and ontology', *Diacritics*, vol. 26 no.1, pp. 11–32.

Lucie-Smith, Edward (1987) *Sculpture Since 1945*, London: Phaidon.

McLeod, Katy (2007) quoted in *Review of Practice-led Research in Art, Design and Architecture*, Swindon: UK Arts and Humanities Research Council.

Nietzsche, Freiderich (1968, c 1967) *The Will to Power,* trans. by Walter Kaufmann and R.J. Hollingdale, New York: Vintage Books.

O'Doherty, Brian (1986) *Inside the White Cube: The ideology of the gallery space*, San Francisco: Lapis Press.

O'Reilly, Rachel (2006) 'The Miniature Long March', in *The 5th Asia-Pacific Triennial of Contemporary Art*, ed. Lynne Seear, Brisbane: Queensland Art Gallery Publishing, pp. 130–3.

Olkowski, Dorothea (1988) 'Heidegger and the limits of representation', in Silverman, Hugh J. and Donn Welton (eds) *Postmodernism and Continental Philosophy*, Albany, NY: State University of New York Press, pp. 96–106.

Palmer, Daniel E. (1998) 'Heidegger and the ontological significance of the work of art', *British Journal of Aesthetics*, vol. 38 no.4, pp. 394–412.

Papastergiadis, Nikos (1998) 'Everything that surrounds': art, politics and theories of the everyday', in *Everyday*, Sydney: The Biennale of Sydney Ltd, pp. 21–27

Pennings, Mark (2008) review of Mariko Mori's *Tom Na H-iu*, in *Eyeline: Contemporary visual arts*, no.66, p. 66.

Pliny (1952) *Natural History*, vol. 9, books XXXIII–XXXV, trans. H. Rackham, London: Heinemann, pp. 309–31.

Proctor, Stephen (2008) *Lines Through Light*, Christine Proctor and Itzell Tazzyman (eds), Canberra: RLDI and Christine Proctor.

Robertson, Iain and Derrick Chong (2008) *The Art Business*, London and New York: Routledge.

Serres, Michael (1995) *Genesis*, trans. G. James and J. Nielson, Ann Arbor, MI: University of Michigan Press.

Starrs, Josephine and Leon Cmielewski (2000) 'Teaching new media: aiming at a moving target', *Real Time*, no.38 (August–September), p. 8.

Steiner, George (1999) *Martin Heidegger*, Chicago: University of Chicago Press.

Sturken, Marita and Lisa Cartwright (2001) *Practices of Looking: An introduction to visual culture*, Oxford: Oxford University Press.

Summers, David (1996) 'Representation', in R.S. Nelson and R. Shiff (eds) *Critical Terms for Art History*, Chicago and London: University of Chicago Press.

Vasari, Giorgio (2005) *Vasari's Lives of the Artists: Giotto, Masaccio, Fra Filippo Lippi, Botticelli, Leonardo, Raphael, Michelangelo, Titan*, trans. J. Fraser, ed. M. Lavin, Mineola, NY: Dover.

Watkins, Jonathan (1998) *Every Day*, Sydney: Biennale of Sydney.

Watts, Michael (2001) *Heidegger: A beginner's guide*, London: Hodder and Stoughton.

Wichmann, Siegfried (1985) *Japonisme: The Japanese influence of Western art since 1858*, London: Thames and Hudson.

Williams, Linda 'Spectacle or critique? Reconsidering the meaning of reproduction in the work of Patricia Piccinini', in *Southern Review*, vol. 37 no.1 (2004), pp. 76–94.

Willis, Gary (2007) 'The Essential Question Concerning Art', unpublished PhD thesis, University of Melbourne.

Wrathall, Mark (2005) *How to Read Heidegger*, London: Granta Books.

Young, Julian (2001), *Heidegger's Philosophy of Art*, Cambridge: Cambridge University Press.

Glossary

a priori – Rudimentary knowledge or understanding. Human beings have an *a priori* or pre-conceptual understanding of their being-in-the-world that enables them to relate to and care for and interact with other beings in the world.

aesthetics – Derived from the Greek '*aisthetike episteme*', meaning knowledge of human behaviour with regard to sense, sensation and feeling. Aesthetics is the study of the human state of feeling in its relation to the beautiful.

age of the world picture – Description used by Heidegger to characterise the modern epoch. This picturing of the world is not mimetic picturing, but rather a modelling or framing of the world. He calls this framing 'representationalism'.

aition – From the Greek, meaning that to which something else is indebted.

aletheia – The ancient Greek word for truth as an unconcealment or revealing. For the Greeks, as for Heidegger, truth is not propositional, but rather is a revealing that brings the being of something out of concealment forth into unconcealment.

anxiety/angst – An experience of unhomeliness (*unheimlich*). Anxiety is caused by the recognition of nothingness that arises from our being thrown-into-the-world.

apprehension (*Vernehmer*) – Derived from the verb *vernehmen*, to hear, perceive and understand. Apprehension is figured as openness to the world, in contrast to representationalism.

Art – Heidegger distinguishes between Art and art, or the essence of art ('Art') and art business ('art'). Art is a revealing or bringing to truth. Art operates in the realm of the meaning of Being.

art business – This occurs in the midst of being (i.e. culturally mediated lived experience) as human beings try to negotiate the business of making, exhibiting, viewing, buying and selling artwork in a modern technocratic society. Heidegger suggests that where art business rules, the truth of Art is forgotten. Art business as a mode of revealing is an enframing knowing.

artwork – The object or presentation that we have come to call an artwork.

authenticity – The mode of existence where Dasein is aware of its own self and its own possibilities, and makes choices based on this awareness. To be authentic does not presume any prior 'original self' but rather involves being true to oneself in the face of the domination of they-self.

being (*das Seiende*) – A being is anything that has an existence – humans, animals, objects etc. Human beings are distinguished from other living organisms by their concern with their very Being. An understanding of Being is the fundamental fact of human existence.

Being (*da Sein*) – 'To be', the isness or essence of being. Heidegger is concerned with the question: what is the meaning of Being? While this question is unanswerable, its unanswerability is precisely the point. It is this questioning things in their Being that rouses us out of our habitual way of thinking about the world.

being-in-the-world – The compound expression 'being-in-the-world' posits the experience of existing in the world as a 'unitary phenomenon' (BT 1962: 78). Being-in-the-world is the understanding of being itself. Dasein cannot understand itself isolated from the world in which it lives. Dasein's understanding is not derived from abstract theorising, but from the concrete experience of being-in-the-world.

Being of beings (*das Sein des Seienden*) – Being is always concerned with the Being of beings as such, not with human beings per se.

In questioning the Being of beings, Heidegger argues, we must transcend the mere ontic and pose the fundamental ontological question of Being.

care (*Sorge*) – The feeling of concern or interest; taking care or thinking. For Heidegger, care is a fundamental state of Dasein, and it is care that characterises all associations or involvements that Dasein has in the world. There are different modes of care: being-with-another or solicitude is the mode of care one has towards other humans; careful concern is the way that Dasein handles the entities (the ready-to-hand) that it deals with in the world. Care is primordial, provides a cohesive unifying feature. Dasein is care-worn.

causa – Roman word for cause. '*Causa*' belongs to the verb *cadere* meaning to fall. It is the term that underpins modern notions of causality and is implicit in instrumentalist understandings of the world. In his discussion of the making of a silver chalice, Heidegger identifies the operation of the doctrine of four causes: *causa materialis*, the matter or material out of which something is made; *causa formalis*, the form that the thing takes or the shape into which the material enters; *causa finalis*, the end or the purpose for which the thing is made; *causa efficiens*, that which brings about the finished thing or object.

circumspection *(Umsicht)* – A special kind of sight; an involved looking around. For Heidegger, the world is experienced and made meaningful to us by our practical relation or involvement with things. It gives us a particular understanding or sight. It is through our practical relations with things-in-the-world, rather than through abstract thinking about something, that gives us the 'sight' through which we come to know how to do something, for example to paint, to dance or to write. Our awareness of the world increases through our practical involvement in it. In this practical involvement we become aware of the ready-to-hand.

clearing – openness or receptiveness to experiencing truth as a revealing; an open space in which Being can be revealed.

concern – The state of having concern, being concerned with, having an interest or investment in something, being affected by something. As a

primordial way of being in the world, Dasein's concern goes against the notion of disinterestedness.

Dasein – From '*da*' ('there') and '*Sein*' ('being'). Heidegger uses the term 'Dasein' for the fundamental fact of being-right-there that characterises human existence. It relates to the German term for 'Being', '*das Sein*', i.e. 'the to be' or '*existenz*'. Dasein is not an abstract entity, but rather what it means to be, what it means to exist. Dasein is constituted by being-in-the-world.

destining (*Geschick*) – To send or start something on its way. For Heidegger, there are different modes of destining. Enframing is one mode, *poiesis* is another.

disclose/disclosedness – To lay open, or having the character of being laid open.

earth – The potential and possibility that enables different worlds to emerge. Earth is the dynamic and creative force of possibility.

eidos – In common parlance, mere appearance or look. For Plato, *eidos* names the non-sensuous aspect of that which is physically visible (e.g. the idea of a table which is repeated in myriad ways as a material manifestaton in the world). Heidegger used the term '*eidos*' to designate the coming-to-presence appearance of a thing, i.e. the Being of a thing.

enframing (*Gestell*) – This involves an ordering and mastering of what-is. The ordering that reduces objects to standing-reserve belongs to the dominion or sovereignty of *Gestell* (enframing). It is characterised by a way of thinking or knowing or revealing that sees things as a means to an end, i.e. instrumentalism.

entwurf – Projected design, 'project-in-draft' or 'projection'.

episteme – The root of 'epistemology', the theory of knowledge.

equipment totality – Entities that are ready-to-hand operate in a network of practical relations. Heidegger refers to this network as equipmental totality.

equipmental-being – The equipmental-being of an object or piece of equipment is identified as its usefulness for something. The equipmental-being of the work involves 'use value'.

equipmentality – The equipmental quality of equipment rests in its usefulness as a means to an end. We discover the equipmental being of equipment by using entities. It is through active use of things that we establish original relations with them.

essence – Heidegger does not see 'essence' as some single, enduring universal quality of something, an attribute or state of that thing, as is commonly conceived. There is not one defining feature or attribute that holds for the multifarious forms that art or technology or truth take. Rather, for Heidegger, the essence is a 'happening', where the Being of something is unconcealed.

essence of technology – Technology in its material manifestation as tools, equipment and instruments is not equivalent to the essence of technology. The essence of technology lies in its revealing as a particular mode of being.

everyday Dasein – In developing his thinking on Dasein, Heidegger pays particular attention to its emanation as everyday Dasein. The distinction between Dasein and everyday Dasein is the difference between the ontic life of human beings and a being's concern with its very Being. Where Dasein understands its fundamental possibility of being-in-the-world, it is open to self-understanding. This is Dasein. However, merely existing leads Dasein to fall into everydayness. Everyday Dasein understands itself via entities in the world rather than via the world itself.

facticity – Derives from the noun *'Faktizitat'*, meaning 'in fact' or 'a matter of fact'. Facticity is differentiated from the scientific understanding of fact and truth as correspondence. Facticity relates to the possibilities that our 'thrownness' enables, and how the sum total of our existing situation sets up or opens up future possibilities.

fallenness – When Dasein gets caught up in the verbiage and chatter of the everyday it falls prey to the ways of the-*they*. In this state, Dasein

forgets what it is to be. Falleness is not some failing from which we must be saved, but is an inevitable consequence of living life.

fore-conception – The prior knowledge of something that one needs in order to understand or interpret it. For example, without prior knowledge of what a canvas stretcher can do, it will appear incomprehensible, therefore unusable.

fore-having – The understanding of the entity and the context in which it exists. For example, if we work in the digital realm our understanding of the context of the digital environment will help us negotiate new software packages that we encounter.

fore-sight – The focus or lens through which the entity is to be interpreted. For example, the fore-sight required to work with watercolour will be different from that required to work with oil or acrylic paint. Watercolour requires an understanding of transparency, and hence the need to work from light to dark; oil paint can be both transparent and opaque, and can be worked differently.

fore-structure – The fore-structure of understanding is the prior awareness of the significant web of relations that enables us to understand the purpose, usability or as-structure of a ready-to-hand entity. For example, in order to work as an analogue photographer one needs to understand the relationship between the types of film, available light, speed and movement, the opening of the aperture, the various controls on the camera etc. Heidegger delineates three aspects to the fore-structure: fore-having, fore-sight and fore-conception.

form – Provides a limit to matter that allows something to 'show itself' (*phainesthai*) according to its *eidos* (its outward form). Otherwise we would have formlessness or chaos.

form–matter synthesis – In the form–matter synthesis, matter stands together with a form. According to the form–matter synthesis an artwork can be interpreted as formed matter.

handlability – The concrete understanding of entities that we gain through 'handling' them. For example, we learn to ride a bicycle through riding it, or learn to drive a car through driving lessons: we gain concrete understanding through handling.

hypokeimenon – Greek word that signifies the core of the thing that was always already there.

inauthenticity – The state of everyday Dasein, in which we get caught up in the everyday and lack self-awareness. The lack of self-awareness that stems from being caught up in what others tell us (customs, expectations, social values, peer pressure, fashion, markets etc.) is an inauthentic mode of being. Heidegger terms this 'the way of the-*they*' or 'they-self'. We are thrown into 'the way of the they' (socialisation) from the moment we are born. We are modelled and shaped by the-*they*. Inauthenticity is characterised by fallenness.

instrumentalism – The use of tools and materials as a means to an end. Entities are conceived of as existing 'in-order-to'.

interpretation – The faculty of being able to see things as complete. All interpretations are based on a prior context of intelligibility, which is gained by an innate capacity to recognise what something can do.

meaning – The meaning of something emerges from the ability to interpret the as-structure of things, that is to understand its function within a particular context. This goes as much for words as it does for other entities.

metaphysics – Branch of philosophy concerned with the study of the principles of existence (substance, space and time), and in particular with explaining the nature of being and the world.

mimesis – Imitation based on likeness or appearance.

mood – Related to our thrownness or being-in-the-world and the disposition that Dasein holds towards existence. It is Dasein's 'disposedness' to existence that differentiates mood from an emotion. Emotion is a specific response to a situation.

nihilism – The belief that human existence does not have significance. Heidegger rejected nihilism as a destructive force.

ontic – The everyday, concerned with the lived, culturally mediated experience of human beings. The realm of the ontic is the realm of the everyday, the world of things. We have become caught up in the ontic realm of human beings, and forget the question of Being in itself.

ontological difference – The fundamental distinction between the being (*das Sein*) and the Being of beings (*das Sein des Seienden*). Being is concerned with the ontological while the being operates in the ontic realm.

ontology – The study of Being, which is concerned with Being as such. Heidegger's concern with Being frames his whole philosophy. The study of ontology emerged with the early-Greek thinkers such as Anaximander, Perminedes and Heraclitus.

parousia – Greek word for being 'to be'.

phenomenology – The philosophical approach concerned with understanding phenomena. Heidegger expanded on Edmund Husserl's phenomenological approach, to encompass a concern with the understanding of Being and experience of Being in itself. Heidegger's phenomenology is ontological, having to do with the study of the meaning of Being.

physis – The revealing that occurs in nature. *Physis* is *poiesis* in its highest form, in that it is a bringing-forth out of itself. Heidegger cites the bursting forth of a blossom into bloom as an example of *physis*, and contrasts this bringing-forth of something out of itself with the bringing-forth of art, which is bringing-forth out of something else.

poiesis – Openness before what-is, a mode of being's coming to presence. While enframing concerns an ordering and a mastery of what-is, *poiesis* involves openness before what-is. Openness before what-is relates to the Greek understanding of presencing. It is a bringing-

forth or unconcealment of being. *Poiesis* as a mode of the Being of beings is characterised by an emergent quality, rather than being a knowing in advance. *Poiesis* is a bringing-forth of something out of itself. Heidegger believes that aesthetic revealing as *poiesis* can preserve humans from the danger of the particular technological revealing that is enframing.

post-human world – The concept of the post-human emerged out of the impact that techno-science (including biotechnology) had had on the way human beings live and understand what it is to be human. A post-human world involves the prosthetic union of human beings and the intelligent machines. While some celebrate this union, others claim that the post-human epoch merely inverts the hierarchy of power so that technology becomes the master and humans become slaves to technology. Heidegger's project, epitomised in his essay 'The question concerning technology,' calls for a total rethinking of this relationship.

praxis – Our involvement in or relationship with the world underpins the primarily praxical nature of being in the world. In Heidegger's praxical formulation, entities are not grasped thematically, but only in use. It is through our concernful dealings with things that the world is already discovered. Dasein does not come to know the world theoretically through contemplative knowledge in the first instance. It comes to know the world theoretically, only after it has come to understand it equipmentally. It is only through use that we gain access to the world.

present-at-hand (*Vorhandenheit*) – In presence, entities appear as 'just there', as mere 'things' that lies there.

preservation – This opens up the human being to the openness of being. It enables us to step outside the noise of everyday existence and reflect on what it is to be.

preserver – One with a willingness to openness. It would be easy to read Heidegger's distinction between 'creators' and 'preservers' as artists and 'viewers', but there is no reason at all why beings should be divided into artists and viewers. Viewers are as much creators as artists are preservers.

primordial – Prior to everything. In Heidegger's world, the practical world is primordial, that is prior to any thinking, investigation or theorising of it. Moods are primordial. Dasein is always in a mood. While our everyday emotions provide little insight into our Being and instead absorb us in our ontic life, Heidegger suggests that deep existential boredom can reveal the nature of existence and provide insight into our being-in-the-world.

projection – To project is to see things in terms of their future possibilities.

ready-to-hand (*Zuhandenheit*) – The being of entities discovered through our practical involvement with them. Where something is used by Dasein for a purpose, it is termed ready-to-hand. The being of the ready-to-hand derives from its character as 'something' *for* something. In this conception, equipment manifests itself in its readiness-to-hand in-order-to do something. The ready-to-hand belongs to the realm of productivity, not that of contemplation. The tool is a means to an end. In this instrumental view of the tool, man focuses on what tools can do for him, not on the manner in which they are. Dasein's relationship with or practical understanding of the ready-to-hand is fundamental to being-in-the-world. Heidegger sees this relation as a relation of care (*Sorge*). The ready-to-hand contrasts with the present-at-hand.

referral – A way of relating.

represent (*vorstellen*) – Representation is not an outcome, but rather a mode of thinking and a relationship to the world that involves setting the world before oneself as an object in relation to oneself as subject. It establishes a relationship where whatever is is figured as an object for man-as-subject.

representationalism – A mode of thought that insists on grasping reality through imposed conceptual structures. It is characterised by a setting-before and objectifying of the world through which it orders the world and predetermines what can be thought. Under the sovereignty of representation, to be human is no longer to be open to what-is, but rather to become caught up in a quest to get things under control.

revealing (*Entbergung*) – From the German verb '*entbergen*', to reveal. In order to understand the nuance of the use of the term 'revealing', we can break down *entberge* into its component parts; prefix '*ent*' and '*bergen*'. '*Ent-*' means a change from one situation to another, a transformation. '*Bergen*' means to 'rescue, recover, secure, harbour or conceal. Taken together, *entbergen* involves 'an opening out from protective concealing, a harbouring forth' (QCT: 11, fn 10). Thus revealing is a bringing-forth that comes to pass only insofar as something concealed comes into unconcealment. Heidegger argues that revealing comes in different forms, and specifically contrasts the revealing of early-Greek society that involved the unfolding bringing-forth of *poiesis* with the form of revealing that rules in modern technology, that is an enframing revealing. According to Heidegger, an enframing revealing is a challenging revealing, since it 'puts to nature the unreasonable demand that it supply energy that can be extracted and stored' (QCT: 14). Objects and equipment become absorbed into the totality of standing-reserve and even lose their character as objects.

rift – From the German '*der Riss*' – a crack, gap, fissure, split or cleft. In he German it also means a plan or design in drawing. In the rift of world and earth, a sketch, outline, profile, blueprint or ground-plan emerges.

Seinphilosophe – Philosophy of Being.

standing-reserve (*Bestand*) – A store or supply being available to some ends as destined by man. In this schema, objects are ordered and reduced to their readiness for use by man as representing subject. Under this regime, objects are reduced to standing-reserve and, as such, are available to some ends as destined by modern representing man. Things in the world exist 'out there', ready to be collected, quantified and calculated, turned into representations, so that man may use them in his quest to master the world. Objects and equipment become absorbed into the totality of standing-reserve and lose their quality as objects. The consequence of the transformation of the world into standing-reserve is that the earth is viewed as a resource which man dominates through technology. This ordering becomes the standard on which everything is based.

stellen – To place, or set in place, or set upon, supply. The stem *'stellen'* is to be found in a number of verbs that Heidegger uses to criticise that way in which modern man has reduced the fecundity of being-in-the-world to a resource for use by humans. Thus *'gestell'* ('enframing'), *'bestellen'* ('to order, command or set in order') *'vorstellen'* ('to represent') are words that carry with them this nuance that the world is at our command.

strife – The disruption or unsettling of preconceived or established ways of thinking that art enables. It is the dynamic that is created between world and earth in the creation of the work of art.

subiectum – Translation of the Greek word *'hypokeimenon'*, which means 'that-which-lies-before', that which provides the ground against which things can be seen (AWP: 128). In its broad sense it is concerned with presencing. As presencing it does not offer a special place for humans. However, with Descartes the human becomes *subiectum*, as one who sets the world before him as an object for a subject. Descartes's declaration 'I think therefore I am' shifted the ground. This dynamic can be exemplified most clearly in one-point perspective or in anthropomorphism, where the human forms the standard against which everything that is is understood.

techne – The bringing-forth of the artist or craftsperson. *'Techne'* is a term that has transformed in meaning over time. In Greek thought, *techne* was a kind of knowledge. However, with modernity it came to be understood as a mode of production. The slippage from a kind of knowledge that 'guides' making to the making and producing of things has come to inform our contemporary understanding of technology. When understood as the term for the activities and skills of the craftsman, *techne* comes to be seen in an instrumental way as an enframing. It is a means to an end. If thought instrumentally, *techne* assumes the character of a controlling revealing. Heidegger wants us to rethink our relation to technology and return to the conception of *techne* as a bringing-forth that is *poietic*.

technology – A mode of revealing. 'Technology comes to presence [*West*] in the realm where revealing and unconcealment take place, where

aletheia, truth happen' (QCT: 13). Technology as a mode of revealing takes us beyond commonsense understandings of technology as something that we use as a means to an end.

thing-being – The being of a thing, or its essence before it has been given a name or acquired a value.

thing-concept – The enframing of a thing as concept. The thing-concept is part of a representationalist mode of thinking. For example, once Duchamp's *Fountain* had been subsumed under the thing-concept 'the readymade', it was very difficult to understand it outside this enframement.

thrownness (*Geworfenheit*) – In its thrownness, Dasein is catapulted involuntarily into existence. Thrownness is momentum, the flux or process of life. In being thrown into the world we get caught up and carried along by the forces of chance and randomness. We never get control of it or step aside from it. This is at the base of our anxiety. We are always already in it. We are thrown from the past into the present and from this present we project into the future.

truth (*Wahr-heit*) – To watch over and keep safe. Scientific approaches to truth are concerned with correctness, with defining criteria and establishing truth and falseness. According to the paradigm of propositional truth, there is a subject-knower and an object known. This sets up the structure for scientific knowing and scientific research. For Heidegger, this approach to truth ignores what truth means and what happens when truth is revealed. Disclosure is the essence of truth and truth is in the constant process of being revealed. Heidegger suggests that without Dasein there can be no truth. Dasein provides the clearing in which truth can happen. Everyday Dasein is Dasein fallen. Where that happens there is a closure that prevents the revelation of truth. This closes off or conceals truth. Thus in the structure of Dasein we see both openness and closure, truth and untruth. Here untruth is not a proposition that can be assessed in terms of falseness, but rather it is a reservoir of possibility of unconcealment.

understanding (*Verständnis*) – Involves an act of understanding (*Verstehen*). Understanding is not a theoretical knowing that we possess,

but involves a process through which we come to know. It is something that we do. Understanding is being-in-the-world.

ur-*Spring* – A founding or primal leap, an origin.

vor-*stellen* – To re-present, or enact a setting-before oneself.

Wesen – Coming-to-presence; the way in which what-is becomes established as a mode of thought and holds sway in its ongoing presence.

will to mastery – The tendency for humans to set the world in place as a resource. As *subiectum*, techno-calculative man orders this resource to achieve his own ends.

work-being – The work-being of the work consists in setting up a world and the setting-forth of earth. The work-being of work is the strife that it causes between world and earth.

work of art – The 'setting-into-work of truth', not the making, manipulating or manufacturing of artworks.

world – The conceptual framework that creates an integrated and coherent whole for human beings. This framework structures our relations to other entities in the world, both human and non-human. World has its etymology in being. The concept of world does not refer to the world-out-there as something that we as human subjects look at and ponder. Heidegger's conception of world relates to our being-in-the-world as Dasein. The world is something we find ourselves in. Where we understand our world, we know what to do, how to act or comport ourselves. How I move in the world depends on my dispositions – aptitudes, skills, experience and opportunities to act. The relationship between earth and world reflects the dynamics of the ontological difference that is the relationship between Being and being. Just as Being is a precondition for being, so earth is a precondition for world. However, just as Being is invisible, the ground upon which beings can exist, so earth provides the ground on which world emerges.

world view (*Weltanschauung*) – Related to the notion of world picture, or world picturing. Establishes the relationship of man to what-is. It is the ideology that structures the way we can think, represent and act in the world.

worlding of the world or worldhood of the world – The way the world is discovered through Dasein*'s* involvement with it. Our experience in the world is not constituted of things-in-themselves as present-to-hand, but through our involvement with the ready-to-hand.

worldliness – An ontological concept which denotes the fundamental and constitutive fact of being-in-the-world. We are concerned with a phenomenologically experienced world.

Index